THE HISTORY OF
TAROT ART

DEMYSTIFYING THE ART & ARCANA,
⤚ DECK BY DECK ⤙

BY HOLLY ADAMS EASLEY & ESTHER JOY ARCHER

EPIC INK

Brimming with creative inspiration, how-to projects, and useful information to enrich your everyday life, Quarto Knows is a favorite destination for those pursuing their interests and passions. Visit our site and dig deeper with our books into your area of interest: Quarto Creates, Quarto Cooks, Quarto Homes, Quarto Lives, Quarto Drives, Quarto Explores, Quarto Gifts, or Quarto Kids.

Epic Ink titles are also available at discount for retail, wholesale, promotional, and bulk purchase. For details, contact the Special Sales Manager by email at specialsales@quarto.com or by mail at The Quarto Group, Attn: Special Sales Manager, 100 Cummings Center Suite 265D, Beverly, MA 01915 USA.

21 22 23 24 25 5 4 3 2 1

ISBN: 978-0-7603-7124-4

Digital edition published in 2021
eISBN: 978-0-7603-7125-1

Library of Congress Cataloging-in-Publication Data available upon request.

Authors: Holly Adams Easley & Esther Joy Archer

Printed, manufactured, and assembled in Guangdong, China, 07/21

Slipcase: Illustrations from The Moonchild Tarot reproduced with permission of Danielle Noel. Copyright ©2016 by Danielle Noel. Model Awen Sophia Rose.

Front cover: (clockwise from top left) Cosmic Tarot: Illustrations from Cosmic Tarot reproduced by permission of AGM-Urania/Koenigsfurt-Urania Verlag, Germany, © AGM-Urania/Koenigsfurt-Urania Verlag. Further reproduction prohibited.; Numinous Tarot: Illustrations from the Numinous Tarot reproduced with permission of Cedar McCloud. Copyright ©2018 by Cedar McCloud.; Modern Witch Tarot: Illustrations from Modern Witch Tarot reproduced with permission of Liminal 11. Copyright © 2019 by Lisa Sterle.; Tarot of Sweet Twighlight: Illustrations from Tarot of Sweet Twighlight reproduced with permission of Lo Scarabeo. Copyright © Lo Scarabeo.; Robin Wood Tarot: The Magician from the published work Robin Wood Tarot is used with the permission of Llewellyn Worldwide Ltd.; Visconti: Bonifacio Bembo, Public domain, via Wikimedia Commons; Tarot de Marseille: Chronicle / Alamy Stock Photo; Deviant Moon : Illustrations from the Deviant Moon Tarot reproduced with permission of U.S. Games Systems, Inc., Stamford, CT 06902 USA. Copyright ©2015 by U.S. Games Systems, Inc. Further reproduction prohibited.

Back cover: (clockwise from top left) Motherpeace: Illustrations from the Motherpeace Tarot reproduced with permission of U.S. Games Systems, Inc., Stamford, CT 06902 USA. Copyright ©2015 by U.S. Games Systems, Inc. Further reproduction prohibited.; The Wild Unknown: from The Wild Unknown Tarot Deck and Guidebook (Official Keepsake Box Set) by Kim Krans. Copyright (c) 2016 by KimKrans. Used by permission of HarperCollins Publishers.; Black Power Tarot: Illustrations from Black Power Tarot reproduced with permission of Michael Eaton & A. A. Khan. Copyright ©2015 by Michael Eaton & A. A. Khan.; Rider-Waite-Smith: Illustrations from the Rider-Waite-Smith Tarot reproduced with permission of U.S. Games Systems, Inc., Stamford, CT 06902 USA. Copyright ©2015 by U.S. Games Systems, Inc. Further reproduction prohibited. The Rider-Waite Tarot Deck® is a registered trademark of U.S. Games Systems, Inc.; Textured Tarot: Illustrations from the Textured Tarot reproduced with permission of Lisa Mcloughlin. Copyright ©2018 by Lisa Mcloughlin Art.; Morgan-Greer: Illustrations from the Morgan-Greer Tarot reproduced with permission of U.S. Games Systems, Inc., Stamford, CT 06902 USA. Copyright ©2015 by U.S. Games Systems, Inc. Further reproduction prohibited.; The Urban Tarot: Illustrations from the Urban Tarot reproduced with permission of U.S. Games Systems, Inc., Stamford, CT 06902 USA. Copyright ©2019 by U.S. Games Systems, Inc. Further reproduction prohibited.; Our Tarot: "The Fool" and "The Sun" from Our Tarot by Sarah Shipman. Copyright© 2020 by Sarah Shipman. Used by permission of HarperCollins Publishers.

MIX
Paper from responsible sources
FSC® C124385

#341366

FOR THOSE WHOSE STORIES
WE CAN'T TELL YET,
AND THOSE WHOSE STORIES
WON'T EVER BE KNOWN

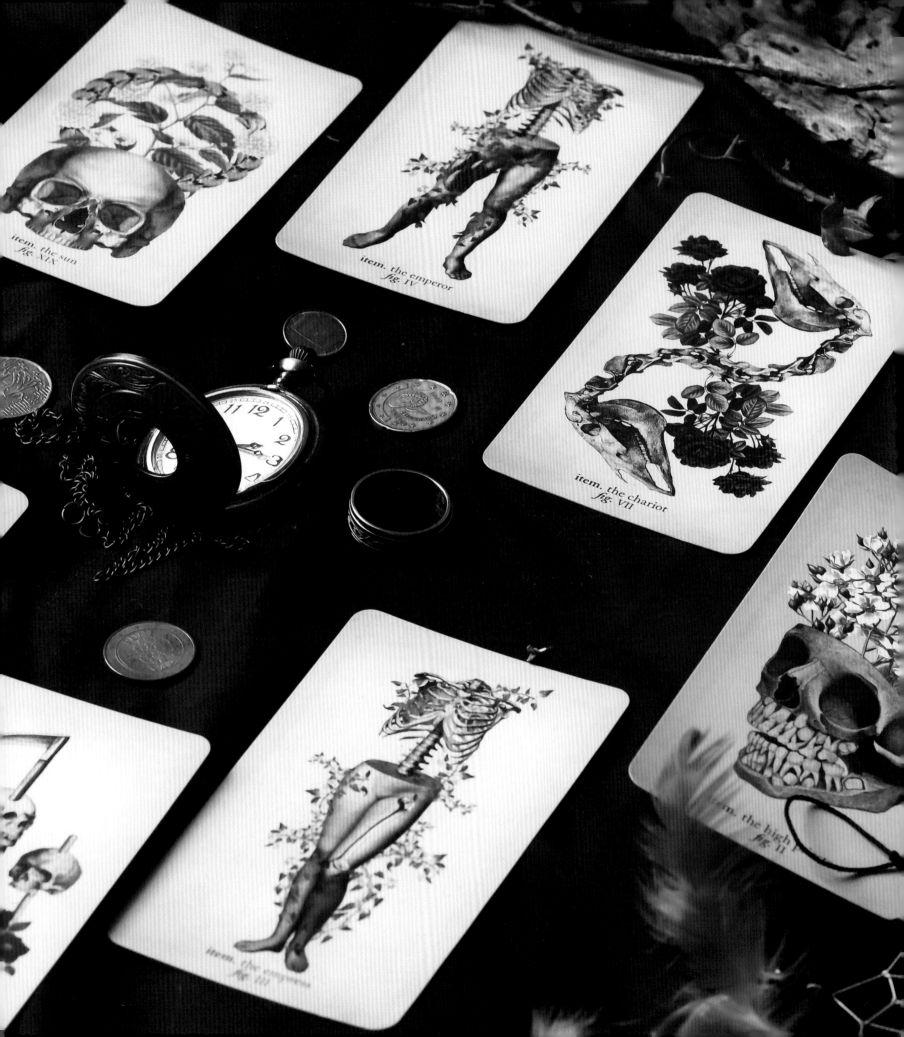

CONTENTS

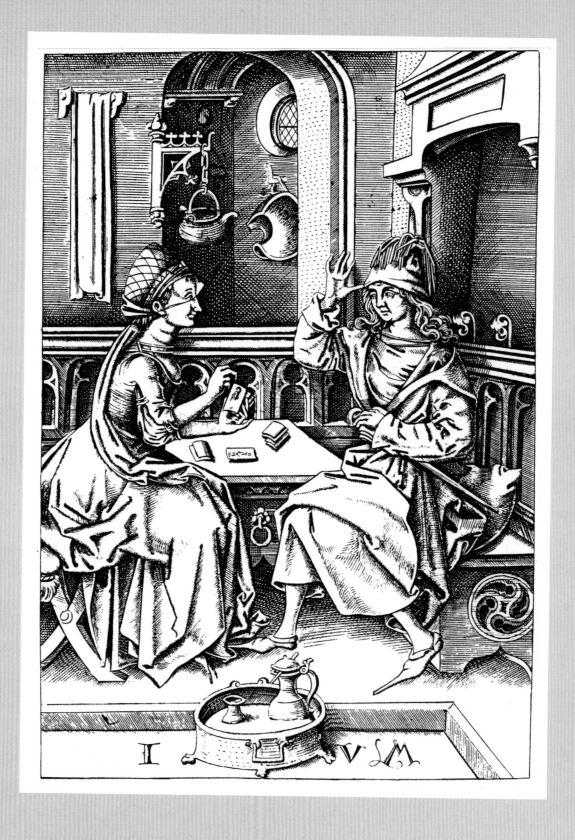

INTRODUCTION

INCE THE BEGINNING OF CIVILIZATION, humans have tried to figure out how this thing called "life" works and whether or not there is a way to predict the future. Thousands of years ago, people used the weather, migratory patterns, and heavenly bodies in the natural world to divine what might happen. Some cultures turned to formally trained scholars who studied constellations, comets, the moon, and eclipses so they could tell kings and emperors at a moment's notice what would come to pass. Their records codify the first methods of divination.

Most cultures assumed that this knowledge of the future flowed from a source, usually a higher being labeled "god," to a chosen speaker or spiritual leader. In the Bible, God chose to speak through prophets who wandered from town to town. Ancient Greece had the infamous Pythia, the name for the series of oracles of Delphi, who went into a type of trance before they uttered prophecies said to come directly from the Greek god Apollo.

As civilizations spread to new parts of the world, they developed their own forms of divination. Some African tribes used bones to tell the future, and in what is now China, the *I Ching* taught readers how to use yarrow sticks. An ancient Germanic alphabet, whose initial use was possibly in magical charms, led to the creation of runes and the practice of casting them. Ordinary people around the world drew lots, threw dice, and interpreted dreams. There is evidence of hydromancy (divination with water), ornithomancy (divination with birds), and even alectryomancy, where ancient Roman scholars watched hens peck at grains and divined the future from what they left behind. In Mexico, the Mazatec indigenous people used a precious spirit plant, *Salvia divinorum,* or "sage of the diviners," in their sacred ceremonies and rituals.

Tarot grew out of the universal human desire to demystify the future. It started as a card game played mostly by medieval upper classes, but eventually turned into a divinatory process accessible to laypeople without formal training.

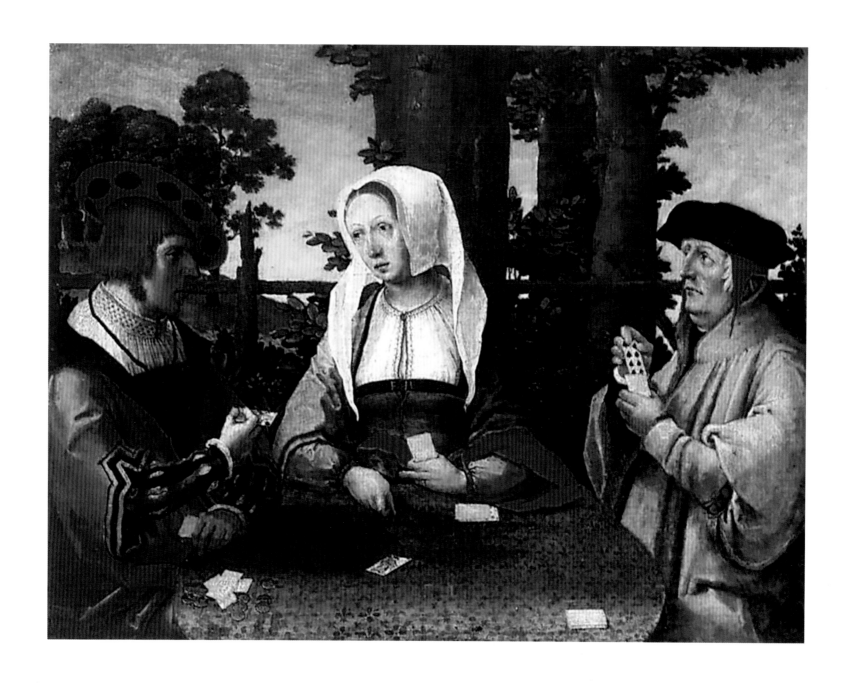

ABOVE: *The Card Players*, ca. 1520, oil on panel by Lucas van Leyden

AFTER THE ENLIGHTENMENT OF EUROPE in the seventeenth and eighteenth centuries, occultists linked tarot cards to ancient pre-Christian wisdom and encouraged their use as a divination method. There was backlash as tarot came to be associated with witchcraft. Powerful religious communities forced tarot to go underground for most of the nineteenth century, and it was taught and shared only in secret. That's why there's an old wives' tale in tarot communities that you need to be gifted your first deck, because stepping into tarot required a trust between teacher and student. It's alarming to us that in England, during the era of the Witchcraft Act of 1735 (which wasn't repealed until the 1950s!), learning tarot could mean jail or even death.

Today, tarot readers like us don't need to worry about jail or death in our countries. But even as tarot emerged from the shadows and occult beliefs gained popularity in the late nineteenth and twentieth centuries, there was an intracommunity shift among the powerful, secret, spiritual societies to gatekeep the symbols and meanings of tarot from ordinary people. Only those whom the groups seemed "worthy" (which we understand to mean "had the social capital that appealed to the group's sense of glamor and mystery" and were educated, monied, and almost exclusively white) could learn how to divine the tarot "correctly."

Only after those societies disbanded in a new trend toward individualism did a handful of people, some seeking personal fame, develop and widely distribute tarot decks. This allowed more people than ever before to discover a user-friendly form of divination where pictures, symbols, and intuitive leaps could communicate the future or give advice.

That's where we are today, in a new, golden age of tarot—and that's why this is the perfect time for a book digging into the history of how tarot art has changed over time. The Tarot has been so meaningful in our own personal lives as tarot readers, and we're excited to show you why. Tarot is something we reach for on a daily basis for advice, comfort, and even sometimes for a "what the heck is going on with you" session. It's what brought us together as friends, and now we have the fun and benefit of sharing our favorite hobby with others through our podcast and social media sites. As for how much we trust tarot for divination? There have been so many times when we, either together or individually, have consulted the tarot with our own doubts, and for us, the results have been correct to the smallest detail.

Our passion is to make tarot accessible to everyone, and that's one of our driving motivations in writing this book specifically about the art. For so long, gatekeepers and occultist insiders have controlled the narrative of tarot history and its artwork, and we want to help you understand the bigger origin stories of these decks based on historical facts and documentation, not "fakelore." We're sharing documented historical facts, and if we don't know something, we'll simply tell you we don't know.

We want to compile these stories in one place before they're lost in dusty archives and forgotten. Some sources we used to write this book are no longer in print and will likely be deleted off Wayback Machine servers as time goes on. The stories of the creation and impacts of these iconic decks deserve to live.

Finally, and most importantly, we want to celebrate the artists whose contributions to tarot are usually not celebrated or widely known. Often, the "great minds" behind a project get all the glory, but tarot wouldn't be accessible without the visual representations of those ideas. Tarot artists deserve more than credit on the box; their stories and immense contributions to each project are largely what draw us to one deck instead of another. We hope to rectify this by bringing awareness to how important their role was in the popularity and ongoing success of tarot.

We're so grateful and thrilled that you have decided to pick up our book. We hope that these stories captivate you like they did us, and that you will fall in love with these images all over again—or for the first time.

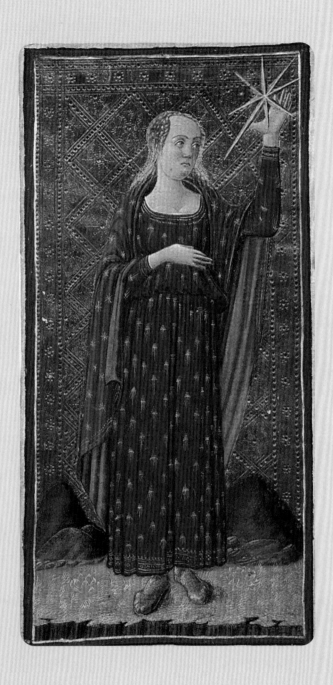
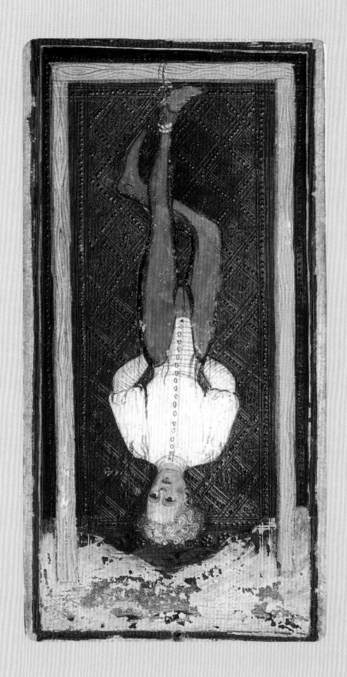

LEFT: The Star, Visconti Tarot
RIGHT: The Hanged Man, Visconti Tarot

VISCONTI TAROT

WHEN: 1451-1466 ▨ **WHERE:** MILAN, ITALY ▨ **CREATED BY:** BONIFACIO BEMBO

O ONE REALLY KNOWS how tarot gained a foothold in fifteenth century Europe. The earliest known card games originated in China during the Tang Dynasty in the ninth century. Playing cards in the Mamluk style—named after the Mamluk Sultanate in Egypt—were brought to Europe in the late fourteenth century by either the Romani people, traders, or crusaders via North Africa and Spain. These cards from "the east" (primarily China, India, Persia, and Egypt) used the same four-suit style we still use in traditional playing cards. Over time, these suits evolved along two paths: one into the iconic tarot suits of Coins, Cups, Swords, and some sort of baton, and the other into the modern cards suits of diamonds, hearts, spades, and clubs.

What we know about the spread of playing cards in European society comes mostly from local ordinances concerning gambling and card games. Though there exist rumors of legislation regarding card-playing in prior decades, the first known the first known documents explicitly banning the use of playing cards for a specific game of chance are from 1377 in the city of Florence, Italy.

Like many questionably legal and therefore thrilling pursuits, the playing card, and specifically a game called tarocchi (the early name for tarot), appealed to the rich and bored of the era, and it was extensively played within just a few decades, even while still illegal in some cases.

The oldest existing example of a tarot deck is called the Visconti deck. It comes from the mid-fifteenth century and isn't a complete deck, but rather a reproduction of several collections of similar sets of cards from different owners painted by the same artist's workshop with only slight variations.

These were the days before tarot had mystic and occult backstories, and the Visconti deck was not made for mysterious or esoteric reasons. It was simply a deck commissioned by a wealthy family for game play use to commemorate a wedding and the alliance of two powerful Milanese families.

So what makes the Visconti deck we now see special? By the time Francesco I Sforza and Bianca Maria Visconti were married in 1441, their families and other local nobles likely had what they called tarocchi decks, but this is the only one that largely survived. Like with any paper-based art, tarocchi decks used for playing games had been destroyed by being handled, but the Visconti cards had been hand-painted and covered in gold. This shimmering layer of Renaissance gilding made it more of an extravagant and luxurious work of art than a normal tarocchi deck. The cards were painted and illuminated on heavy cardboard and are very thick, making it even more unlikely they were used to play in any real games.

OPPOSITE PAGE: an uncut sheet of Visconti tarot cards from the Cary Collection at Yale University

THE ORIGINS OF TAROT

AS FAR AS WE KNOW from contemporaneous documents, tarot wasn't seen as a divinatory method in the fifteenth century. Later occultist historians claimed that the Romani were using tarot cards in divination as early as then, but we now know those occultists, wanting to legitimize divination and spirituality, were prone to adding mysterious historical fakelore to their writings. While we, the authors, agree that tarot is a method of divination, when we write about the origins and art of tarot, we can't perpetuate the fakelore that has run rampant for centuries.

So while we're mostly sure that the Visconti-Sforza deck, like others commissioned and written at the time, was a purely social card game, we're not sure what the game was. By the time tarocchi documentation pops up in the mid-fifteenth century, the rules had become so complex, allegorical, and multilayered that historians think people must have already been playing for decades.

Card games like tarocchi and later trionfi, both of which used decks that included trump cards, were trick-taking games in which a dealer placed a card down and players around the circle had to "follow suit" (playing a card with the same suit down). In trionfi, using trump cards that would later be familiar to us as the Major Arcana would let a player avoid having to follow suit. Points were earned based on the value of the cards, with all suited cards worth one point, the face cards (court cards) worth two to five points, and the trump cards worth varying amounts of points. Points were tracked with each round.

These general rules were likely personalized by each household as card game rules are wont to change. By the 1440s, the trump cards had taken on extra allegorical meanings by telling the story of a journey through the cards. More and more rich families loved the game enough to commission luxurious copies for themselves.

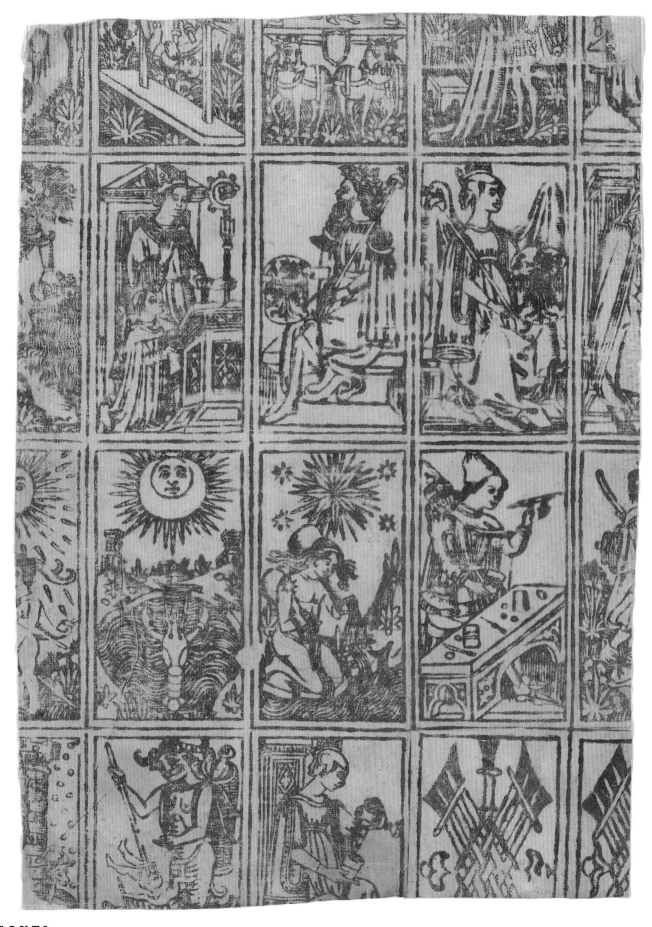

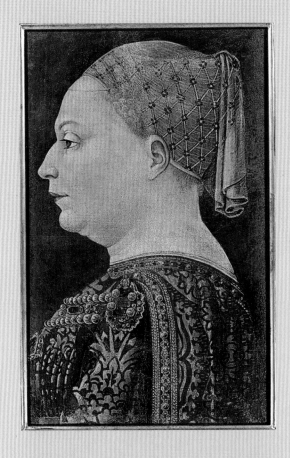

HISTORICAL PATRONS

PATRONS OF THE ARTS WERE NOTHING NEW TO RENAISSANCE ITALY. Though we often think of noble families commissioning or sponsoring large and important works of art from people like Leonardo da Vinci or Michelangelo, less well-known Renaissance artists also relied on the patronage of the rich for smaller pieces. For some Italian families, hiring sculptors, painters, and decorators was as common as hiring skilled laborers to make repairs to a house. Bonifacio Bembo was one of these artists.

Bonifacio Bembo has historically been considered the painter behind the original Visconti-Sforza deck. Records from the time are virtually nonexistent, and much of the attribution comes down to style and who we know was in town at the time. Famed art historian Roberto Longhi attributed the creation of the decks to Bembo in the late 1920s, and other art historians followed suit. However, Bembo's assumed role as the only artist of the deck has been disputed by many art historians in the last few decades. There were at least nine artists in northern Italy with the same last name (largely relatives of one another) during this time period, and it's now believed that the variations among the three decks indicate that several artists collaborated to create the cards we have today. Some also argue that the decks could have been created by the Zavattari family or Michelio de Besozzo, since they were also artists in residence in the area at that time, and their frescoes reflect similar details in the artwork that remains on the Visconti-Sforza tarot cards.

Two pieces of art we absolutely know Bonifacio painted that tie him to the Visconti-Sforza family are the portraits of Francesco I Sforza and Bianca Maria Visconti from the 1450s. They likely selected him to paint these portraits because he was already Bianca's favorite artist and because he was vocal in his support of Francesco after the death of Franceso's predecessor, Duke Filippo Maria Visconti of Milan. If Bembo was also the artist behind the tarot deck a decade before the portraits, it would show a longstanding relationship between an artist and a noble family that survived political upheaval, regime change, and decades of working together.

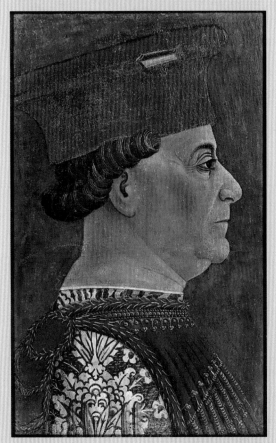

TOP: Bianca Maria Visconti
BOTTOM: Francesco I Sforza

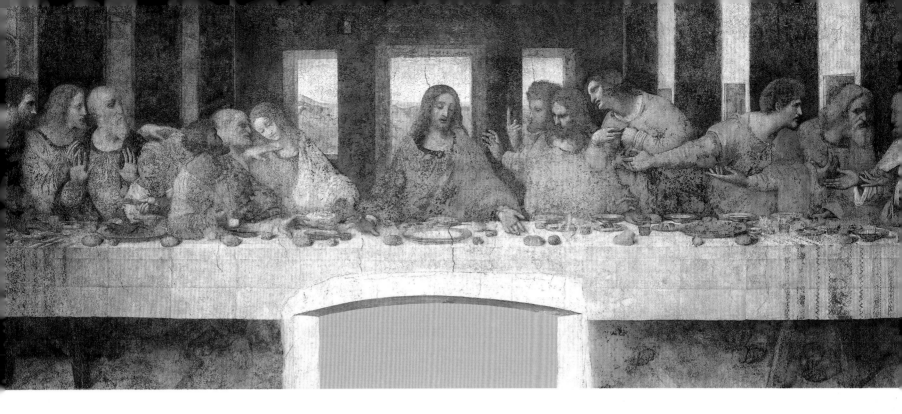

THE FIFTEENTH CENTURY MILANESE ART SCENE

AT THE TIME THE DECK WAS CREATED, Milan was not as well-known for a peaceful, art-filled renaissance as neighboring Florence—mostly because the Duchy of Milan, an alliance of twenty-six towns in central-northern Italy, was trying to consolidate power in the region by wresting control of each individual city-state from its ruling family. Many of the most important Milanese works of the era are architectural, like the Santa Maria delle Grazie church designed by Guiniforte Solari and perhaps later with Giovanni Antonio Amadeo.

It wasn't until the late fifteenth century that Leonardo da Vinci became a key player in the art of Milan, catapulting the region to cultural significance. Interestingly, it was Francesco and Bianca's fourth son, Ludovico Maria Sforza and the regent of Milan for over a decade, who commissioned da Vinci's *The Last Supper* in the 1490s, which has become one of the most recognizable pieces of Renaissance art.

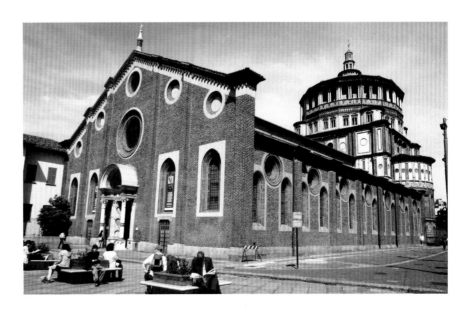

TOP: *The Last Supper* by Leonardo da Vinci
RIGHT: Santa Maria delle Grazie, Milan

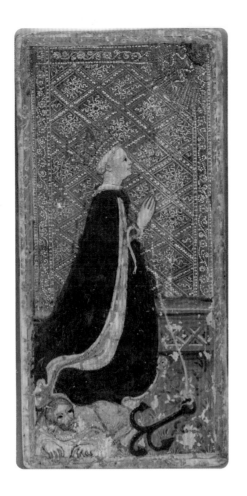
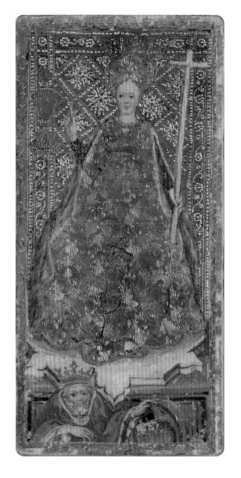
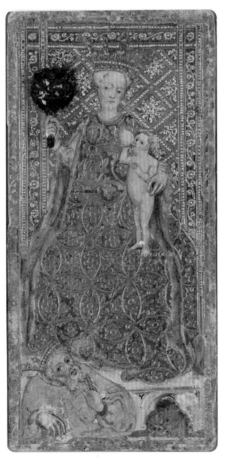
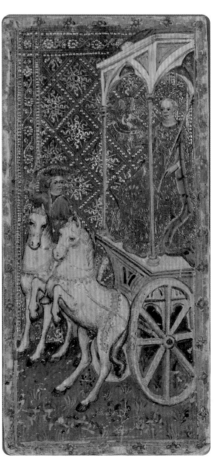

THE VISCONTI DECKS

FRESCOS, MURALS, and architecture are more capable of withstanding the damage that time brings to paper-based art, which is why there's no complete copy of the Visconti Tarot in existence now. Instead, there are three partial decks, all attributed to Bembo's workshop, from which the modern printings of the Visconti Tarot have been compiled and created.

The most complete deck, called the Cary-Yale deck, contains sixty-nine cards and is housed at the Yale University's Beinecke Rare Book & Manuscript Library. This set is also known as the Visconti di Modrone set and is dated at around 1466.

The Brera-Brambilla deck contains forty-eight cards and has been in the Brera Gallery in Milan since 1971. Nothing is known about this set prior to 1900, when Giovanni Brambilla acquired these cards in Venice.

The Pierpont-Morgan-Bergamo deck is believed to be the oldest of the surviving sets, produced around 1451. It has sixty-one surviving cards and is also known as the Colleoni-Baglioni or the Francesco-Sforza, and how the cards from this deck survived this long is somewhat of a mystery. We know the original set was commissioned and owned by the Sforza family. It disappeared from historic records until the seventeenth century, when the deck showed up in the possession of Canon Ambivero of Bergamo. From there, it was passed on to the Donati family, then to a Count Allesandro Colleoni of Bergamo. It's difficult to date the exact time of this transfer because there was an Allesandro Colleoni in every generation. (This is a good reason why you shouldn't name your children after family members!).

Sometime in the late nineteenth century, one of the Allesandro Colleonis traded twenty-six cards from the deck with a friend, Francesco Baglioni, in exchange for some pieces of art that included family heirlooms. Upon Baglioni's death in 1900, his twenty-six cards became part of the museum Accademia Carrara in Bergamo. In 1911, the Pierpont-Morgan Library in New York acquired thirty-five cards from a dealer in Hamburg, who likely received them from Count Colleoni. As far as we know, the remaining thirteen cards are still in the private collection of the Colleoni family.

All three decks reflect the traditional tarocchi-style influence of playing cards. What we now call the twenty-two major cards were illustrated with figures and scenes, but the minor cards are in what are called a "pip" style, showing only the symbol of the card and its rank. If you draw the Four of Cups, for example, there would be four cups on the card face, but no extra illustration.

Each of the three sets have artistic variations and gilding differences, common in hand-painted decks created long before modern printing methods allowed mass production. When we look at the decks together, only four cards have been lost to time and history: The Devil, The Tower, the Knight of Coins, and the Three of Swords.

OPPOSITE PAGE, CLOCKWISE FROM TOP LEFT:
Hope, Faith, The Chariot, and Charity
Visconti tarot cards, from the Cary
Collection at Yale University

THE POLITICS BEHIND THE VISCONTI ART

ART DURING THE ITALIAN RENAISSANCE was not just a way to document family histories, but to show off wealth, political power, and influence, sending a message about the state of a family's affairs. Hence, the commission of a tarot deck with gold gilding wasn't just about a game or a nice wedding present; it was a powerful message about the state of a political alliance. We see this in the ways the artist pays special attention and meaning to certain cards.

In the Empress and Emperor cards of the Visconti-Sforza deck, we see symbols of the strength and unity between the two families. The Empress, who wears gold and the shade of blue associated with the Sforza coat of arms, holds a shield decorated with the black eagle associated with the Viscontis and later the Sforzas. The Emperor has the same eagle on his headpiece, and he holds a globe with a cross on it—a medieval symbol of Christian authority. Both figures wear clothes embellished with repeating, interlocking, diamond rings—symbols also used to represent the Sforza family's wealth and prestige.

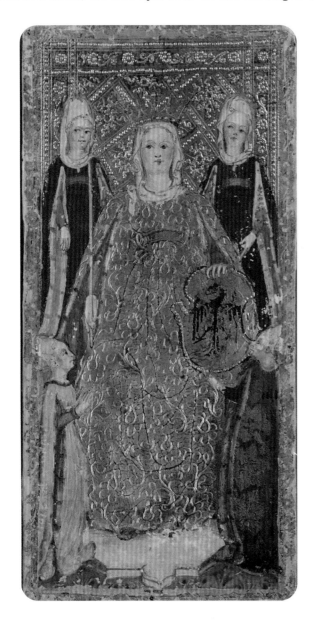
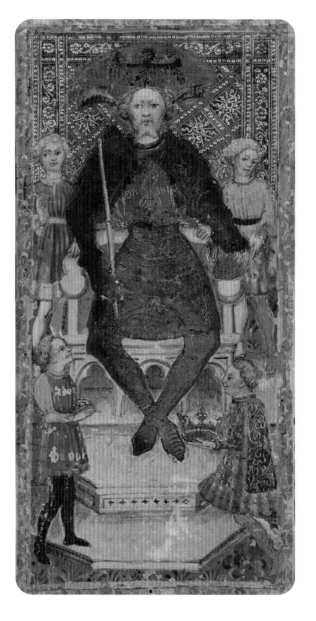

THE OBVIOUS THEORY about The Lovers card in a deck created for a wedding is that it represents the besotted bride and groom. However, it's hard to overlook that in this image, the figures seem of equal age and equal enthusiasm. In reality, Francesco I and Bianca Maria were twenty-five years apart in age, and despite having nine children together, there isn't a lot of evidence that the pair had any true affection for one another. In fact, the stories of Francesco's affairs are well-recorded, and while maybe Bianca didn't care, there's also a story about one of her husband's favorite mistresses disappearing under mysterious circumstances during their rule.

Showing two powerful political figures joining together strengthens each family's legacy and ties them together moving forward. We think this card also shows the political savviness and intelligence of the artist. The source of a steady income, especially as a favored artist in the family, would be a perfect reason for Renaissance artists to portray their patrons in the light they wanted to see themselves—powerful, wealthy, and young, with a prosperous future ahead of them.

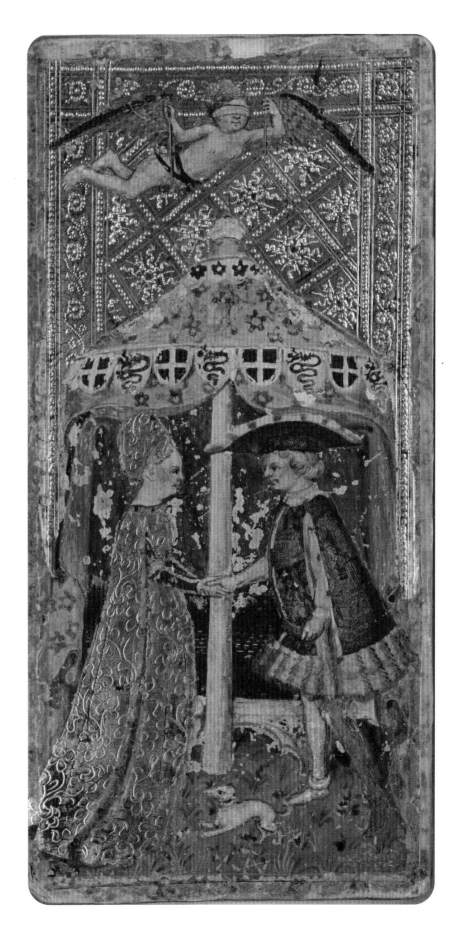

OPPOSITE PAGE: The Empress (left) and The Emperor

RIGHT: The Lovers

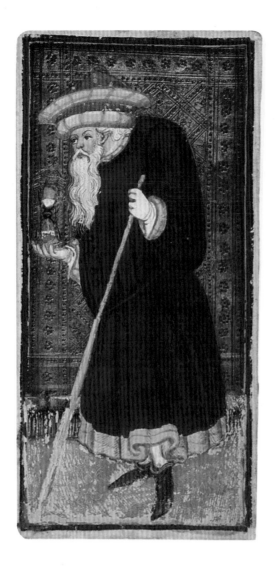

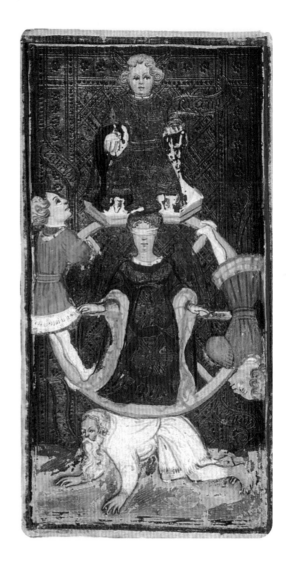

IN THIS DECK, THE HERMIT and the Wheel of Fortune both can represent the passage of time and the continuation of power. The Hermit, unlike its more modern representations, holds an hourglass rather than a lantern and is clothed in rich fabrics with gold trim. He doesn't seem impoverished or existentially alone, but simply alone for now. In modern times, this card is also sometimes called the Father Time card, again representing the passage of time and moving on from historical struggles and grudges.

The blindfolded figure in the center of the Wheel of Fortune wears the multirayed sun symbol that often appears in the symbolism of the deck, showing that the passing wheel of time is outside anyone's direct control. The four figures tied to the wheel all have implications of time passage and power. On the left is a figure with donkey ears that says *Regnado,* or "I shall reign." The figure on top of the wheel still has the donkey ears and says *Regno,* or "I reign." The figure on the right of the wheel no longer has donkey ears (which could represent foolishness for the other two figures, and thus more wisdom for this figure) and says *Regnavi,* or "I reigned." Finally, the figure at the bottom, worn out and ancient, says *Sum sine regno,* or "I am without reign."

EVEN ON THE LESS ILLUSTRATED suited cards, we find references to the Visconti family and their overarching power. Some, like the Ace of Swords, Four of Pentacles, and Five of Wands, are emblazoned with banners that say *A bon droyt,* the Visconti motto meaning With Justice. The Two of Cups has a banner that only appears on that card saying *Amor myo,* which references love— perhaps one represented by sharing chalices as part of a wedding ceremony.

 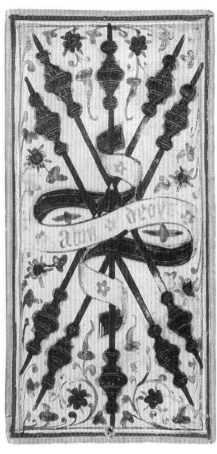
 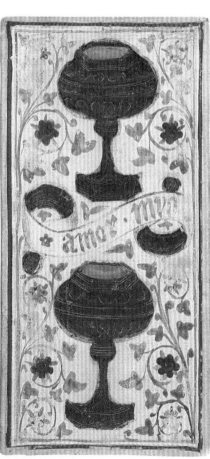

OPPOSITE PAGE: The Hermit (left) and The Wheel of Fortune

THIS PAGE, CLOCKWISE FROM TOP LEFT: Ace of Swords, Five of Wands, Two of Cups, and Four of Pentacles

MILANESE POWER STRUGGLES

THE COMMISSION OF A GORGEOUS DECK of cards shows us that the alliance of two powerful families was worth celebrating, but it doesn't tell the whole story.

The bride's father was Filippo Maria Visconti, the last Visconti Duke of Milan. When Filippo took over after his brother's assassination in 1412, he embarked on decades of consolidation of power and influence throughout northern Italy. He fought alongside Francesco I Sforza, his future son-in-law, in several battles, and in 1430 betrothed his five-year-old daughter, Bianca Maria, to him as a reward for loyal service in order to tighten the alliance.

The marital agreement came with a dowry of land and money, but doesn't appear to have created any trust between the men, who continued to fight both together and on opposite sides for several more years. Records show that Visconti actually tried to break the engagement he brokered several times. Nonetheless, a decade after the original betrothal, Filippo was presumed to have commissioned the elaborate Visconti Tarot to celebrate the long-awaited marriage between his teenage daughter and his longtime frenemy.

We may see a hint of this history in the King of Swords, who wears full armor and carries a sword and shield bearing the heraldic device of a lion with a halo. The lion might represent Francesco I Sforza or, more likely, Venice. Francesco and Bianca's 1441 wedding also signaled the end of a conflict between Milan and Venice, during which Sforza, in an ironic turn of events, fought on the Venetian side against his soon-to-be in-laws.

Bianca Maria wasn't the duke's legitimate and legal daughter because her mother was his mistress, not his wife, and so Francesco and Bianca weren't the immediate successors when Filippo died in 1447.

THIS PAGE, TOP TO BOTTOM: Visconti Coat of Arms, Original House of Sforza heraldic symbol, Sforza Coat of Arms circa late 15th, early 16th century

OPPOSITE PAGE: King of Swords (left) and King of Coins

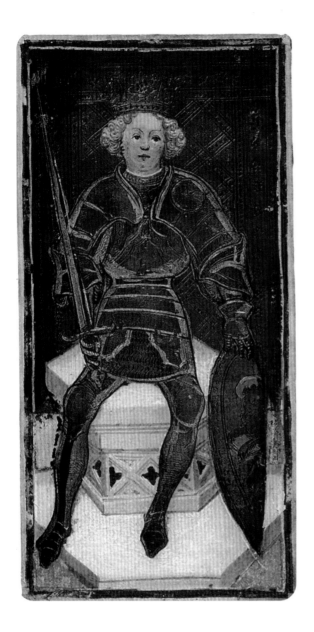 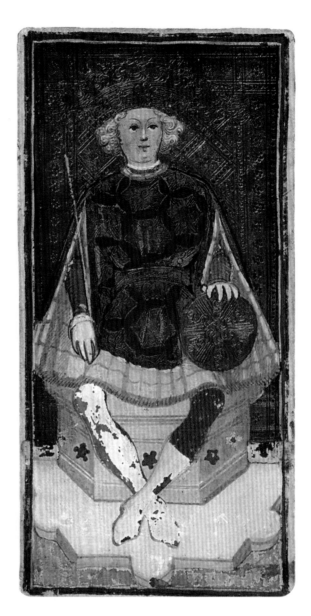

There was a brief but intense power vacuum after the duke's demise, and members of the University of Pavia formed the Golden Ambrosian Republic, which existed in partnership with Francesco while the region weathered several crises with neighboring city-states. After four years, Sforza and his young wife defected to Venice in exchange for Venetian support. In March 1450, Sforza declared himself captain of the people and, because of his wife's lineage, the new Duke of Milan. They ended up ruling together for sixteen years.

The King of Swords is the only king in this deck who seems prepared for battle, carrying a shield. The King of Coins, on the other hand, wears an elaborate hat and holds a large coin with the Visconti heraldic device of a sun with wavy rays. This could be seen as a reference to the peace, art, and fortuitous riches that were yet to come.

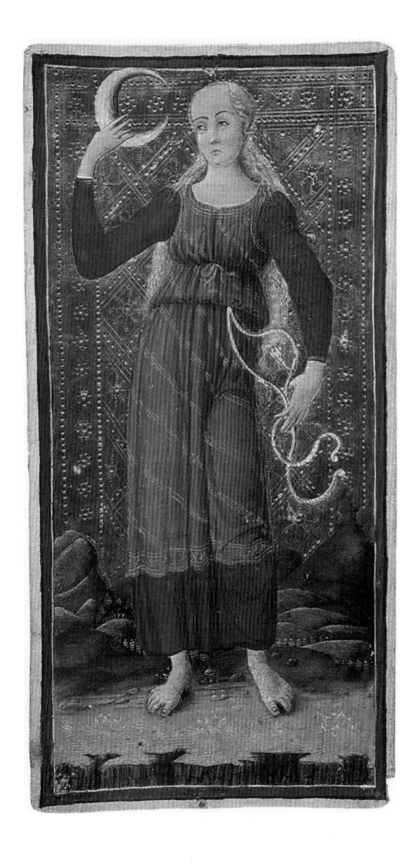

THE MOON AND THE WORLD CARDS are noticeably different from the majority of the other trump cards, and most experts believe they hadn't been drawn by the hand of Bonifacio Bembo. Both seem slightly more refined and naturalistic than the other face cards, bridging the gap into more of a traditional Renaissance look.

The Moon card shows a young woman in a more classical artistic styling that harks back to the Renaissance move toward classicism, as well as referencing Greek and Roman mythology.

The cupid figures on The World card also reflect that with the additional image of a safe and vibrant walled city overlooking a rough sea. Since The World is the final trump card in the sequence, in modern divination metaphors it points to a completion. This is the last card in the majors, so you have reached the end. In the Visconti Tarot, this impression feels relevant as a symbol of ultimate goals of the partnership and leadership of the Visconti family.

LEFT: **The Moon**

OPPOSITE PAGE: **The World**

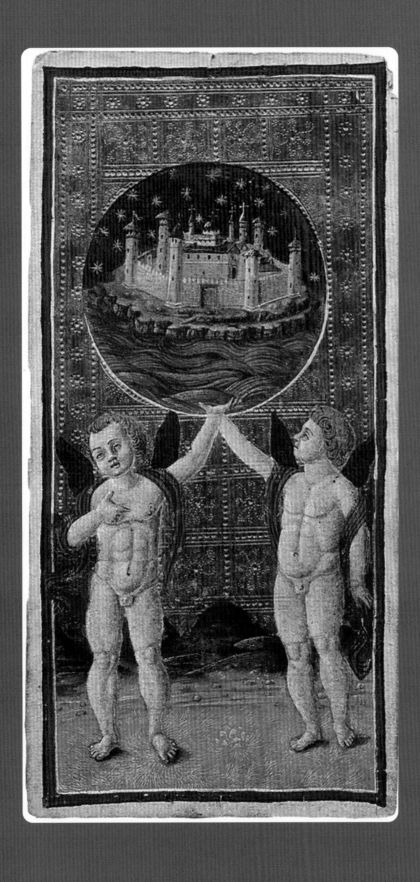

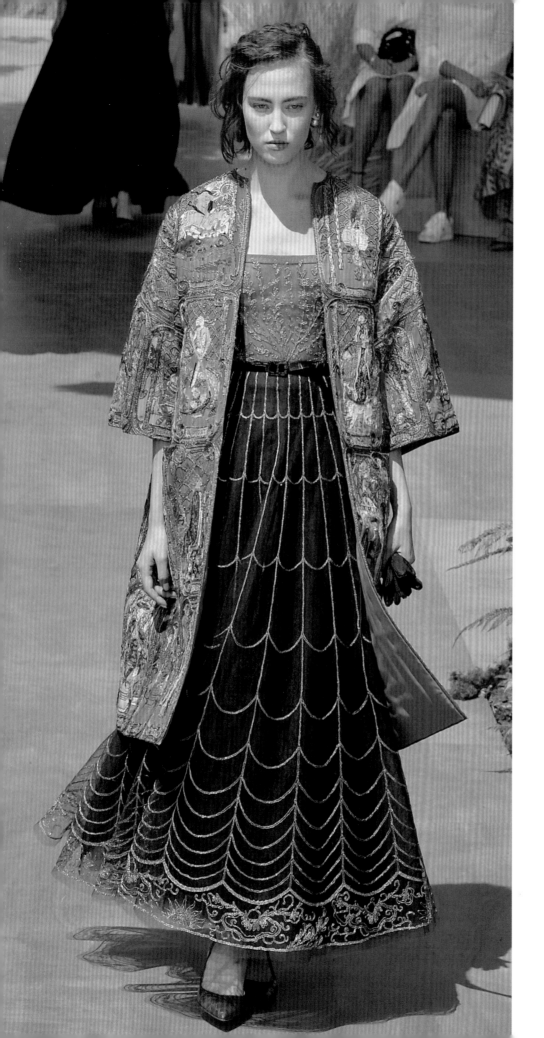

THE VISCONTI LEGACY

EVEN THOUGH THE VISCONTI cards were part of the collections of several museums, it doesn't seem like they had much pop cultural influence beyond other tarot artists building on what Visconti had begun. The famous Rider-Waite-Smith and the Thoth tarot decks, which we'll look at in future chapters, took the archetypes and symbols established in the Visconti-Sforza tarocchi game and paid homage to them in their artwork. In the mid-1970s, publishing companies started to compile and release their own versions of a Visconti tarot deck, recreating their own versions of the missing cards, which explains why a modern tarot reader may notice such variations between these cards in the republishing of Visconti Tarot.

Then, in 2017, Visconti Tarot showed up in the spotlight. Under the helm of creative director Maria Grazia Chiuri, the fashion designer House of Dior's Autumn Winter show featured Visconti Tarot in a stunning and intricate deck-inspired coat that reportedly took 1,500 hours to hand sew. This wasn't the first or the last reference that the House of Dior made to tarot (Christian Dior himself is said to have gotten readings before many of his shows), but the sheer undertaking of this elaborate homage got a lot of attention from the tarot and tarot-curious alike.

THE 1JJ SWISS DECK was published in the mid-1960s based on a style that came much later than the Visconti deck, but it shares the unillustrated pip cards, as well as the elaborate lines and flourishes of the original deck.

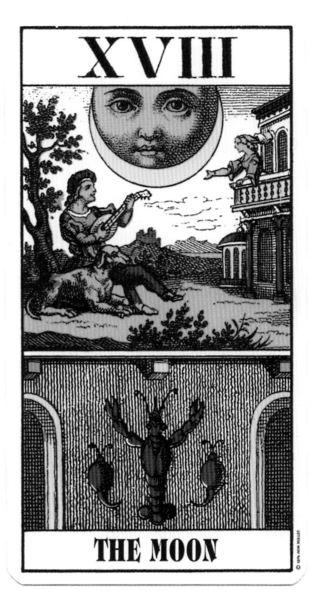

The Three of Swords (left) and the Three of Wands from Sola-Busca Tarot

SOLA-BUSCA

WHEN: 1490 ■ **WHERE:** ITALY ■ **CREATED BY:** NICOLA DI MAESTRO ANTONIO

IN 1490, JUST A FEW DECADES AFTER the Visconti Tarot commemorated a wedding in Milan, another northern Italian family commissioned the deck we now know as Sola-Busca Tarot (sometimes styled as Sola Busca without the hyphen). There's no documentation about who specifically commissioned the deck the way there is for the Visconti deck, but we know that the Busca-Serbelloni family owned it for at least 400 years. Even after changing hands in the twentieth century, the Sola-Busca deck remained a private family heirloom, only briefly making public appearances to the outside world until 2009. Understandably, it's not an immediately recognizable tarot name to many modern tarot readers, but as we'll see, the art of Sola-Busca influenced much of our modern visual expectations of tarot artwork.

Perhaps most importantly, the Sola-Busca Tarot deck is the only deck from the fifteenth century to have all twenty-two Triumph (Major) and fifty-six number (Minor and court) cards still intact.

Artistically, Sola-Busca is also the first deck to use alchemical and philosophical intentions on allegorical minor cards, and that influenced future artists, including the popular Rider-Waite-Smith deck in 1909.

Unlike the hand-painted Visconti deck, the original Sola-Busca was printed in a way that exact copies could be made and distributed to other wealthy individuals of the era. Cards were created using a copperplate printing method where an artist etched an illustration lightly onto copper plates, spread ink on top of the impression, and then stamped the illustration onto paper. Later, color could be added by hand to the impression.

The few surviving copies of the Sola-Busca deck remain in black and white, never colored in. The only fully colored and intact copy of the deck is the original Busca-Serbelloni family heirloom. The continuity kept the deck whole.

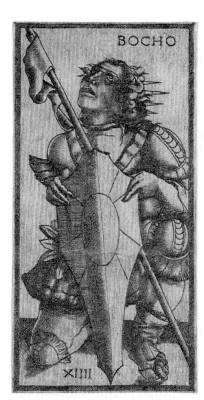 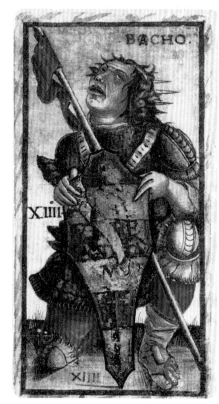

ABOVE: Bocho, Trump XIII, from Sola-Busca Tarot, engraved on paper (left) and colorized (right)

OPPOSITE PAGE: *The Saints Jerome, Sebastian and Rochus* by Nicola di Maestro Antonio d'Ancona, 1478

SOLA-BUSCA TAROT ORIGINS

UNTIL RECENTLY, THE ARTIST of the Sola-Busca was unknown and was referred to only as the Maestro dei Tarocchi Sola-Busca. However, scholars from the Brera Museum in Milan where the cards are currently held now positively identify Nicola Di Maestro Antonio as the artist responsible for the creation of this historical heirloom.

Nicola di Maestro Antonio was one of the lesser-known and more eccentric artists of the Renaissance, recognized today mostly for his paintings of biblical characters and Catholic saints, including the work *Saints Jerome, Sebastian and Roch*. He was born in 1448, was almost certainly the son of the Florentine painter Antonio di Domenico, and was perhaps trained in Padua in the style of Squarcione. He died after returning to his hometown of Ancona in the central Marches region of Italy in about 1510.

Arcona is now a wine-growing region with a healthy grape production, but in the era di Maestro Antonio lived there, it was the subject of many back-and-forth political movements due to its strategic location along the Adriatic coastline. That meant there was a steady influx of thinkers, artists, and others who wanted patronage that was available in a bustling environment.

It's not a great leap to assume that di Maestro Antonio's understanding of alchemical and classical philosophy references could have come from Lodovico Lazzarelli, a philosopher and humanist about di Maestro Antonio's age who lived not far away. As the capital of the region, Ancona would have been a natural place for two young, creative-minded men to meet, and the overlapping content we see in their surviving work furthers that theory. (In a fun-for-us-tarot-history-nerds turn of events, at thirteen years old, Lazzarelli wrote a poem that received an award from Alessandro Sforza, Duke of Pesaro and Francesco I Sforza's brother and military collaborator. What a small world that region of Italy turned out to be.)

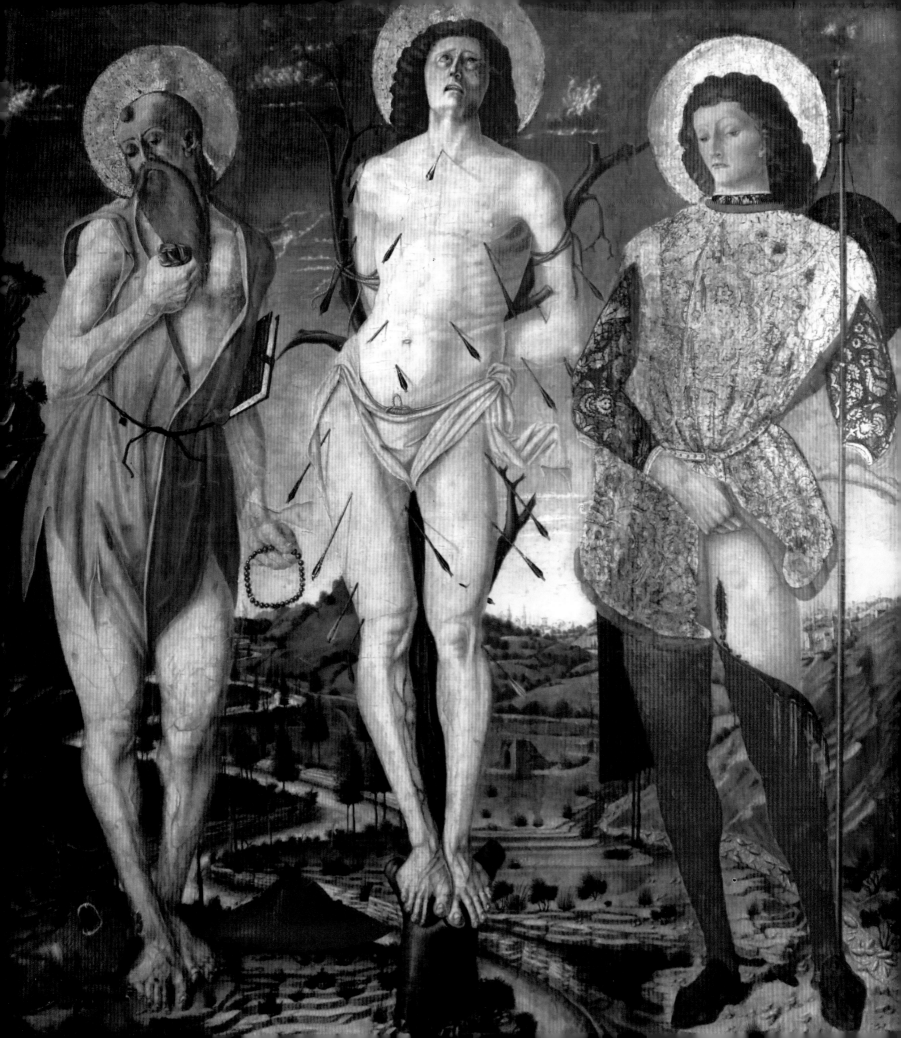

Lazzarelli was an avid student of famed Hermeticist and alchemist Giovanni Mercurio da da Correggio. In fact, Lazzarelli wrote and edited commentaries in the collection of the *Corpus Hermeticum,* for which the belief system is named. At the time of the Sola-Busca deck's creation, many believed the original text was written by a contemporary of Moses (yes, *that* Moses) named Hermes Trismegistus. Modern scholars now say it was more likely assembled from other writings by various Greek philosophers in the second to fourth centuries.

Hermeticism is a religious, esoteric, and philosophical practice that became hugely popular in the Renaissance. It boils down to the idea that the truth of the universe was given to humans in antiquity (presumably by some kind of god or a universal force). Hermetics used ritual, astrology, and alchemy to understand that truth they believed was hidden in everything around us. We can see in this the Renaissance's glorification of the Romans, and through that, the carryover of Rome's fascination with ancient Egypt as a cultural and religious ideal. In the chapters that follow, we'll see a lot more examples of the super common urge to connect all emerging spiritual and religious beliefs to the ancient Egypt and its pharaohs.

At the time Sola-Busca was created, Hermetic ideas of alchemy and transformation were very much in the zeitgeist. *Corpus Hermeticum* was so popular that in 1460, the famed Italian scholar and humanist philosopher Marsilio Ficino stopped translating the works of Plato in order to translate *Corpus Hermeticum* into Latin. Many spiritual practices still familiar to us today stem from Hermetic writings, including much of the New Age movement and, perhaps most importantly for tarot history, the occultist movement of the early twentieth century.

If the connection between di Maestro Antonio and Lazzarelli is accurate, then Lazzarelli's background with Hermeticism lends a lot of legitimacy to the idea that this was a key influence on the symbolism in di Maestro Antonio's tarot art.

LEFT: The *Corpus Hermeticum*

OPPOSITE PAGE: Hermes Trismegistus, as pictured in a floor mosaic in the Siena Cathedral.

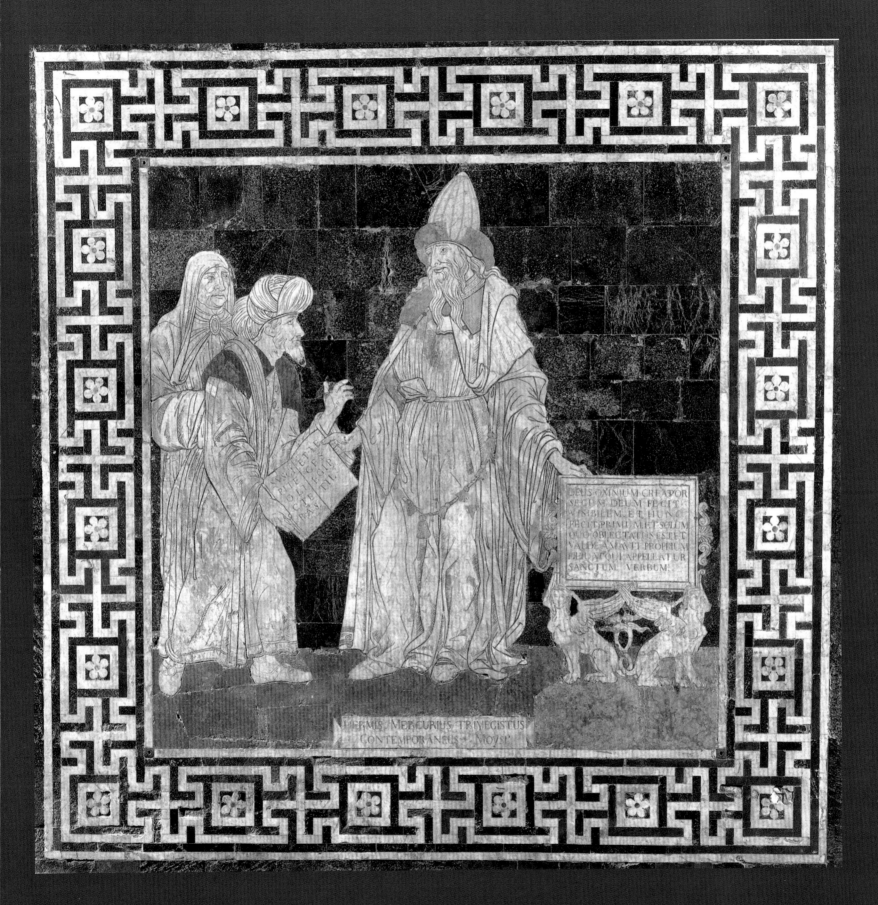

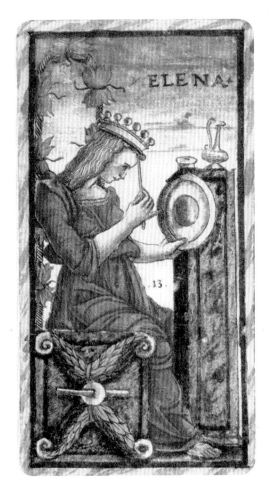

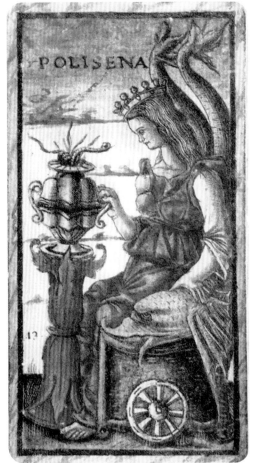

THE HISTORICAL FIGURES IN SOLA-BUSCA

NOT ONLY IS SOLA-BUSCA THE OLDEST tarot deck completely intact, the first to be created via printing methods, and the first deck to have illustrated minors, Sola-Busca is also the first to have names and Arabic numbers on the cards themselves, as well as the first deck to deliberately celebrate identifiable esoteric traditions and mythologies in its artwork.

With the exception of The Fool, which is similar to other Fool cards of that time, every card in the Sola-Busca deck seems to depict historical and mythological figures as archetypes. Most come from Roman and Babylonian history, but some are famous individuals from that era, and some have not yet been identified. The figures we recognize make this deck compelling as a historical artifact of its time and give the modern reader a look into what was culturally important in the late fifteenth century.

Of course, the comparisons and links made by fifteenth-century Italians playing a card game won't necessarily align with what we, as twenty-first-century tarot readers, think of as traditional meanings of the tarot cards, primarily because the traditional meanings of the cards weren't codified (whatever that looks like when we're talking about tarot) until much later. That doesn't make it less interesting, but keep the time frame of tarot turning into a format of divination in mind as we nerd out about these awesome connections.

For example, the inspiration for the Queens of the court cards all seem to come from a 1362 book written in Latin by Giovanni Boccaccio. *De Claris Mulieribus* (*On Famous Women*) was the first book exclusively devoted to telling "biographical" stories of women as a way to extol virtuous actions and shame immoral behaviors. It was popular enough that educated people of the fifteenth century would have probably recognized these Queens in the Sola-Busca Tarot art and would likely know what the artist was implying with their historical and mythological significance.

The Sola-Busca's Queen of Disks (Coins) is Helen of Troy, who in Greek mythology was the most beautiful woman to ever live. After Helen ran away with Paris, the Prince of Troy, the Greek armies fought for ten years against Troy to win her back. Homer depicts Helen as ambivalent and regretful of her choice, while other writers characterize her as a traitor who rejoiced in the carnage she caused. In the tarot art, the Queen is focused intently on earthly possessions and what's right in front of her, perhaps emphasizing

her lack of understanding of the larger ramifications of her actions. A rude take, but one that di Maestro Antonio's audience would have understood.

Polyxena, another Greek mythological princess, appears as the Queen of Cups. Legend says the Greek warrior Achilles fell in love with the Trojan princess Polyxena. To end a war between the Greeks and the Trojans, a marriage of political alliances was agreed upon, but Polyxena betrayed Achilles and allowed Paris to shoot a fatal arrow into her betrothed's heel, his only vulnerable spot. Polyxena regretted her decision—turns out it was hugely shocking to find yourself responsible for your lover's death—but her reputation as a double-crosser followed her for the rest of her days. A snake emerges from Polyxena's cup on her card in the Sola-Busca deck, perhaps a sign of betrayal and deceit.

Athena, also known as the Roman Minerva or Pallas in fifteenth-century writings, is the only goddess depicted in Sola-Busca art. Pallas was Zeus's favorite daughter and the goddess of wisdom, war, and handicrafts. She was born from Zeus's head; the source of her divine wisdom and knowledge came from the head of a god. In Sola-Busca, she is the Queen of Wands, and her fiery, active nature fits the suit.

The final queen depicted in the court cards is Olympias, Alexander the Great's mother, as the Queen of Swords. The real Olympias was a very complex woman—we know she was jealous, meddled in politics, and was willing to have opponents killed when she believed they threatened her son's dynasty. (Not a great historical legacy!) However, the classicist revisionist history that was common during the Renaissance had turned Alexander the Great into a enlightened collective ancestor, and had rejuvenated Olympias's reputation to a mother worthy of a mythologically wise and just leader known as "the New Sun."

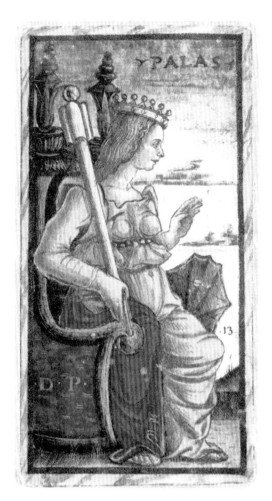

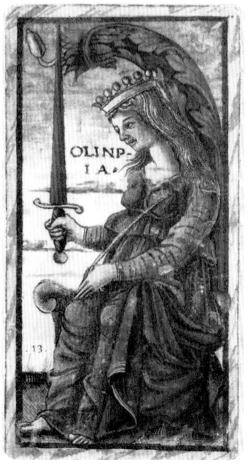

OPPOSITE PAGE TOP TO BOTTOM: Queen of Disks (Helen of Troy), Queen of Cups (Polyxena, the princess who betrayed Achilles)

PICTURED TOP TO BOTTOM: Queen of Wands (Pallas, otherwise known as the Greek goddess Athena), Queen of Swords (Olympias, the mother of Alexander the Great)

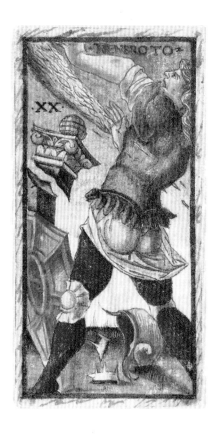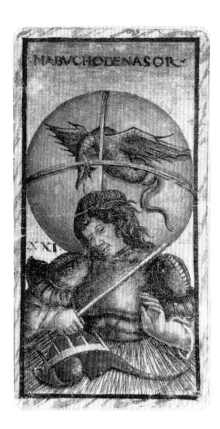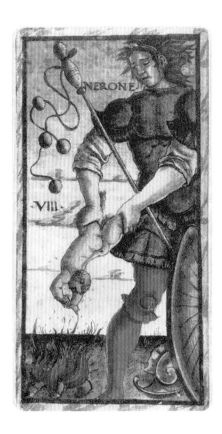

CONTINUING THROUGH THE CARDS, we see that the Sola-Busca cards portray three popular biblical figures as trump cards, reinforcing the Renaissance's commitment to celebrating Christian mythology. Nero (Justice), Nimrod (Judgement), and Nebuchadnezzar (The World) not only all have names that begin with the letter N, but were all great kings of their time, known for conquering lands, building wealth and great cities, and destroying the empires of their enemies.

Nero's name continues to live in infamy as a man associated with political murders, persecution of Christians, debauched lifestyle choices, and such a passion for music that it ignited the rumor that the emperor "fiddled while Rome burned" in a great fire. Linking him with Justice is interesting (and a little wild) because Nero is Neroing all over this card. It looks like he's tearing a baby in half before casting it into a fire, which feels neither justified nor justifiable.

Nimrod was a "mighty man before the Lord" according to the book of Genesis. He's said to have built the Assyrian empire, which is actually called "the land of Nimrod" in biblical texts.

Scholars note there are many similarities between Nimrod and the Mesopotamian epic hero Gilgamesh. The Sola-Busca image seems to depict his shock at the sheer power of the biblical God, who shakes the very foundations of the buildings around him. This card's archetypal connection to the Judgement from God is clear (and a little heavy-handed, if you ask us).

Nebuchadnezzar II was the king of the Neo-Assyrian empire. The Bible depicts him as the king who destroyed the Temple of Solomon and initiated the captivity of the Jewish people in Babylon, but later reluctantly acknowledged that Yahweh was the one true God, pairing political valor and authority with acceptance of the power of God. His capital city, Babylon, spread across 2,000 acres and is the largest archaeological site in the Middle East today. It's easy to imagine it being perceived as the entire world, as the card name suggests.

Since Italy in the fifteenth century was filled with constant political grappling and upheaval, we can assume di Maestro Antonio's decision to depict warlike figures on cards with significant—but not necessarily warlike—meanings shows the priorities of his culture.

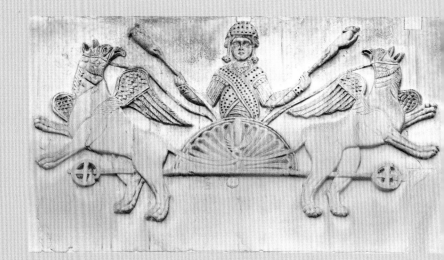

ALEXANDER THE GREAT, the Macedonian conqueror of an empire that stretched from the Balkans to modern day Pakistan, appears as the King of Swords in Sola-Busca tarot. As we mentioned earlier, Alexander has always been a well-known military leader, but at the time this deck was made, he was also receiving a historical face-lift with an alchemical twist. In the fifteenth century, Alexander was widely referred to as "The New Sun," a name that not only aligned with his new reputation of being virtually perfect, but also hinted at ancient alchemical references to gold, the perfect metal and an item necessary for the philosopher's stone. As Hermetic teachings and understandings grew popular, this pure, strong, and important king became iconic of both wisdom and strength—the ultimate goals of the Hermetic practices.

In one popular tale of the time, Alexander's mother Olympias (Sola-Busca's Queen of Swords) summoned the last Pharaoh of Egypt, the sorcerer Nectanebo II (depicted on the King of Cups), while her husband Philip was away at war. Nectanebo foretold a miraculous birth from Olympias's union with an "earth god," thus indicating that Alexander's "true" father was the figure depicted on the Sola-Busca Knight of Swords—the god of Libya, the horned, wealth-bringing Ammon.

This legend spread, and the art that came after Alexander's death often depicts him as a quasi-deity who hadn't died at the age of thirty-three, but instead ascended to heaven led by a team of griffins. His motif in the Sola-Busca Tarot shows him surrounded by four griffins tied to a chariot in the background. You may recognize the biblical parallel of Elijah, a prophet who also avoided death when he was taken by a chariot into heaven.

OPPOSITE PAGE LEFT TO RIGHT: Sola-Busca's Trump XX (Nimrod), Trump XXI (Nebuchadnezzar) and Trump VIII (Nero).

PICTURED TOP TO BOTTOM: *Flight of Alexander the Great*, an 11th century relief carved into Saint Mark's Basilica in Venice, the Sola-Busca King of Swords

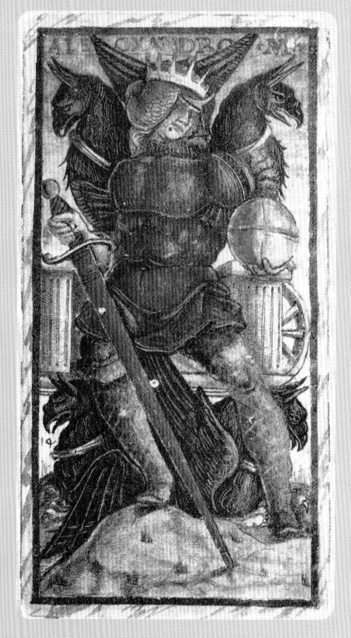

THE ALCHEMICAL INFLUENCES IN SOLA-BUSCA

That which is below is like that which is above
and that which is above is like that which is below.
—*The Emerald Tablet* by Hermes Trismegistus,
translated by Sir Isaac Newton

WHILE SOLA-BUSCA ISN'T a deck created specifically for divination purposes, we can see, explicitly and implicitly throughout the illustrations, links to alchemy: creating the most ideal material or self. This makes sense, considering the single greatest alchemical influence on the fifteenth century came from the *Corpus Hermeticum*, a book that, if researchers are correct, Nicola di Maestro Antonio's friend and influencer Lodovico Lazzarelli had a hand in editing.

We see implicit references to alchemical intentions on cards like the King of Swords with Alexander's griffins, which were recognized in alchemical circles as representing the duality of mankind by containing both human and divine traits.

The cycle of alchemy was believed to happen through a four-step process: *nigredo* (blackening/decomposing), *albedo* (whitening/purifying), *citrinitas* (yellowing/emerging), and *rubedo* (reddening/realizing). These are also the prominent colors of di Maestro Antonio's Sola-Busca deck, which incorporates many images of objects being heated or put through challenges in order to emerge stronger and better, such as in the Nine of Disks (Coins) of this deck.

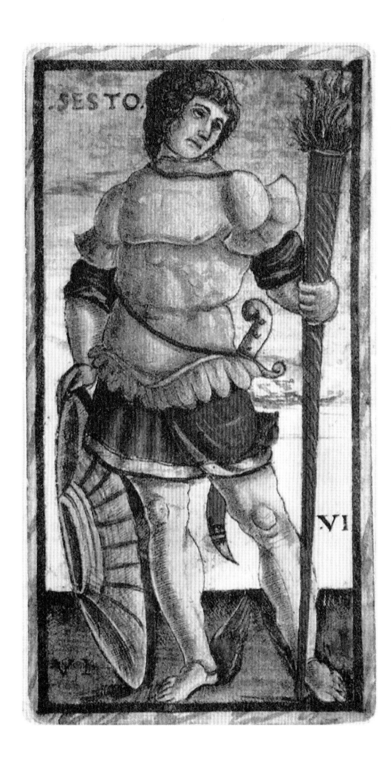

ALCHEMY IS A CHEMICAL SCIENCE and speculative philosophy that aims to turn base metals into gold, which alchemists believed would lead to eternal life and the curing of diseases.

Put another way, alchemy is the way of thinking philosophically about stuff by changing it. Alchemy in the Renaissance wasn't solely understood as an effort to literally change lead into gold; philosophy wasn't just something debated or discussed in lecture halls or college classrooms, but a way of life for many of the people whose writings still survive today. Alchemy was about the spiritual purification of the soul through the cleansing of earthly desires to obtain salvation.

When the Sola-Busca deck was created, alchemists believed that without mercury—then called quicksilver—there could be no alchemy. The element was believed to have been able to shift between liquid and solid states, making it an earthly element as well as the symbol of shifting between life and death and obtaining eternal life. Mercury was so important that the spiritual icon and patron deity of alchemy was the Greek god Hermes, who the Romans adapted into their pantheon under the name Mercury.

The figure on the Sola-Busca card labeled Sesto, the sixth of the trump cards, appears to have winged shoes similar to Mercury's. This card has also been linked with Sextus Pompey, a Roman ruler who was in the triumvirate alongside Julius Caesar. It's a multi-layered comparison that might be reaching, but the Sola-Busca deck may have made the same connections between historical figures and stories that contemporaries would recognize, while also introducing alchemical additions to emphasize the timelessness and importance of Hermetic theories on truth and transformation.

OPPOSITE: Hermes Trismegistus

ABOVE: Sesto, Trump VI

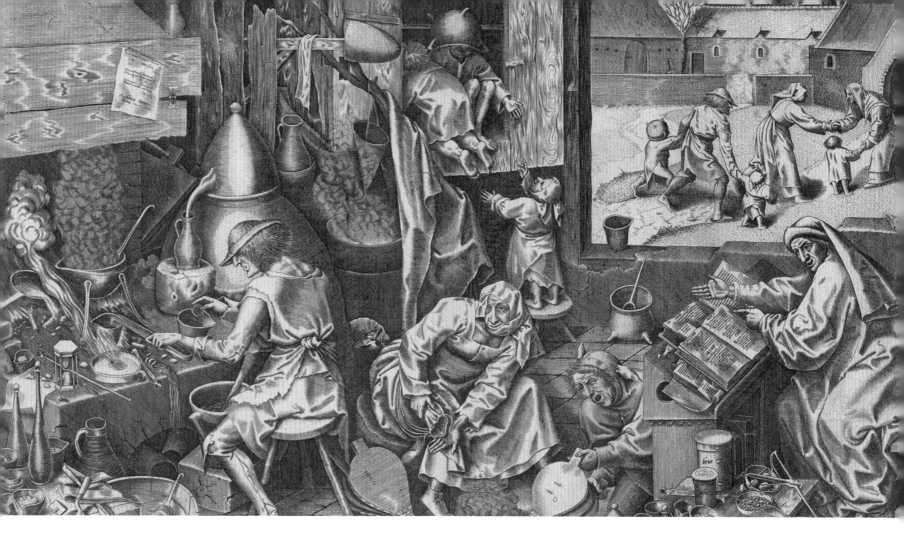

TRENDS SHIFTED IN THE SIXTEENTH CENTURY, and alchemy became a hobby of the lower class and the gullible, who spent all their money to buy more materials. Art from that time depicts alchemists spending their last coins to purchase metals needed to create the philosopher's stone while their destitute families suffered. This may be one of the reasons why Sola-Busca Tarot art, despite having printed multiple copies, hadn't gained popularity beyond its generation. Alchemy and its adherents went underground and didn't re-emerge until the late nineteenth century.

Alchemy resurged when European and even American culture shifted back toward an interest in and acceptance of philosophy and esoterica. What changed?

With industrialization came an expanding middle class to bridge the divide between people who could access classic philosophical texts and those who didn't have the resources to do so. More people expanded their spiritual beliefs and transcended what Christian ministers had been preaching for centuries. Along with an increase in individualism, more spent the time exploring the process of philosophizing for themselves.

Alchemy went through its own transmutation from the dual "scientific" and spiritual process into a purely spiritual one. This happened primarily through the influence of Mary Anne Atwood's popular book *A Suggestive Inquiry into the Hermetic Mystery*, published in 1850. Atwood said, "Alchemy is philosophy; it is the philosophy, the seeking out of The Sophia in the mind." This idea gained popularity and solidified alchemy as a valuable principle in modern esoteric beliefs. We'll talk more later about Sola-Busca's influence on the Rider-Waite-Smith deck and the emergence of the Golden Dawn and other late nineteenth- and early twentieth-century spiritual organizations.

THE ALLEGORICAL MINOR CARDS

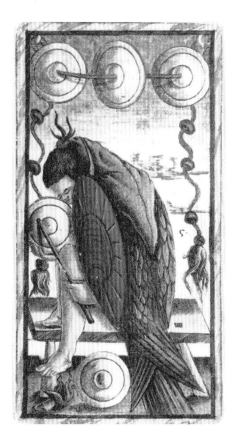

THE FINAL THING that distinguishes the art of Sola-Busca from other card game decks of its time, or the decks of the next 420 years, is its allegorical minor cards.

The first thing you might notice is that the suits themselves are slightly different from other tarocchi games. While the Swords suit looks the same, Coins are depicted as disks, Wands as clubs, and Cups look like amphorae, a Mediterranean pot with two vertical handles.

While the art on each card is still dominated by the objects from each suit, for the first time in tarot card history, the Sola-Busca's artist incorporated the objects into a scene instead of laying them in a rigid, structured form. Images include people and objects in movement, bringing an opportunity for interpretation of symbolism in the still images.

In the Six of Disks, we see alchemy with a man hunched over his anvil, hammering what looks like a former disk into a thin sheet of metal. Since the cards were strictly meant for game play, it's unlikely that the artist was trying to communicate any divinatory meaning; this is a good example of a card having an allegorical meaning that isn't the same as the meaning we would give to this card in modern times. However, divinatory meaning could be more intuitively read from this allegorical picture than just six coins laid out in a pattern on a card. Later, Pamela Colman Smith adapted this image from the Six of Disks and used it for the Eight of Pentacles, which generally refers to the perfection of hard work.

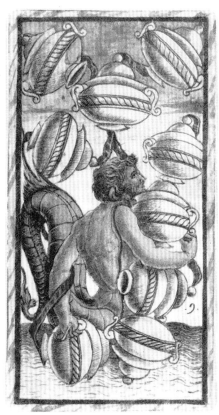

Another good example of the power of allegorical imagery is the Nine of Amphorae (Cups). A man is surrounded by amphorae that seemingly float in the air. The inferred movement and the meticulous balancing of the pots gives this merchant (Mer-man-chant? He has a tail, after all!) the appearance of forward movement.

Perhaps receiving this card meant something to the fifteenth century game player and this scene had significant meaning, but it also could mean nothing at all except that the eccentric di Maestro Antonio just wanted to draw a mer-man-chant (we're sticking with this) with amphorae floating around him. Either way, as tarot decks began to be used for divinatory purposes in later years, it was easy for a reader to draw meanings in the Sola-Busca minors without rote memorization of what each card meant. Including such scenes allowed a person to use their imagination to ascertain a card's meanings and intent.

RIGHT: Five of Disks and Nine of Cups

OPPOSITE PAGE: *The Alchemist,* **a 16th century engraving by Pieter Bruegel the Elder**

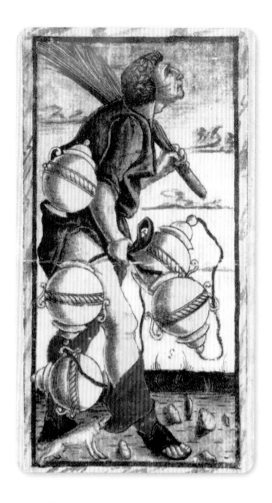

Largely because of these allegorical minors, it can and has been argued that the art of Sola-Busca heavily influenced modern tarot art, specifically the tarot deck that would impact all of Western esoterica for more than a century—the Rider-Waite-Smith.

We'll take a more in-depth look at the Rider-Waite-Smith later, but for now, let's pause to appreciate how the Sola-Busca, a 500-year-old work of art almost lost to history, came back to change tarot forever.

In 1907, the Busca-Serbelloni family loaned black-and-white photos of all seventy-eight of their heirloom cards to the British Museum. This happened to be the same time London residents Arthur Waite and Pamela Colman Smith were collaborating on a new deck of their own. It's obvious to us that Smith, possibly under the direction of Waite, sought out the exhibit and received artistic inspiration from some of the Sola-Busca cards; there are only minor differences between the decks in the setting and time periods, colors used in final renderings, and Waite's intentional esoteric meanings that directed Smith's artwork. We're not saying that the Sola-Busca cards were intentionally copied, but still, it's surprising to note just how many similar scenes there are.

For example, Sola-Busca's Five of Cups and Rider-Waite-Smith's The Fool aren't even the same cards, but you can see the similarities in the small dogs following alongside the travelers, who both carry staffs over their shoulders.

Again, Sola-Busca's Six of Disks and Rider-Waite-Smith's Eight of Pentacles aren't the same cards, but they do have very similar content. Both show figures in the exact same position hard at work using an anvil and hammering out a craft. There is also implicit alchemical symbolism to the Sola-Busca card in that hammering on an anvil would be part of the symbolic reshaping of the self.

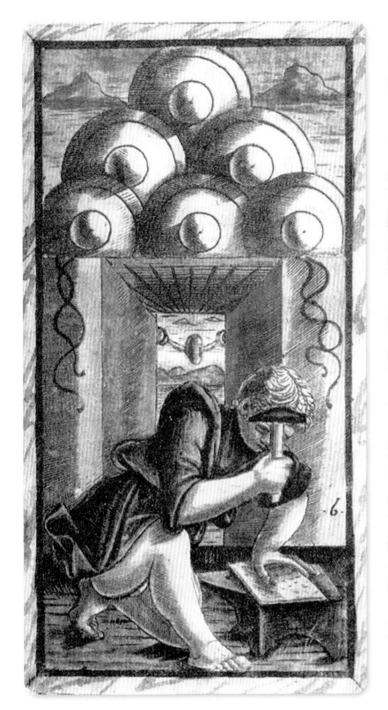

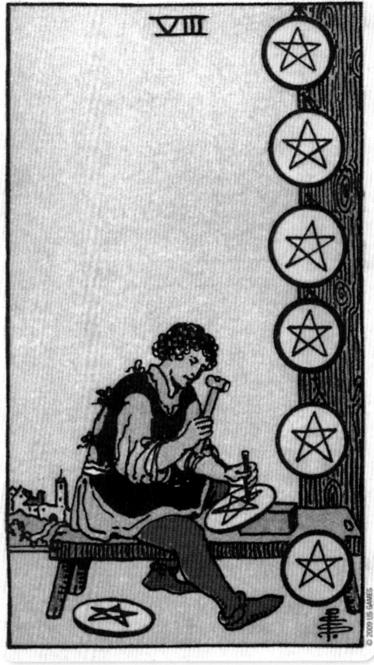

ABOVE: The Six of Disks from Sola-Busca tarot (left) and the Eight of Pentacles from Rider-Waite-Smith

OPPOSITE: The Five of Cups from Sola-Busca tarot (left) and The Fool from Rider-Waite-Smith

 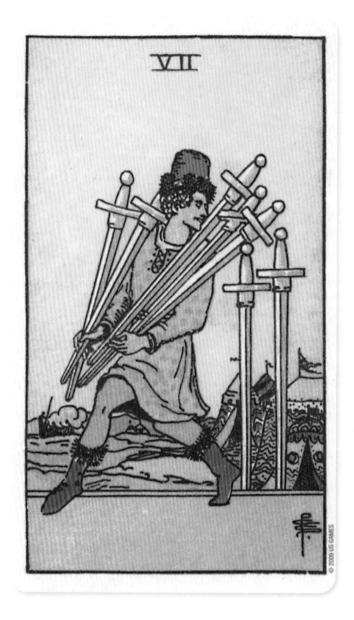

You can see both figures in the Seven of Swords clutching their swords in very similar ways. They both focus on the collection process, which becomes important for the meaning of the Rider-Waite-Smith card—which, depending on your perspective, could mean the collection of information or sneakiness and thievery.

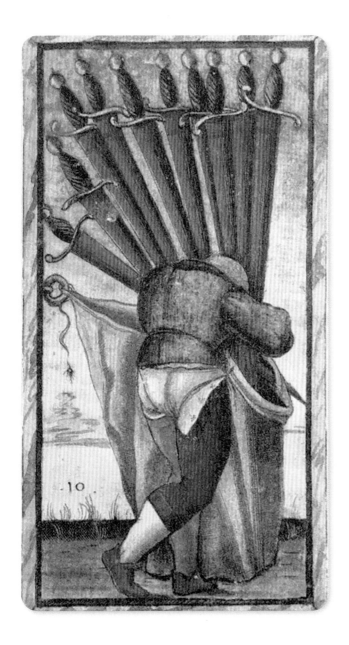
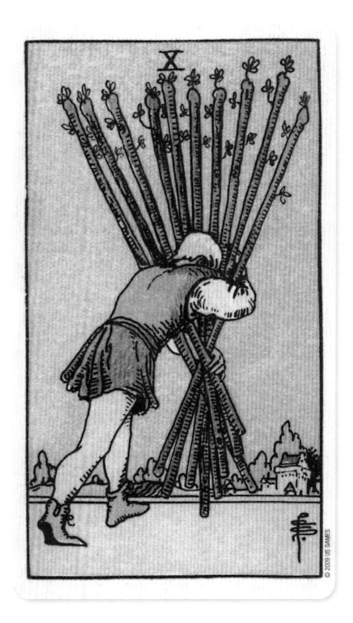

We see almost identical body movement on the Ten of Swords in the Sola-Busca and the Ten of Wands in the Rider-Waite-Smith. The only difference is that the figure on the Sola-Busca card carries sheathed swords, and the figure on the Rider-Waite-Smith card carries wands. Otherwise, these two cards are virtually identical in composition.

THE LEGACY OF SOLA-BUSCA TAROT

IN 2009, THE SOLA FAMILY sold their original copy of the Sola-Busca deck to the Italian Ministry of Heritage and Culture for €800,000. It now resides in Milan at the Pinacoteca di Brera, which oversaw publishing replica copies of the official deck through the publisher Lo Scarabeo. Other independent Sola-Busca decks were also published throughout the twentieth century based on previous renderings.

Today, the impact of Sola-Busca can be seen in the illustrated minor cards on any modern deck found on the shelf of a bookstore. Without the influence of this unique deck's interpretations and alchemical symbolism, it's hard to know if any tarot deck we have today would have been presented in a pip style.

LEFT: The Ace of Cups

YOU MIGHT ALSO LIKE:
ENGLISH MAGIC TAROT AND THOTH TAROT

ENGLISH MAGIC TAROT has muted tones, bold images, and an aesthetic similar to Sola-Busca Tarot. It also draws on lesser-known magical traditions from John Dee, the court astrologer to Queen Elizabeth I, and alchemical studies from Sir Isaac Newton.

Just as the foundation for Sola-Busca was history, mythology, and alchemy, Thoth Tarot includes a similar foundation in ancient occult beliefs and tradition, but is presented in an updated and more accessible format. We'll explore the Thoth more in a later chapter.

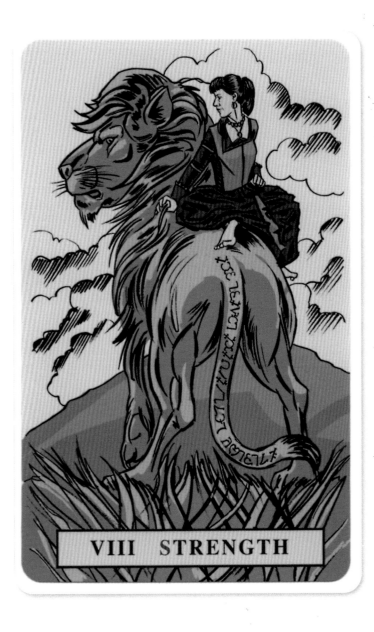

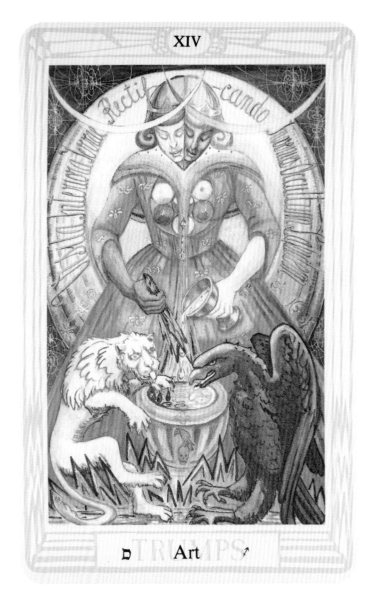

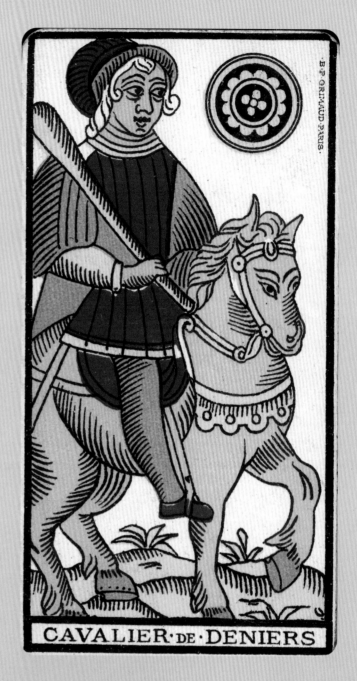

The Ace of Coins (left) and Knight of Coins (or Cavalier de Deniers)
in the Tarot de Marseille style

TAROT DE MARSEILLE

WHEN: 17TH AND 18TH CENTURIES ▪ **WHERE:** FRANCE

▪ **CREATED BY:** MULTIPLE ARTISTS

 E'LL BEGIN THIS CHAPTER with a disclaimer. Tarot de Marseille is an important piece of tarot art history for two reasons: first, because it was the first mass-printed deck, and second, it was wildly popular and widely distributed for centuries before it was used for divination. However, that longevity comes with limitations. Since Tarot de Marseille was used for card games—the Renaissance equivalent of Uno—there isn't a lot of variation of artwork from one popular edition to the next, and there isn't the same flexibility or layering of meaning. And since it's so old, we also don't know much about the lives or intentions of the original artist(s).

As a result, this chapter is more an exploration of the different generations of the Tarot de Marseille cards themselves, following them from the playing card game known as tarot to the divination style that the Tarot name is associated with today.

TAROT WAS LIKELY INTRODUCED into southern France in 1499 when the French conquered Milan and the Piedmont, and it thrived in the wealthy French salon culture of the Enlightenment age. Academics mingled with noble patrons and artists for long evenings of discussion, petty intrigue, and of course, entertainment—of which playing cards of all types were part of the experience. Researchers and collectors have found cards from this time illustrated with costumes, iconic landmarks, and various educational lessons.

By the early eighteenth century, the port city of Marseille in southern France had emerged as the playing card printing powerhouse and tarot trendsetter of the European world. By the late nineteenth century, the commonly accepted name for any French-printed deck with illustrated trumps and individual pips for minor cards was Tarot de Marseille. Later divinatory enthusiasts would popularize the name even more when they sought these specific French-printed decks. In fact, the first time the specific name "Tarot de Marseille" appeared in print was in 1889, when the famous French occultist Papus published an infamous text about tarot as divination called *Le Tarot des Bohémiens (The Tarot of the Bohemians)*.

What made French decks so popular with the masses? For one, the French cards were prettier and more elaborate than their Spanish-styled counterparts. French-styled decks also came with the names of each of the trump cards printed on the card face, and they changed some of the names, making the cards and depictions more accessible. (We're thankful today to be drawing "The Tower" instead of one of the original names, "The House of the Devil." Yikes.)

French decks also chose to base their suits on Italian designs, which allowed for more flourished artistic expression. Italian decks displayed batons and swords that crossed and bowed over each other, while cups and coins remained separated, non-touching objects. In the Spanish suits, however, none of the objects in the pip cards touched each other. These Marseille Tarot decks also added their own elaborate flourishes, flowers, and ribbons to fill up empty

space on the cards, while the Spanish-styled cards left blank white space around the objects.

With a few exceptions, French tarot followed a predictable pattern: four suits—Cups, Coins, Swords, and Batons—with aces through tens and face cards, both alongside allegorical trump cards. The trump cards are immediately recognizable with their iconic blocky, stained glassesque figures in bright primary colors of red, blue, yellow, and black. The key figures in the Major Arcana art were no longer the mythological creatures or gods we saw in the earlier decks. Instead, the Marseille decks highlighted contemporary military and philosophical leaders who exemplified the Enlightenment's ideals of rationality, purity, and strength. You'll see figures like Alexander the Great, Julius Caesar, Charlemagne, Judith, Pallas, Hector, Lahire, and Lancelot, to name a few. (If you've read our chapter on Sola-Busca Tarot, you'll recognize a few holdovers in these names.)

The other major difference we see in Tarot de Marseille decks can't be seen in the cards themselves, but in our knowledge of who used them. Woodblock printing made it possible to produce all types of playing cards en masse, including tarot cards, and stencils made it easy to shade them with bold colors. For the first time, a deck and the artwork that defined it were in the hands of the people.

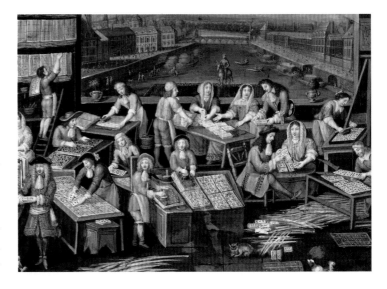

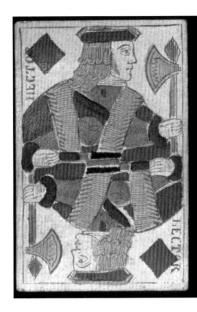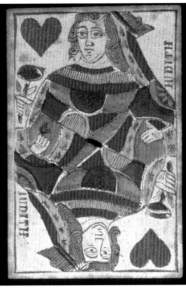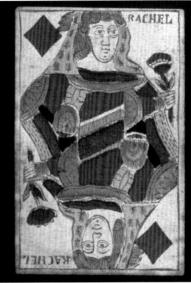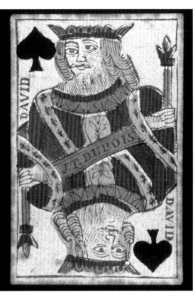

WHILE MORE TAROT DECKS were printed and shared in France during these years than ever before, paper is still ephemeral, and only a few used decks from the eighteenth century survived. Instead, what we know about these cards comes mostly from unused and uncut sheets of cards sometimes used as linings in other books and archived company records in old printing houses.

As early as 1377, municipal records show that the city of Paris banned the use of playing cards on weekdays, and many other cities across Europe prohibited playing cards of any kind altogether. By the time Tarot de Marseille decks were accessible, playing cards were already so popular that local governments needed to "protect" the working class from playing when they should have been producing. (Geez, capitalism, take a chill pill.) Eventually, governments figured out that forbidding an activity didn't make it as undesirable as regulating and taxing it did (plus, the government got to benefit from money in their coffers), which was how countries like Spain, France, and Germany eventually dealt with the "problem" of playing cards.

By the eighteenth century, there were nine separate regions of France with printing houses, and each had a slightly different style from their competitors. To make sure each business paid what it owed, a 1701 law required that each printer put its name on the Knave of Clubs and that all cards carried identifiable markings to distinguish them from the other regions. This, more than anything else, is what led publishing houses to stick to consistent designs within their decks.

Decks from different regions may seem similar at first glance, but if you look carefully, you'll see symbols reversed or patterns with slight differences. Today, this helps scholars identify which region a deck was printed in and distinguish the subtle nuances of regional variations.

For instance, the Paris-style and Lyons-style decks have differences in the physical characteristics of the figures, the sharpness of the woodblock printing, and their mythical and literary references. Recognizing these is how we know that Lyons and Rouen were the source of most playing card exports to other countries. The French-styled cards were a smashing success not only within France itself, but also outside the country. Copies of early Tarot de Marseille decks have been uncovered in the British Isles, Germany, and the Netherlands.

OPPOSITE: 17th Century depiction of a card factory from Musee Carnavalet, Paris

ABOVE: Early French playing cards

THE EARLIEST SURVIVING COPY of any French-made tarot deck, the first "true" Tarot de Marseille, was designed by Jean Noblet in Paris around 1650. Its design was limited, and the engravings were rough around the edges. In this edition, The Fool was titled "Le Fou" and was depicted as an actual fool—a half-naked man with all his glory hanging out, running around the countryside with his . . . dog? . . . cat? . . . rodent of unusual size?

We don't know much about who Noblet was or who owned this particular set of cards. The only original copy is at the Bibliothèque Nationale in Paris. Surprisingly, given its age, the deck is only missing five cards, from the Swords suit.

As the popularity of card games grew within France, more engravers popped up around France. (Economics 101: Supply and Demand.) This led to the first big shift in style from Noblet's version, usually referred to as a Type 0 Marseille deck, to the more "refined" style known as Type I Marseille decks.

Type I was produced primarily in the latter part of the seventeenth century and the early eighteenth. The engraver and master card maker Pierre Madenié (whose studio was in the city of Dijon, not Marseille) designed what would become popular templates for Tarot de Marseille decks. He changed "Le Fou" to "Le Fol," and thank goodness the poor man finally found a pair of pants somewhere in his journey.

While we don't know much about him or the other artists who later modified his work, we can see Madenié's insignia on two of the earliest examples of standardized Tarot de Marseille cards—a complete deck in the Swiss National Museum of Zurich, and a partial version at the British Museum. On the Two of Coins of each deck, the artistic imprint says "Pierre Madenié Cartier du Prince 1709," and on the Ace of Cups we see "Pater Graveur a Dijon." This is Madenié's signature on every deck printed with his woodblocks, authenticating the artwork.

The British Museum's copy of Madenié's Tarot de Marseille deck includes fifty-six intact cards. It was donated to the museum in 1895 by Lady Charlotte Schreiber, an English aristocrat, translator of medieval Welsh fairy tales, and a notable collector of both porcelain figurines and card games.

Lady Charlotte has a unique place in the history of card game preservation and quite the story of her own. To escape a bad home life, Lady Charlotte married a man twenty-seven years older than her when she was just twenty-one. She and John Josiah Guest went on to have ten children before he died, and then Lady Charlotte went on to wed her son's tutor, Charles Schreiber, who was fourteen years younger than her. (In the words of *Arrested Development*'s Lucille Bluth, "Good for her.")

Upon her death, Lady Charlotte left more than 2,600 items to the British Museum, including porcelain figurines, fans, and card game memorabilia. She didn't just have Madenié's version of the Tarot de Marseille—she also had impressions of other Tarot de Marseille decks in various regional styles, a Spanish deck etched on brass from Francesco Zavoli, and an Italian-style deck painted by Giuseppe Facchina on thick plates of silver. Her collection also included an original copy of The Game of Hope, which later transformed into the divination style known today as Lenormand.

So if you're a dedicated tarot deck collector (*cough* deck hoarder *cough*) like we are, you may find it reassuring to know that you're following Lady Charlotte's footsteps and participating in a long-honored tradition.

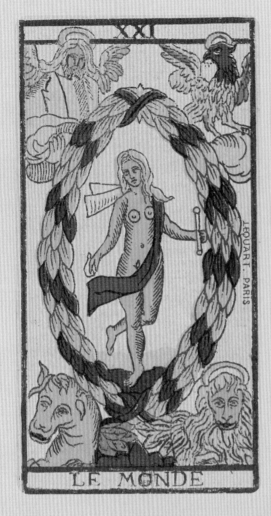

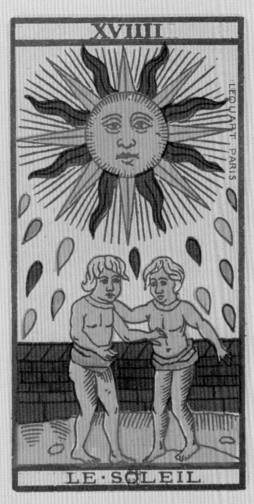

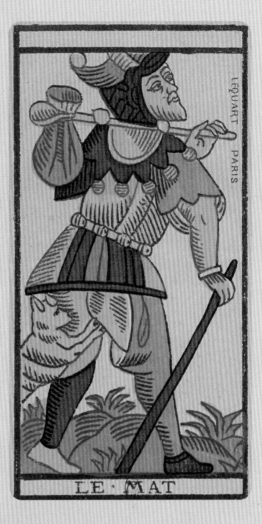

ABOVE, LEFT TO RIGHT: a Type II Marseille variation of The World, The Sun, and The Fool.
BELOW, LEFT TO RIGHT: a Type I Marseille variation of The World, a Type II variation of The World,
a Type I variation of The Lovers, a Type I variation of The Fool, and a Type I variation of The Sun

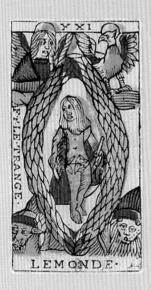

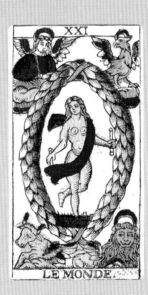

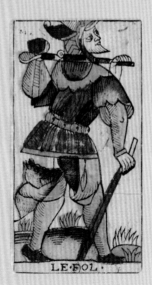

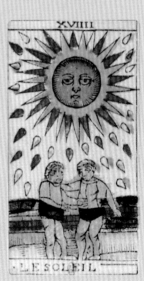

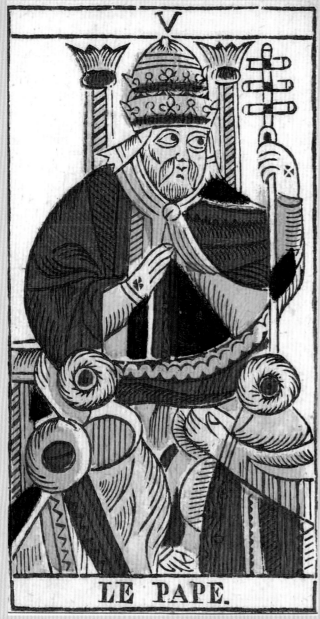

LE PAPE.

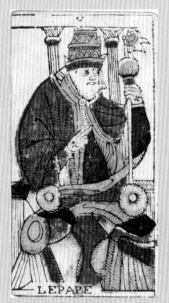

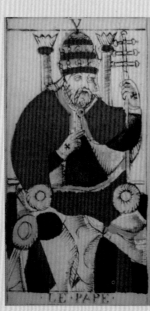

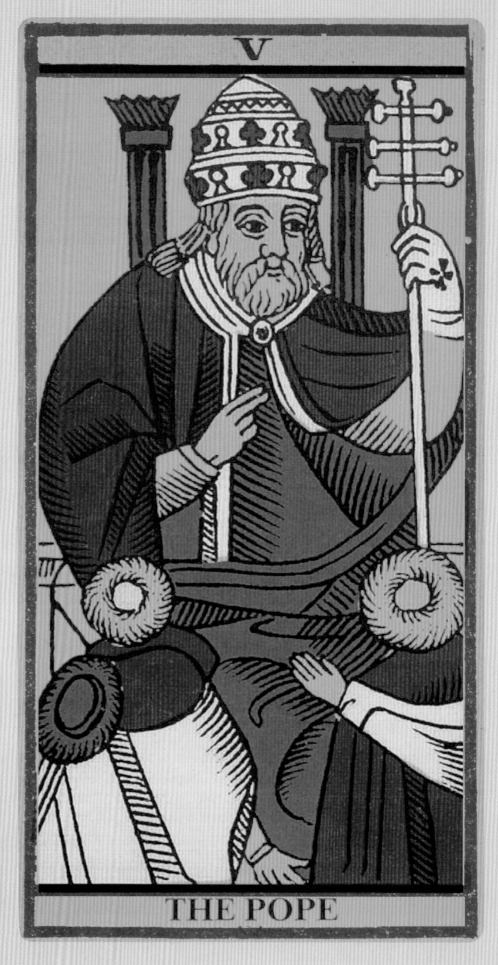

THE POPE

FIFTY YEARS AFTER MADENIÉ'S popularized design started making the rounds, Nicolas Conver of Marseille—the "Master Cartier in Marseille, engraver in the King [Louis XV of France]'s Court"—burst onto the scene with his own version of Tarot de Marseille. Conver's grandiose title is a sign that his reputation then matches what we know about him today—he was one of the most important, prolific, and pervasive card makers of his time.

In about 1760, Conver carved his version of the Tarot de Marseille into blocks of pear wood. Various printers in France used those woodblocks for over a century, distributing hundreds or thousands of almost identical tarot decks until the forms chipped and deteriorated beyond use. Because they kept printing despite the wear on the blocks, the later decks weren't as crisp in their printing, which gives us an excellent reference for dating cards.

Conver's deck is what is now called Marseille Type II. It became so popular that it was the deck of choice for the earliest divinatory readers in the nineteenth century, and Conver's art is the Tarot de Marseille design we are most familiar with today. It reached its pinnacle of distribution in 1930, when Paul Marteau inherited the publishing company B. P. Grimaud and decided to publish a deck called the Grimaud Ancien Tarot de Marseille, using Conver's deck as a template.

There was some timeline overlap between the public distribution of Type I and Type II Marseille decks, and some engravers combined elements from both to create their own unique style. Type I appears most often in Genoese and Milanese printed decks from northwest Italy, perhaps indicating regional popularity, while Type II was produced widely in the eighteenth century by French and Swiss card makers.

Eventually, however, Type I went out of style, and Type II became the standard for Tarot de Marseille art. We see this in the Pope card, which in Type I uses a staff with a bulb on the top of it, while the Type II Pope has a triple cross that was carried into almost all modern Tarot de Marseille and Rider-Waite-Smith decks. The Fool changed again as well. He is now called "Le Mat" and looks very similar to the Type I The Fool, only zoomed in. The Fool's companion in Type II became the familiar jumping dog that is now an icon in tarot artwork in itself, rather than something that resembles a floating cat.

OPPOSITE: a variety of Pope cards from Tarot de Marseille Clockwise from upper left: a Type II variation, a modern variation (note the English translation on the title), a Type I variation, a different Type I variation

MARSEILLE'S INFLUENCE OUTSIDE OF FRANCE

WE KNOW THE CARD GAME OF TAROT was played all over Europe, and there's evidence that companies outside of France copied and printed Tarot de Marseille–style cards. Two of the best-known examples are the Besançon Miller deck of Germany and the Vandenborre deck of Belgium.

In 1780, Josef Rauch Miller printed the widely popular Besançon Miller deck in Salzburg, Germany. Besançon is a type of tarot that emerged in the eastern French town of Besançon, but manufacturers produced decks in a variety of places, including southern France, Switzerland, and southern Germany. A faithful reproduction was printed in the late 2000s by Italian tarot scholar Giordano Berti, who declared the Besançon Miller unmatched in beauty, perspective, and its refined color and line work for its time. It is now housed by the British Museum.

The Besançon deck's iconography is nearly identical to the Tarot de Marseille, but when we look carefully at the art, we see the higher quality of German printing standards. The figures also all wear traditional German clothing, and the Pope and Papesse cards are replaced by Juno and Jupiter cards (in Italian, *Giunione* and *Giove*). There are several theories about the changes, with the most likely being that the Protestants of Germany weren't interested in seeing Catholic images on their playing cards. During the French Revolution, the cards Emperor and Empress received the same scrutiny and for a time were renamed Grandfather and Grandmother.

The Vandenborre deck, sometimes called the Flemish or Bacchus deck, was also released in 1780 and quickly became Belgium's standard tarot deck. When compared to the Tarot de Marseille, there are a couple of variations in the French names. The High Priestess card was changed to *Le'spagnol*, which is Belgian tongue-in-cheek wordplay on the original French intending to poke fun at "The Spanish," who during their occupation had enforced Catholic conversions and carried out witch hunts. The card itself depicts Capitano Eracasse, a popular theater character identifiable by his bravado and swagger. This sarcastic view of the High Priestess is a huge departure from what later divinatory readers would understand the High Priestess to mean, and is a good reminder that tarot was still just a game at that point.

Furthering that point, the Vandenborre Two of Cups is inscribed with *"Pour conoistre que la Plus basse de Deniez et De Coupes enporte les Plus hautes quant au Fait du jeu,"* a very practical reminder that low-numbered cards beat high-numbered cards.

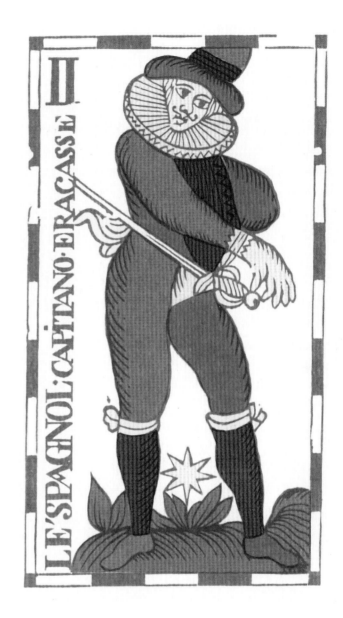

OPPOSITE PAGE: Jupiter from a Besançon-style Marseille deck

THIS PAGE, TOP TO BOTTOM: The Spanish Captain card from the Vandenborre-style Marseille deck, detail of the markings on the Two of Cups from a Vandenborre-style Marseille deck

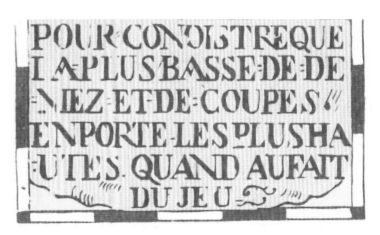

WOODBLOCK PRINTING

THE MATERIALS AND METHODS of woodblock printing allowed for the Tarot de Marseille to grow popular through mass publication, but it also affected the style of the art itself. It took no fewer than four professional craftsmen to complete a Tarot de Marseille card: a paper-maker, a designer, a form cutter, and a printer.

The designer drew the images in black lines on fine-grained wood—typically pear, apple, or pine. Since tarot cards are larger than normal-sized playing cards and rows of tarot cards would be carved into a single piece of wood, the woodblock itself was usually very large and heavy.

After the designer finished drawing the images, the form cutter whittled away the excess wood, leaving the impression of a raised image that could be later covered with ink and transferred onto paper. The automation of papermaking hadn't made its way to Europe yet, so there had to be an expert papermaker to handcraft each sheet of paper. If one got any of the intricate steps involved in papermaking wrong, the sheet of paper would be ruined.

The printer laid the paper on the woodblock over the ink and rubbed a wooden instrument smoothly over the back of the paper, transferring the ink. Once the ink was dry, an apprentice would usually add the color via stencils with a stippling brush or colored pencils. Once that final layer dried, the sheets were glued onto an unprinted layer sandwiched on the other side by the card's back, then packaged and sold.

Since much of the art is relatively the same in these mass-produced decks, the finesse of certain master engravers becomes obvious and worth noting, seeing as the pen and the scalpel give expressions to the faces of the characters and more nuance to the settings.

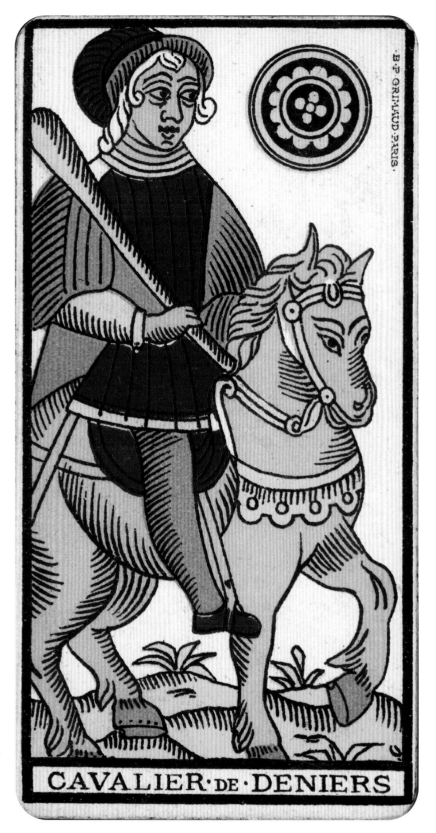

ABOVE, LEFT TO RIGHT: The Two of Coins (note the inscriptions from the printers), the Ace of Cups

OPPOSITE: The Knight of Coins

MENSÆ ISIACÆ, SIVE TABVLÆ ÆNEÆ VETVSTISSIMÆ, SACRIS ÆGYPTIORVM LITERIS CÆLATÆ VERVS, ET GENVINVS TYPVS, QVAM PRIMVM E MVSEO TORQVATI BEMBI, VNDE ET BEMBINA DICITVR. AN. M DLIX. EXTRACTAM ÆNEAS VICVS PARMENSIS EDIDIT. ATQVE FERD. I. CÆSARI CONSECRAVIT. HANC DEINDE IN FORMAM COMMODIOREM CONTRACTAM SERENISSIMO PRINCIPI LEOPOLDO GVILIELMO ARCHIDVCI AVSTRIÆ, SVPREMO BELGII ET BVRGVNDIÆ GVBERNATORI NECNON MAGNO TEVTONICI ORD. MAGISTRO.

FROM CARD GAME TO DIVINATION

DURING THE TIME WHEN THE WOODBLOCK art of the Tarot de Marseille decks was still the most popular visual representation of tarot, a man named Antoine Court, who would later name himself Antoine Court de Gébelin, stepped onstage as one of the most influential—and controversial—figures in the history of tarot. Whether we like it or not, we can't talk about how the eighteenth century game of tarot transitioned to the divination style without talking about Gébelin.

In short, Gébelin was the first person to document the esoteric use of tarot cards. In 1781, the former Protestant pastor-cum-Freemason cowrote two essays about the history and hidden meanings of tarot in his anthology *Monde Primitif, Analysé et Comparé Avec le Monde Moderne* (*The Primitive World, Analyzed and Compared with the Modern World*). In it, he described tarot as an esoteric tool used to gain wisdom, but we now know he manufactured sources to substantiate his claims.

Citing either mysterious acquaintances or no one at all, Gébelin asserted that tarot cards were ancient Egyptian relics created to share the secrets of ancient wisdom. He linked cards to Egyptian myths and gods, the Hebrew alphabet, Egyptian and "oriental" numerology, and even created a mythological spiritual heritage about how tarot made its way to Europe from Egypt. You might still hear many of these things still cited today as if they were facts.

If it sounds like we're skeptical, it's because we are. From everything we know about him, Gébelin had a mission to bring ancient religious and spiritual practices to his modern world. It wasn't enough to claim that he developed a new reading method, or that Italians who believed in alchemy created an esoteric practice. Gébelin needed something more. He needed to show that his understanding of tarot was all connected to an "ancient" civilization and "mysterious" beliefs passed down through the centuries. Since the card game Mamluk

OPPOSITE PAGE: Bembine "Table of Isis"

THIS PAGE: A portrait of Antoine Court de Gebelin (top) and the Pope card

was part of the origin of tarot cards, Gébelin fit it into his tarot thesis and turned to the Egyptians.

If there was one thing Gébelin's peers loved, it was ancient Egypt. We saw hints of that in the references to alchemy and Hermeticism in the Sola-Busca deck, but Egyptomania was a fad that really took off in the 1730s. It lasted into the 1930s with an especially vibrant period in the late eighteenth and early nineteenth century after Napoleon's failed expeditions into Egypt. The French saw the ancient country as a collective historical touchstone and the home of a thousand mysterious and exciting things to explore. Gébelin couldn't have chosen a better origin story to get the attention of his time.

Like most folklore, the fabrications came in small bits of truth mixed with ego. It's true that tarot cards grew from an Egyptian card game called Mamluk. But from there, Gébelin suggested that a mysterious tarot text had survived the fire in the Library of Alexandria, and it revealed the ancient mystical practices and source of the tarot. It's not clear if there was actually a book or if this was something else he fabricated. We're skeptical since Gébelin also said he could give the book's truths of the tarot to others—even though no one at the time could translate ancient Egyptian to a modern language.

He had to do some mythological tap dancing to fit certain cards that had clearly developed from Western influence with Egyptian archetypes. For instance, when faced with the triple cross on the (very Catholic appearing) Hierophant, he states (translated), "As for the scepter with the triple cross, it is a symbol absolutely Egyptian: one sees it on the Table of Isis, under Letter TT; an invaluable monument which we have already caused to be engraved in all its details in order to present it some day to the public." This "Table of Isis" is more accurately known as the Bembine Tablet and is actually of Roman origin, filled with a hodgepodge of fake Egyptian hieroglyphs for their worship of Isis.

Gébelin "translated" the tablet and wrote his book twenty-two years before the Rosetta stone was discovered, and a full forty-one years before the Egyptian hieroglyphs on it would be

properly translated. Despite all evidence to the contrary, the essays by Gébelin influenced centuries of esoteric literature and occult practitioners.

It is unknown if Gébelin himself was an occultist, but by the time he died in 1784, his name was synonymous with esotericism and tarot. As a result, tarot and esotericism were now entwined.

After Gébelin's death, the author and card reader Etteilla stepped into the spotlight as Gébelin's spiritual and tarot successor. Etteilla was the pseudonym for Jean-Baptiste Alliette, the first professional tarot card reader and the author of a 1785 book called *Manière de se récréer avec le jeu de cartes nommées Tarots (How to Entertain Yourself with the Deck of Cards Called Tarot)*.

Etteilla claimed he learned how to read tarot for divination in 1750, earlier than Gébelin claimed he started. This bolstered Etteilla's reputation as the expert in tarot reading. A few years later, he formed a French language correspondence group to discuss the esoteric and Egyptian roots of the Book of Thoth, thus creating an entire lineage of Thoth- and Egyptian-tarot linkage for years to come.

Etteilla.

BY THIS POINT, the split between occultists seeking divination and card players looking for a fun deck was affecting the art of tarot, as well as the purpose. The era of Tarot de Marseille's dominance for both communities would eventually come to an end.

Occultists in the eighteenth century preferred older-looking, almost medieval-styled art on their cards because it evoked historical gravitas and importance to what was much more than a game to them—a mystical tradition passed down from the Egyptians. On the other hand, playing card creators evolved their styles and themes to fit the newest trends of the time. Before long, modernized card decks emerged with two faces in the royal suits, a style we still see in the traditional fifty-two-card playing decks.

Practitioners of the occult and those who used Tarot de Marseille for divination stuck with the traditional Marseille designs well into the nineteenth century. While other tarot decks existed in circulation—a few popular ones even taking an Egyptian flair—it wouldn't be until the creation of the Rider-Waite-Smith design that another tarot deck would take the place of the Tarot de Marseille in esoteric circles.

ABOVE: French-style playing cards

OPPOSITE: Jean-Baptiste Alliette (Etteilla) at his work table, from the *Cours Théorique et Pratique du Livre de Thot,* **1790**

YOU MIGHT ALSO LIKE: MARSHMALLOW MARSEILLE

BEYOND THE DOZENS of carefully reproduced historical replica Tarot de Marseille decks, there's a great crop of updated, vibrant, and fun decks that fall into the bold Tarot de Marseille style. Marshmallow Marseille, created by The Wandering Oracle, follows the traditional format closely, but uses pastel colors to update the deck from the primary-colored medieval originals.

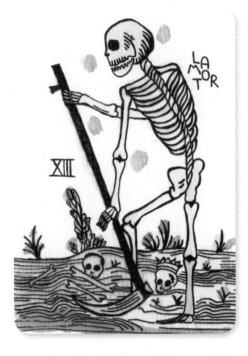

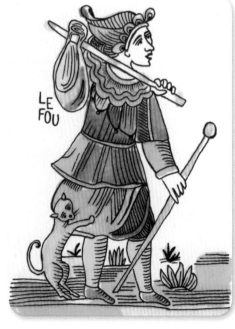

YOU MIGHT ALSO LIKE:
TAROT SIRENE

If you loved the Mer-man-chant (the Nine of Amphorae) in Sola-Busca, then you'll love this entire deck of all things mermaid and mermen. The pastel, shimmery interpretation of woodcut designs in the Marseille style brings a fun, under-the-sea vibe.

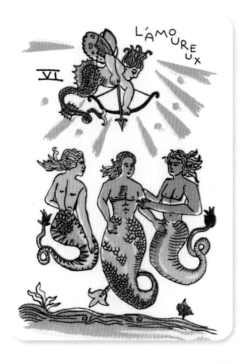

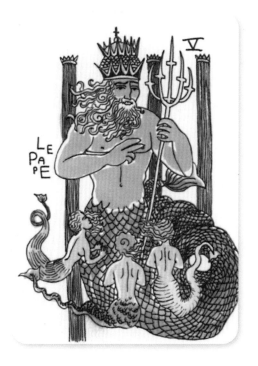

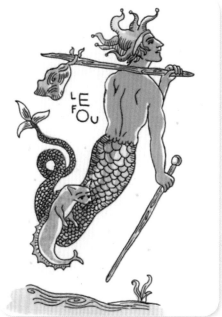

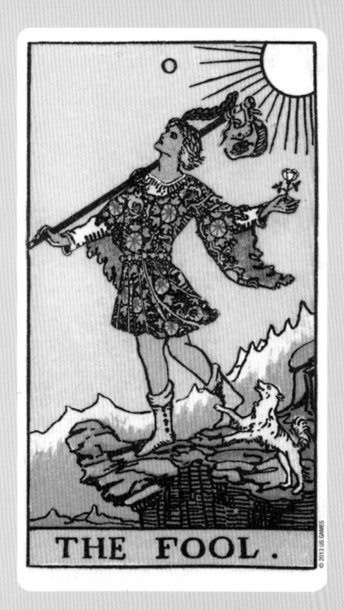

THE FOOL.

ACE of PENTACLES.

RIDER-WAITE-SMITH

WHEN: 1909　　WHERE: LONDON

CREATED BY: ARTHUR WAITE AND PAMELA COLMAN SMITH

 HEN MOST PEOPLE THINK OF TAROT, the images that immediately come to mind are the iconic illustrations found in the Rider-Waite-Smith Tarot deck, first released in 1909. The colorful artwork layered with symbolism and illustrated Minor Arcana cards, above and beyond its predecessors and successors, are instantaneously recognizable, and it continues to be the most popular tarot deck of all time.

Artist Pamela Colman Smith (who liked to be called Pixie) took the vision of a man named Arthur Waite and propelled tarot into a new era of public acceptance. After Rider-Waite-Smith, tarot was used by not only those interested in esoterica, but also normal people who wanted to try divination for themselves.

Until recently, Smith's role has been understated at best or ignored altogether. Most deck creators and scholars referred to it only as the "Rider-Waite" deck, and we still see that name used today. While it's true that Arthur Waite directed the project, Pixie (which is what we'll call her as truly devoted fans) is the focus of this chapter. Without her brush, this deck—and possibly tarot itself—would not have had the same societal impact.

We're not alone in thinking this. There has been a push in recent years to call this deck the "Smith-Waite" deck. To avoid confusion, here we will call it Rider-Waite-Smith.

PAMELA COLMAN SMITH

PAMELA COLMAN SMITH was born in 1878 in London into a wealthy and well-traveled American family. Her parents, Charles Edward Smith and Corinne Colman Smith, came from wealthy and established New York City families that had found success in prolific publishing, writing, acting, land development, and political ventures. Pixie thrived in this robust artistic environment, where her affluent grandparents, aunts, and uncles succeeded and prospered.

When Pixie was ten years old, her father's job took the family to Jamaica, opening new doors for Pixie's artistic trajectory. Five years later, she applied to and was accepted at the prestigious Pratt Institute in New York to study art and illustration. She was considered somewhat of a child prodigy at the time and was the first student whose artwork was reviewed and written about in the Pratt Institute Monthly.

In the fall of 1895, Pixie took Arthur Wesley Dow's class on illustration, and his unique style of combining the look of woodblock prints with emotive weather and nature scenes had a significant impact on her. We see a remarkably similar style in several of the stormy skies and peaceful seas depicted in the works and cards that Pixie would go on to create with simplicity of lines, a balance of darkness and light, and a symmetry of color.

Pixie developed her own artistic presence during her time in Jamaica, including the year she had to withdraw from school and move home to help her family after the death of her mother in 1896. When she returned to New York, she performed miniature theater productions and Jamaican folklore stories for her friends and colleagues at Pratt, and explored her own voice in writing, producing, and exhibiting her work. It was through her playwriting during this time that she met one of the most prominent supporters of her early career, the Irish poet W. B. Yeats, who ended up being her shepherd into the esoteric world.

In New York on Christmas day in 1900, Pixie developed musical synesthesia, an experience that became an essential part of her later artistic style in designing the Rider-Waite-Smith cards. We think this ability to visualize music is what gave her work its ethereal quality and set her apart from her contemporaries at the time. Her watercolor pieces are often filled with lots of movement—flowing robes, roiling sea-foam-capped waves, and twinkling stars. Pixie loved to paint folkloric and mythological subjects, not hyperrealistic figures, but they were never overly stylized either. There's a dreamy—dare we say musical—feel that fits with her subject matter.

As she told the story, she was quietly listening to a composition by Johann Sebastian Bach on Christmas Day when she received a flash of inspiration. It lasted merely a moment, but that flash was all she needed to artistically compose an entire outline of what would become a watercolor on newspaper based on the work. You can see the way the cloak of the main figure integrates with the earth itself, and how adeptly the feelings of yearning and sorrow are conveyed through the absence of background color and in the face of the larger figure. She heard the image via synesthesia.

Though her illustrations were popular, she didn't publicly act on her ability to create art with this unique method of hearing colors for another two years. Then, Pixie's friend W. B. Yeats invited her to bring her talent to the series of concerts by Arnold Dolmetsch. Yeats had already begun an ongoing effort to pair musical instruments with his poetry, and bringing in Pixie made it a triple show of poetry, music, and fine art. She agreed and vigorously created large drawings in front of an audience as the music played, drawing up to thirty drawings in one sitting, further embedding herself in the artistic and often mystical community of Yeats.

French Impressionist composer Claude Debussy called her synesthesia paintings designed from his music "dreams made visible." He told her, "You have not only captured the idea of which was in my mind, but you carried it further."

RIGHT: Synesthesia-inspired watercolor,
Sonata No. 11 - Beethoven, 1907

OPPOSITE: Pamela Colman Smith's *The Blue Cat,* 1907

THE GOLDEN DAWN

PIXIE HAD ALWAYS EXPRESSED an interest in esotericism and the occult, perhaps stemming from things she learned or saw during her childhood years in Jamaica. Her love of magic led her to the Hermetic Order of the Golden Dawn in 1901, just a few months after her first synesthesia-inspired visions. This was where she met Arthur Waite.

The Hermetic Order of the Golden Dawn was a secret society popular in the late nineteenth and twentieth centuries. Its members were dedicated to studying the occult, paranormal activities, and the magical practices of what they called "ancient" civilizations, aligning with Hermeticism of past eras. Members were admitted after an initiation, and then completed levels labeled "Orders" to gain access to more esoteric knowledge. The Golden Dawn ultimately influenced many of the practices and beliefs later found in Wicca and Thelema, two solidly twentieth-century spiritual paths.

Most importantly for us, the Hermetic Order of the Golden Dawn was progressive for its time. At a time when women were increasingly aware of, and frustrated by, their lack of suffrage and opportunity, Golden Dawn offered men and women equal access to knowledge, esoteric practices, and rituals, rather than separating them the way that Freemasonry or other secret esoteric societies of the time did. We can see how that would appeal to the artistic and progressive Pixie.

BELOW: **A seance held by Eusapia Palladino at the home of astronomer Camille Flammarion in France in 1898. Many educated Europeans in the late 19th century were caught up in the growing fascination with all things related to the occult, which helps to explain the Golden Dawn's popularity.**

ARTHUR WAITE

ARTHUR WAITE WAS BORN in New York in 1857, but grew up in London. He was Catholic when he was younger, but had a crisis of faith after the death of his sister in 1874. He left Catholicism, but never really left behind his love for ritual and liturgy.

In his twenties, Waite became a regular at the library of the British Museum. He had a voracious interest in esoteric knowledge, and he soon stumbled across Eliphas Levi's studies of the occult. Levi, who is often paired with Antoine Court de Gébelin and Etteilla (both of whom we talked about in the Tarot de Marseille chapter) was instrumental not only in Hermetic and magical thought, but also in further linking tarot cards to systems of ancient wisdom. He's also the first person to say that an upside-down pentagram or pentacle was a symbol of evil, which we find pretty amazing. It's such a relatively new association—Levi was mostly writing in the 1850s!

Levi's works were hugely important to the 1880s founding of Golden Dawn, and so he gets referenced frequently in Golden Dawn literature. Waite joined the Hermetic Order of the Golden Dawn in 1891 and bounced in and out of the group as a member until 1914, when it was officially disbanded.

Long before Waite met Pixie or dreamed of creating a new tarot deck, he published a number of books and essays about transcendental magic, ceremonial magic, divination, Kabbalism, and alchemy. However, none of his works were commercially successful, as Waite was not formally trained as a writer or historian. In fact, his works were described by his peers as being somewhat common.

The twenty-five years that Waite was counted among the Golden Dawn were contentious years for the organization and for London's esoteric societies in general. In the early 1900s, splinter groups broke away from the Hermetic Order, although many still adhered to the core teachings of the Golden Dawn and the influences of earlier authors like Eliphas Levi. Waite and Smith grew closer when they both found themselves in the schism of Golden Dawn that preferred more of a Catholic and liturgical mystical influence.

Pixie's familiarity with some of the Golden Dawn's secret information about tarot was one of the reasons that Waite commissioned her for the new project he envisioned—a tarot deck like none other.

RIGHT: Arthur Waite

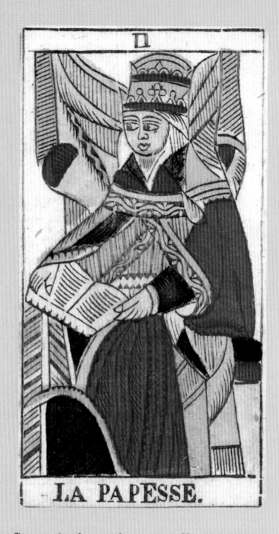

WHAT WAITE SOUGHT TO DO in creating a new tarot deck was revolutionary. Prior to the Rider-Waite-Smith deck, publicly available tarot decks for divination were all either French or Italian in origin, and those had limitations because of the translation of the cards themselves, not to mention the lack of translation of eighteenth and nineteenth century esoteric literature related to them. As we've seen, the Tarot de Marseille began as a card game, not a tool for divination, and when occultists codified the cards for spiritual use, it had been in French.

There was a deck also based on Eliphas Levi's writings available at Waite and Pixie's time called Oswald Wirth Tarot, created in 1899 by a famous occultist in that era. It was certainly an upgrade in color and composition to the Tarot de Marseille, but the minor cards were still pips, and the few figures in the cards were stiff and medieval.

Still, the Golden Dawn and all its offshoots used tarot in much of its practice, and one of the creators of the organization, Samuel Liddell MacGregor Mathers, wrote an entire treatise on the subject of tarot and esotericism. That work was only available in a limited fashion to members of the Golden Dawn however, and there was no ready-to-print deck for people to pick up, as the Golden Dawn encouraged its members to design their own decks of cards. It's so fun to imagine all the incredible decks that Golden Dawn members may have created over the years, but given the nature of secret societies, we can't understand the scope of what might have been.

This lack of an established deck, paired with Waite's desire to make a bigger impact on the spiritual world than he could with his writing, inspired him to finally make his mark.

AT THE TIME WAITE AND SMITH were setting off on their joint project, a pictorial exhibit of the Sola-Busca tarocchi, the fifteenth-century deck explored in Chapter 2, was on display in the British Museum. We don't know whether Waite went to see the cards, although as he was an avid student of the occult and frequent a visitor to the British Museum, it's hard to imagine him passing up a chance to see a fully intact deck based on mythology and alchemy.

We're more sure that Pixie viewed this relatively unknown and somewhat mysterious Italian deck, based on the similarities in some of the major, minor, and court cards in the Rider-Waite-Smith deck. You can go back to the Sola-Busca chapter for some side-by-side comparisons of selected cards with marked similarities from the two decks.

Whether the British Museum inspired them both, by the time they started the creation of their deck in 1909, both Waite and Pixie agreed that they should create allegorical minor cards similar to the Sola-Busca Tarot.

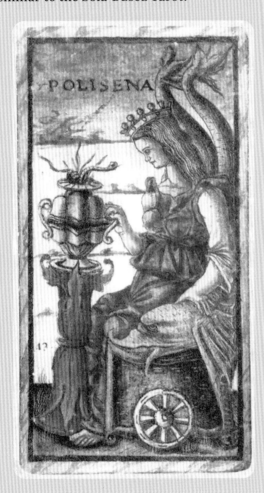

ABOVE: Queen of Cups from Sola-Busca (left) and Rider-Waite-Smith

OPPOSITE: The two primary decks used for divination until Rider-Waite-Smith was created, Oswald Wirth Tarot (left) and Tarot de Marseille

NEITHER WAITE NOR PIXIE described much about their process of creating the Rider-Waite-Smith deck in any of their surviving writings, but we can make some assumptions. Waite was the commissioner and the instigator, so he probably made the major decisions, and as the commissioned artist, Pixie followed his requests. It took six months for Pixie to complete all eighty images, which is an astonishing pace.

Both lived in London, so Waite may have met with Pixie personally to explain the specific details of what he wanted. If he put his ideas into writing, no record of it remains, nor do we have any indication that he gave Pixie sketches of his ideas or that she drew the cards based off any artwork from him. The images are entirely her own, though we know that Waite sometimes had her redraw Major Arcana images several times until things were to his exact specifications.

Waite admitted in later writings that his focus was primarily on properly conveying his esoteric beliefs and knowledge regarding the twenty-two major cards, which gave Pixie more artistic freedom to express the allegorical meanings in the minor cards as she saw fit. Most people believe Waite deferred almost entirely to Pixie on the artwork in the Minor Arcana cards and court cards, an idea that seems likely, since tarot scholars and researchers later identified small Easter eggs Smith included that presumably went unnoticed by Waite. Most notably, two of Pamela's very close actress friends appear in the cards—Florence Farr as The World, and Ellen Terry as the Queen of Wands. Pixie and Ellen were devoted friends—and "roommates"—and Pixie's homage to Ellen as the strong, capable queen of the suit of fire is sweet and wonderful.

Did Pixie's personal understanding of the tarot agree

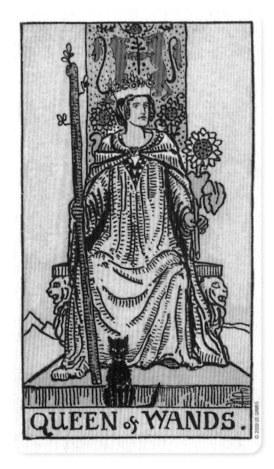

LEFT: The World (possibly Florence Farr), The Queen of Wands (possibly Ellen Terry)

OPPOSITE PAGE: The High Priestess, The Hanged Man

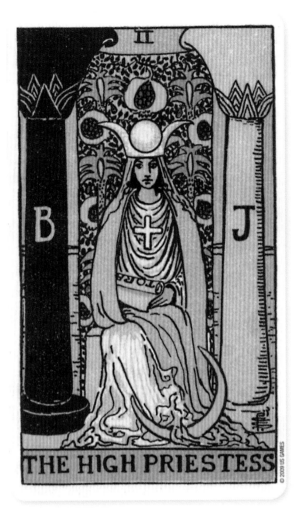

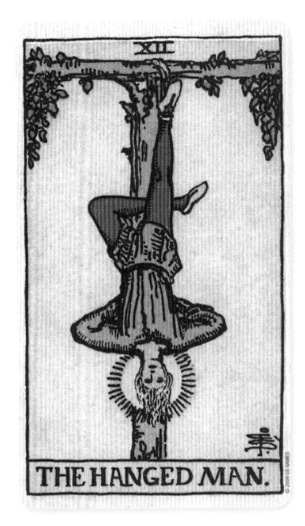

with Waite's, or did her ideas influence his message as well as his art? Neither of them ever reported a disagreement in the project, so it seems her views of the cards and their meanings aligned closely enough with Waite for them to finish the project relatively amicably. Later, Stuart Kaplan, founder of U.S. Games and longtime admirer of Pixie, said, "I think it was more Pamela Colman Smith and her own intuition that did the deck."

While Waite seemed to appreciate the ways Pixie's mystical free spirit and synesthesia influenced her art, and that Pixie came into the project with knowledge about the Tarot, he took the opportunity in his 1938 autobiography to make some (typical of him) degrading remarks. "She had to be spoon-fed carefully over the Priestess Card, over that which is called the Fool and over the Hanged Man." This downplaying another person's influence on his work was a pretty normal attitude for Waite. He had an ego and would pick fights with his contemporaries, including the man we'll meet in the next chapter, his "archnemesis" Aleister Crowley.

In her personal writing, Pixie also complained that the project was "a big job for very little cash," which brings us back to the problem in the creation of many tarot decks: all too often are the artists forgotten or underappreciated.

DESPITE PIXIE AND WAITE'S membership in the Hermetic Order of the Golden Dawn, neither the imagery nor the meanings behind the cards were meant to encapsulate all of Golden Dawn's beliefs. For example, most occult-influenced decks of the time used specific Hebrew alphabet associations to align cards with some of the traditional hermetic thoughts on capital-T Truths about the world, but Rider-Waite-Smith does not.

Waite's distinct vision for the Major Arcana cards instead shows us his personal worldview. There is a mishmash of thematic influences that came from Waite's esoteric hero Eliphas Levi, as well as Paul Christian's 1870 work *The History and Practice of Magic.* Christian's work specifically promoted the Gébelin-instigated fakelore belief that all deep, esoteric secrets of the world originated from Egypt and directly influenced tarot, and that carries through in the Rider-Waite-

Smith artwork of the Major Arcana cards.

We see this confluence of esoteric influences in the Wheel of Fortune card, which has both Hebrew letters and Egyptian influences. The letters on the Wheel spell YHVH, the most common transliteration of Yahweh, interspersed with TARO, sometimes assessed by tarot readers as TORA (as in the Hebrew torah, or law) or ROTA (which is Latin for wheel). The image of the wheel is surrounded by winged figures, but also an Anubis figure, a sphinx, and a snake, which would all have been commonly understood as Egyptian symbolism.

Interestingly, we also see more Judeo-Christian symbology and associations than any other religious theme in the Rider-Waite-Smith Majors. For instance, Judgement reflects the Second Coming of Christ as described in the book of Revelation.

The Lovers card also obviously looks like the biblical story of Adam and Eve in the Garden of Eden—two folks in the buff in a garden being yelled at (or sanctified) by the heavens. There's even a snake and an apple tree. Like Eve, the female-bodied figure on the card seems trapped between the snake, the male figure, and the angel, further emphasizing the element of love and choice the card is meant to express.

Then, there's the good old Death card. Terrifying to some and a welcome respite for others, this card represents transformation and endings, and yet is illustrated with a straight-up specter of a skeleton on horse-back, trampling townspeople, unstopped by a popelike figure. Yet the sun peeks over the horizon, showing that not all hope is lost, because the truth is, no one can escape death. Both of these cards are recognizable to people with basic understandings of the Bible, but with subtle shifts—acceptance of death and getting to choose between the apple and love.

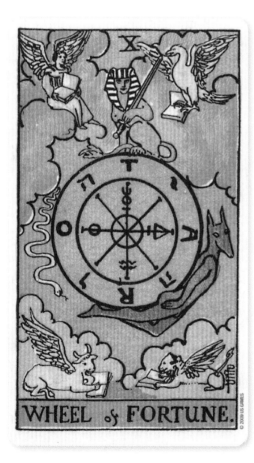

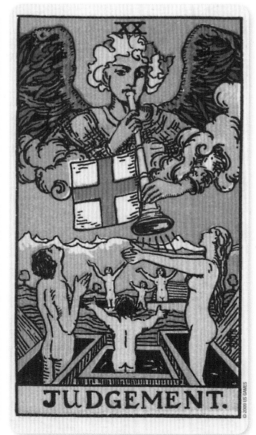

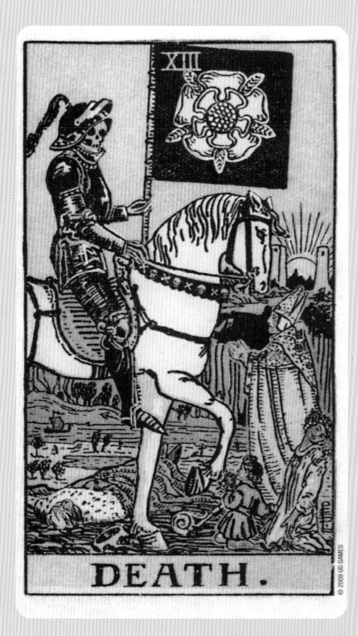

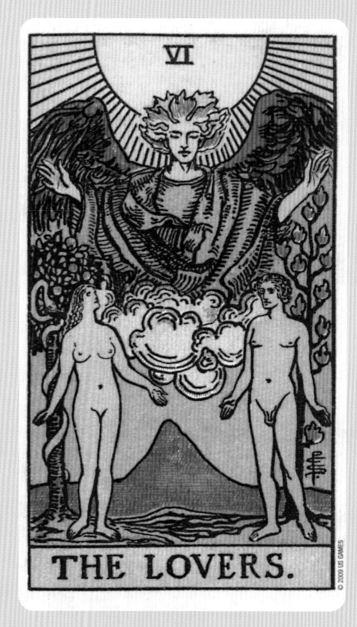

OPPOSITE PAGE: Wheel of Fortune, Judgement

ABOVE: Death, The Lovers

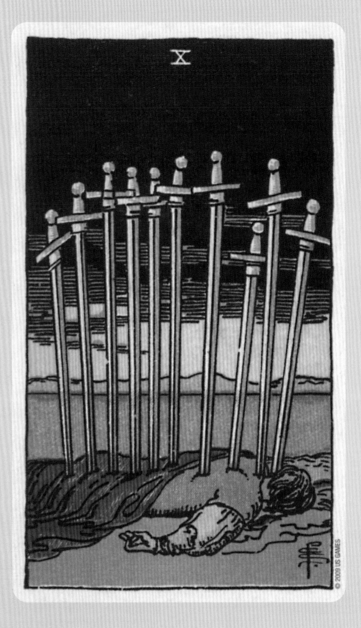

ABOVE, LEFT TO RIGHT: Three of Swords, Ten of Swords

OPPOSITE PAGE: The Queen of Pentacles

THE ILLUSTRATED MINORS

WAITE STATED IN HIS 1938 AUTOBIOGRAPHY that the result of his tarot project was "for the first time on record . . . a marriage of art and symbolism for the production of a true Tarot." It was always his intention for the illustrated minors to give the reader powerful messages of esoteric truth in the form of symbolism and art, a language he believed laypeople could learn and understand.

In the companion book to the Rider-Waite-Smith deck, *The Pictorial Key to the Tarot,* Waite wrote extensively about the esoteric meanings behind each of the Major Arcana cards. However, for the minor cards, he mostly described Smith's artwork and how the image enhanced the card's keywords. Seeing a figure face down and full of swords was enough to understand that the Ten of Swords wasn't meant to be a card about picking up and carrying on. It was a card about being at the lowest point and sitting with the understanding that you needed to heal.

Waite didn't put very much esoteric investment in the meanings or the artwork of minor cards, but instead focused on the emotions evoked from pictures and the divinatory meanings associated with those emotions. With the Three of Swords, the visceral heartbreak of the thrice-pierced heart became the message. Bringing up those gut reactions helped people read the cards more intuitively.

Pixie never wrote about how she read tarot, but she did write about how she viewed paintings in *The Craftsman* in 1908, and her guidance perfectly describes to us how a person can intuitively read tarot from its artwork.

"Note the dress, the type of face; see if you can trace the character in the face; note the pose . . . First watch the simple forms of joy, fear, of sorrow; look at the position taken by the whole body . . . After you have found how to tell a simple story, put in more details . . . Learn from everything, see everything, and above all feel everything! . . . Find eyes within, look for the door into the unknown country."

This is Pixie's personal legacy within the Rider-Waite-Smith deck: creating characters that seem to jump off the paper, each of them celebrating, mourning, or experiencing some facet of life that can become something more to the reader. Pixie changed the standard of tarot decks and how divination messages are conveyed to the querents. Look, for example, at the Two of Cups. These two figures are sharing and exchanging emotions (which Cups represents), and you can sense the closeness the two have. The addition of the chimera caduceus, the head of a fire-breathing Grecian mythological creature on the staff of Hermes, brings a hint of antiquity to create a card that feels both understandable and mystical.

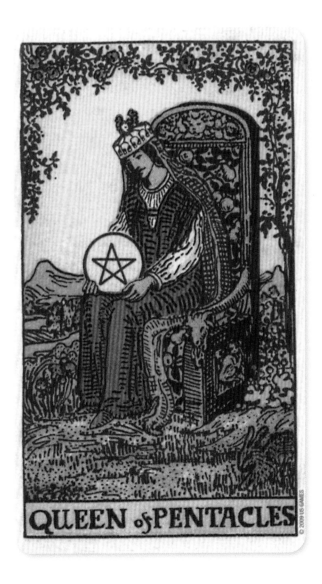

THE RIDER-WAITE-SMITH DECK was published in a limited run in 1909 by William Rider & Son of London Publishing Company. (We're sure you've been wondering where "Rider" came into the picture!) It was immediately popular and quickly sold out. A second printing in 1910 received a card stock upgrade, and it continued to sell well. Rider printed the deck regularly until 1939, and then reissued it in 1971 during the tarot resurgence of the New Age movement. U.S. Games acquired the copyright in 1971 and was the sole publishing house for all Rider-Waite-Smith decks until the copyright ran out in 2021.

Not only has Rider-Waite-Smith remained the most popular and recognizable tarot deck in the world, but it also influenced a lot of what are called Rider-Waite-Smith clones, decks with thematic images based on the scenes depicted in the Rider-Waite-Smith decks. A popular example is Tarot of the White Cats, in which all the scenes mimic Pixie's artwork but humans are replaced by—you guessed it—white cats.

These types of decks speak to Pixie's artwork transcending itself, becoming so accessible and recognizable that it's identifiable even in other art and themes. Anyone can pick up her work, even in a clone deck, and be able to instantly divine with the decks. When it comes down to it, Waite's writings about tarot are almost all but forgotten, but the images that Pixie made, and the way they still draw our attention, carried through to this century and will carry into the future.

Unsurprisingly, the Rider-Waite-Smith deck is also the tarot deck we see most often in TV shows, movies, and other entertainment. Our favorite is in an iconic 2008 episode of the TV show *Mad Men*, where Don Draper gets his cards read using a Rider-Waite-Smith deck. Without giving too much away (though honestly, the episode was aired more

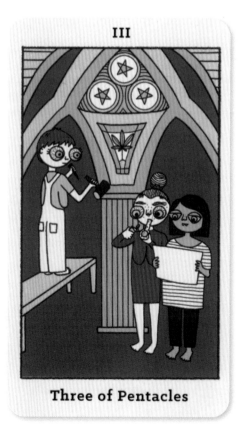

than a decade ago, so if you haven't seen it, you're probably not going to now), a lot of the cards that Don's friend Anna pulls for him show how the series progresses. Our favorite part of the reading is The Sun reversed as the card that represents Don's current situation—it can be interpreted as everything looking like sunshine and roses but actually being completely terrible. Seriously, what a great show. Real Golden Age of Television stuff.

Probably the most common tarot image that turns up on TV and movie screens is the Death card, and it's almost always Pixie's depiction; the looming white horse and scary skeleton is otherworldly and iconic, and the threat of imminent death (even if that card is being misused in those cases) is a great plot point. There are also glimpses of Rider-Waite-Smith in 1995's *Now and Then*, when Janeane Garofalo helps the girls by pulling cards for them, and in *The Virgin Suicides,* which came out in 1999. (Can you tell we're millennials?) Perhaps our favorite place that Rider-Waite-Smith shows up isn't on the screen, but in unexpected musical places. In 2020, the Grateful Dead released a new music video for "Ripple," celebrating the fiftieth anniversary of the iconic song (and Holly's childhood lullaby) by reimagining the song's story using animated tarot cards from start to finish. Fifty years after the song came out, one hundred years after the deck, the imagery of the Rider-Waite-Smith deck is so recognizable that it can be used to bridge the gaps between generations.

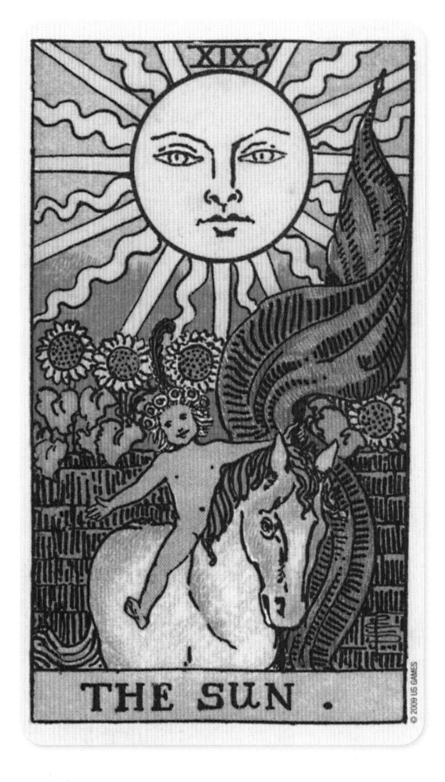

RIGHT: The Sun

OPPOSITE PAGE FROM LEFT TO RIGHT: The World from Game of Thrones Tarot, the Two of Cups from Tarot of White Cats, and the Three of Pentacles from Four Twenty Tarot are all examples of Rider-Waite-Smith clone decks

JUSTICE FOR PIXIE

EVEN THOUGH THE RIDER-WAITE-SMITH deck has been around for more than a century, in recent years there has been a push (and rightfully so!) of people crediting Pixie with its success. Referring to the deck as the Smith-Waite deck or even the Pamela Colman Smith deck gives its artist the credit she deserves and also divorces it from the more problematic components of the Golden Dawn and Arthur Waite.

Thankfully, the resurgence of interest in Pixie brought an incredibly well-researched and beautiful book by Stuart R. Kaplan with Elizabeth Foley O'Connor and Melinda Boyd Parsons called *Pamela Colman Smith: The Untold Story*. In it, the authors show all her artwork and describe the periods of her life and art, reconstructing a spark plug of a woman worn down by constant stressors surrounding money and love. Through this, we meet a woman who, in 1914, gave away the "visitor book" from her infamous salons, filled with notes and little sketches from some of the glitteriest literary and art minds of her era, because she "didn't care for people anymore." A woman who was seen as "the other" by everyone in her life either because it was how she styled herself or because she had been unbothered by social expectations. She had never married, dressed in elaborate costumes almost all the time to correspond with her Jamaican folklore performances, and lived with her "friend" Nora Lake for more than twenty years before Nora died. Pixie was a one of a kind.

Feeling vulnerable, invisible, and not recognized in ways we want to be are things that lots of modern people, especially those of us drawn to reading tarot, can understand. Pixie's desire to create something beautiful and put it out into the world regardless of recognition feels familiar.

Women have often been the creative driving forces in breaking glass ceilings, even as the men they work with receive the bulk of the credit. But in Pixie's case, the images themselves survive to speak for her. People could, and still can, find copies of Pixie's artwork in bookstores all over the world, and an estimated 100 million copies of the Rider-Waite-Smith deck have been sold.

Arthur Waite made money on his tarot work for years, and his name became basically synonymous with tarot. Pixie died basically penniless and unknown in 1951. But if it weren't for Pixie's vision, her art, and her reinvention of the illustrated minor cards, tarot would not be as popular or as accessible as it is today. It's her images that impact us emotionally and leave their imprints on our souls. It's Pixie's hand that guides us as we divine with her art, and she deserves more.

YOU MIGHT ALSO LIKE: MODERN WITCH TAROT

Modern Witch Tarot is a contemporary twist on the traditional Rider-Waite-Smith style. It has inclusive and diverse women, femmes, and gender-fluid people of all kinds and sets them in scenes from the modern world. At the same time, it also maintains the feeling of Pixie's original artwork by depicting the same scenes throughout.

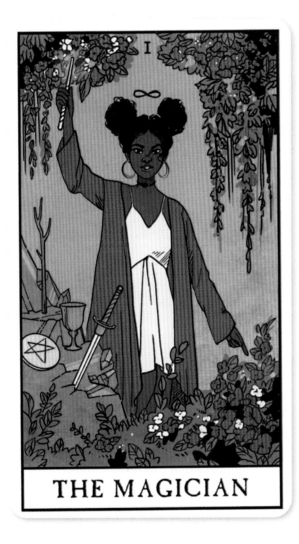

THE MAGICIAN

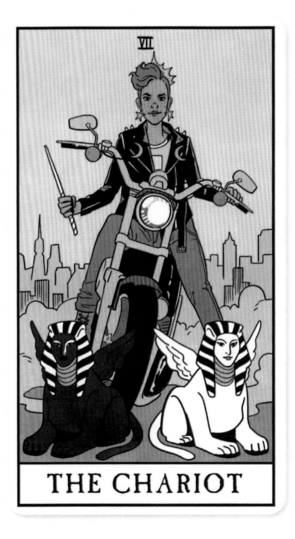

THE CHARIOT

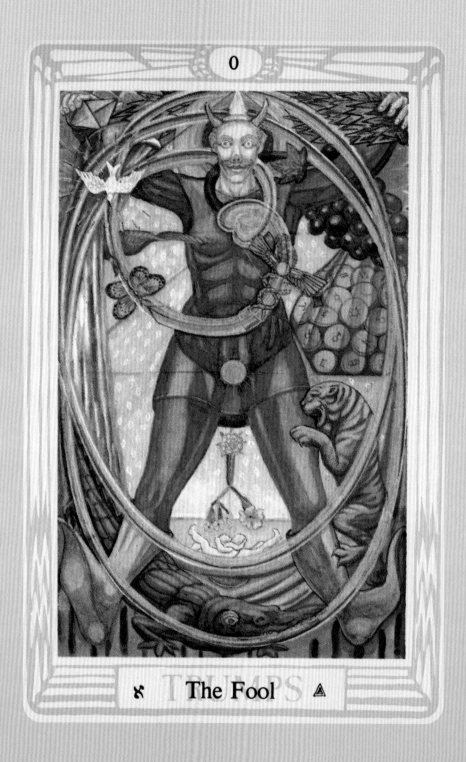

0

♉ The Fool ⚠

5

THOTH

WHEN: 1944 ■ **WHERE:** LONDON

CREATED BY: ALEISTER CROWLEY AND LADY FRIEDA HARRIS

 ODAY, THE THOTH TAROT is the second most popular tarot deck of all time after only the Rider-Waite-Smith deck, and that's due as much to its recognizable artwork and the complexity of its content as to its associations with Aleister Crowley, the famed occultist. Before Thoth, there was no deck in existence that dove so deep into esoteric philosophies and borrowed from multiple sources to merge them together into one authoritative voice.

We cannot ignore that the infamous and magnanimous occult personality Aleister Crowley is the name most widely associated with the deck today, and Thoth Tarot sealed Crowley's legacy in mainstream tarot culture. But it's the art created by Lady Frieda Harris, usually only referenced on the back of the box, that carried Crowley and Thoth to that place.

Lady Frieda continued to be one of Crowley's closest and most trusted friends in the latter years of his life, though given how prickly and sometimes financially demanding of a friend Crowley was, there's no way to know what that friendship truly meant to either of them in practice.

LADY FRIEDA HARRIS

MARGUERITE FRIEDA BLOXAM (who went by Frieda and was later mostly referred to as Lady Frieda) was born in London in 1877, the daughter of a surgeon. Not much is known about her until her adult public life, as she was never one to step fully into the spotlight, but she became a tenacious lion in supportive roles.

In 1901 she married Percy Harris, a career politician and a Liberal Party Member of the House of Commons. As a suffragette, Frieda was one of his most ardent supporters. The couple had two children in the mid-1900s, Jack and Thomas. In 1932, King George V gave Percy the title Baronet, creating a new noble title in recognition to his service to the country. This gave Frieda the title that would follow her for the rest of her life.

Always a spiritual seeker, Lady Frieda was a fervent believer in the teachings of Mary Baker Eddy, the founder and discoverer of Christian Science, during the early years of her marriage. Later, she became deeply involved in the women's branch of Freemasonry, known as Co-Masonry. Deciding to become an artist, she took art classes and cultivated a serious hobby, finding mild popularity for her illustrations and esoteric poetry under the name "Jesus Chutney," which may actually be the best pen name we've ever heard in our lives.

In 1937, Lady Frieda met Aleister Crowley through their mutual esoteric interests and memberships in Freemason organizations, and their worlds collided and exploded into a beautiful display of art and esotericism. Thankfully, both seemed fairly aware of the magnitude of their artistic endeavors, so lots of letters remain available for us to read.

LOWER LEFT: Aleister Crowley in 1906 "with pipe, poshtin, and purity"
UPPER RIGHT: Lady Frieda Harris, date unknown

OPPOSITE PAGE: Rosicrucian cross featured on the back of Thoth tarot decks

ALEISTER CROWLEY

BY THE TIME ALEISTER CROWLEY met Lady Frieda, he already had an established career writing about the occult and ceremonial magic. He wrote extensively about Magick (and was instrumental to the use of that spelling within esoteric communities), systematic ritual, the concept of Will, and, most controversially, the role of "sex magic" in focusing intentions while working through his magickal process. He famously joked about "sacrificing 150 perfect male children" (paraphrasing here) in a reference to masturbation, but it led his critics to accuse him of literal human sacrifice. He was controversial both with mainstream Christian society and less flamboyant esoterics, so much so that his secondary career appeared to be ticking off all the hoity-toity esoteric gatekeepers of that time.

Crowley joined the Hermetic Order of the Golden Dawn in 1898, the same group that brought Arthur Waite and Pamela Colman Smith together, but reports show that he was not well-liked because of his salacious lifestyle and his ongoing feuds with prestigious members, including W. B. Yeats. Crowley eventually burned his bridges with the Golden Dawn and converted to Freemasonry before the turn of the twentieth century.

In 1904, Crowley and his wife, Rose, developed the foundations of what would eventually be their own religious philosophical beliefs, Thelema. This is going to be a major simplification, but Thelema was a hodgepodge of spiritual beliefs that boiled down to the idea that each of us have our True Will that we must explore to find alignment and harmony with the Cosmic Will, the source of all religious and spiritual energy. Another component of Thelema was the idea that the world was now entering the Aeon (era) of Horus, where individuality reigned over all else. This followed the Aeon of Osiris, the time of domination by patriarchal religions, which had followed the Aeon of Isis, the time of goddess worship. By saying we were entering a new age with a new structure that had yet to be revealed, Crowley put himself in the role of the prophet for this age. No red flags there! What could have gone wrong isn't something we'll dig into here, but it's a whole thing.

In addition to Thelema, Crowley pursued other occult memberships and was "initiated" into the Ordo Templi Orientis (OTO) in 1910. By 1912, he was in charge of the whole organization in England and Ireland. OTO chapters, which focus heavily on ritualistic magic, still exist today, and the organization continues to hold the copyright to the Thoth Tarot art.

XIV

Art

ABOVE: Thoth's Art takes the place of Temperance

OPPOSITE PAGE: The Lovers

LADY FRIEDA WAS DRAWN TO CROWLEY, captivated by his words, his methods, and his teachings. She joined his coven soon after their first meeting. In 1938, she joined the OTO, and Crowley allowed her to skip a few levels because of her experience in Co-Masonry. Before long, she was considered Crowley's disciple. She was also his benefactor, sending him a sizable stipend every month. In one letter from 1939, she admonishes him for treating her like a personal bank.

There are different opinions about who initiated the creation of Thoth Tarot. Crowley and others maintain it was his idea, with the relationship between commissioner and artist similar to that of Arthur Waite and Pamela Colman Smith. Crowley was simply looking for someone to illustrate his tarot deck and happened upon Lady Frieda, whose artistic style pleased him. Other stories suggest that it was Lady Frieda who first suggested to Crowley that he create a tarot deck. She volunteered to do the artwork for it, saying she was directed to the project by her holy guardian angel. According to these accounts, it took a little begging on her part, but he eventually agreed to do the project.

The truth is likely somewhere in the middle, though our opinion leans away from Crowley's version, as we know he was a bit of a braggart and Lady Frieda intentionally avoided being credited for her contributions in other areas of her life (remember Jesus Chutney?). While Crowley did have esoteric knowledge and a specific vision he wanted to convey in a tarot deck prior to meeting Lady Frieda, it seems he wanted to create a more traditional deck devoid of the extensive astrological and religious references that ended up in the Thoth deck.

Whoever the initiator was, we see in the letters exchanged between them that the passion and the persistence to complete Thoth Tarot came from Lady Frieda, who coaxed a drug-addled Crowley into sending her card descriptions and details, promising that in return she would send him more money from her own limited budget.

Lady Frieda had established a certain level of notability with her art under her pen name, but it wasn't until she created art within Co-Masonry that we see the signature style of the Thoth tarot deck emerge.

In 1938, she created three Masonic tracing boards, each representing a belief or teaching for different degrees of Freemasonry. Boards were typically filled with symbols and emblems recognizable to those who knew the secrets of Freemasons, but the style and design varied. The process gave Lady Frieda experience with infusing deep esoteric truths and meanings into her artistic vision, while showing her artistic style of art deco, geometric symmetry, fine line work, and deeply saturated colors.

Lady Frieda's Masonic boards were most likely created without any input from Crowley, and so they give us a clear idea of her independent artistic style when she started the Thoth Tarot. While the two were in regular correspondence at the time, neither mentioned the project in any of their letters, and Crowley was never credited with the work, nor did he ask for recognition. Considering how often Crowley demanded credit for things he was only peripherally involved in, this is telling.

The Lovers

IN 1938, CROWLEY AND LADY FRIEDA initially agreed that the creation of Thoth Tarot would take three months, but because of Crowley's eccentric personality and the arrival of World War II on their London doorsteps, the full development of the deck took more than five years.

Crowley and Lady Frieda created the deck through correspondence and periodic meetings because each of them moved around London—and all of England—as the war progressed. Crowley sent specifications of the cards and their esoteric associations, and in turn, Frieda created original artwork that reflected his vision. Crowley was a scrupulous editor and had Frieda redo some cards up to eight times. In his writings on the matter, he doesn't specify which cards caused so much trouble, but based on her general dislike of the suit of Swords by the time she was done with them, it seems a likely culprit. In Frieda's defense, Crowley's instructions were often very specific but inconsistent, and many of the letters we have between the two are Frieda asking for clarification on symbols, colors, and words he wanted in a certain image.

Lady Frieda also had to rein Crowley in to refocus him on the task at hand when he strayed too deep into other projects, going as far as begging him to send more cards. She did all this while living in London at the height of World War II with bombs literally dropping all around her. Lady Frieda, who was already sixty years old when they set out on the project, struggled to get the right colors of paints because of war shortages and often painted by candlelight due to power outages. Her nerves, she wrote, were damaged by the project and the war and never returned to their prewar states.

ABOVE: **Firemen at work in bomb-damaged street in London after Saturday night raid, ca. 1941**

OPPOSITE PAGE: **Ten of Disks, Three of Cups, and The Aeon (top), and the Kabbalistic Tree of Life (bottom)**

In a 1942 letter, Crowley jealously referred to Waite's Rider-Waite-Smith Tarot deck as a "crude, vilely drawn & coloured, ignorant, inferior pack." While Waite had created his deck with the intent of sharing the esoteric principles of Eliphas Levi, we've seen more of a Judeo-Christian theme than that of the occult and esoteric. Perhaps that was why Waite's explanatory book faded into something that only specialty collectors cared about, even as Pamela Colman Smith's "vile" artwork found new and appreciative audiences.

The opposite can be said for Thoth Tarot. Decades after its release, most tarot card users associate not only Crowley's name, but his book with the deck and study it carefully if they want to scratch the surface of what he intended us to understand and learn. Crowley's writing brought together beliefs from Thelema, Kabbalah, and the OTO, which makes it hard to look only at the surface and fuse the ideas together into an understandable package.

In Thoth, for instance, what were Pentacles or Coins in previous renditions of the tarot became Disks. The Ten of Disks card draws heavily from Kabbalahistic beliefs regarding the Kabbalah Tree of Life, which displays the relationship between spheres that represent the human psyche, existence, and God. Lady Frieda created the visual representation that pointed back to something deeper—ten coins displayed in a manner similar to the Tree of Life—but to be understood fully, a tarot user would need to read the text as well.

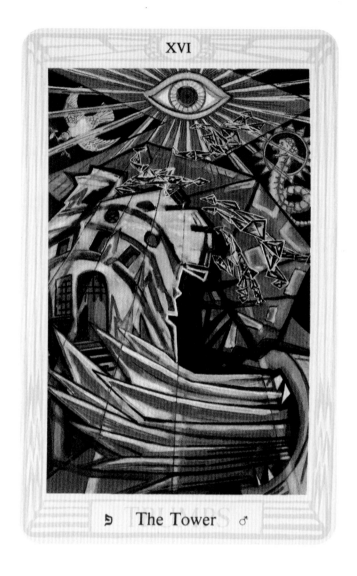

ONE THING THAT WE HEAR OFTEN from new tarot users is that the Thoth deck is more intense and darker than other historical tarot decks like the Tarot de Marseille or the Rider-Waite-Smith. This partially has to do with the challenge of bringing together different esoteric philosophies and associations, but to be honest, the intensity of this deck is likely a reflection of the person who drove the understanding of the meanings behind each card.

By the time he turned his attention to tarot, Aleister Crowley had known the highs and lows of life—wealth and poverty, euphoria and pain. Once Lady Frieda encouraged his expressions through a tarot deck, he went full throttle creating something almost as intense as he was. For better or worse, Crowley spoke bluntly in his everyday life and when sharing his thoughts, beliefs, and philosophies through the cards. The art he demanded was not sugarcoated.

For example, in the Magus card, the line work, depth of color, and bold, vibrant contrasts within the painting itself complements and reflects Crowley's potent vision.

Those familiar with earlier tarot decks, especially Rider-Waite-Smith, may be surprised to see that Thoth Tarot changes some names and that two of the cards have been switched completely in the order of the Major Arcana.

Traditionally, Justice was numbered eighth for the belief that the number eight brought everything into balance. However, influenced by principles of the Golden Dawn, Waite put Strength in the eighth position, since astrologically, Strength was representative of the Zodiac sign Leo. Returning to tradition, Crowley brought back the original numbering while also keeping the astrological associations of Justice as Libra and Strength as Leo. This allowed both traditions to exist in the same card.

Along with the positional change, he renamed Justice to Adjustment and Strength to Lust. Judgement was also changed to The Aeon, transforming the Rider-Waite-Smith meaning of the Christian resurrection and coming of Christ into the ushering in of a new age with the Will of the self, implying a finality to this age and a destruction that led to liberation and hope. For all three of these cards, you can see the strength and vibrancy of the colors and forms that Lady Frieda used. There is no whimsy here, just gorgeous colors and almost industrial lines.

Temperance was also made over into Art, harking back to the belief of alchemy and combining ordinary elements to create something perfect and precious.

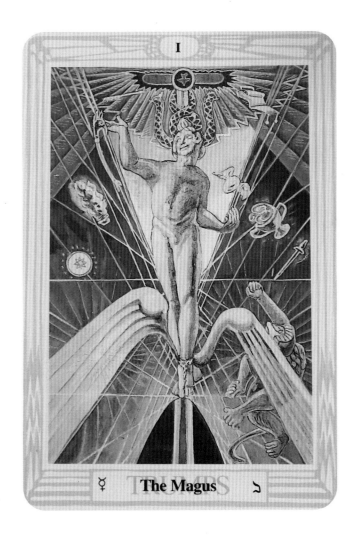

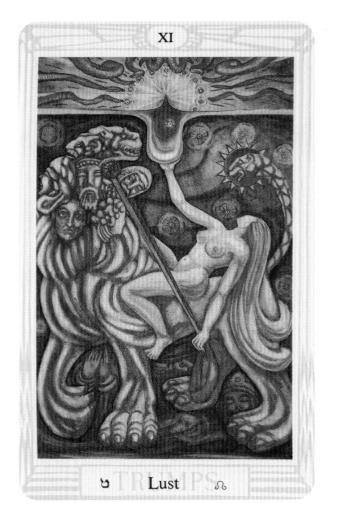

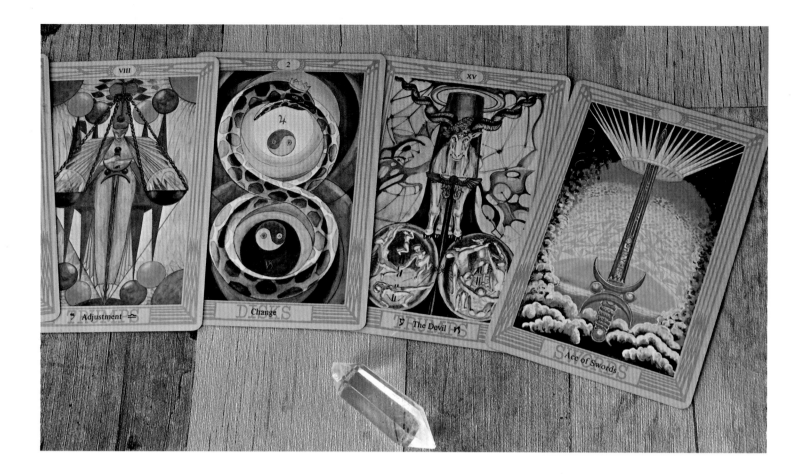

PEOPLE HAVE ASSOCIATED NATURAL elements with metaphysical concepts since the birth of alchemy, but those connections were never obvious in tarot decks until the creation of Thoth Tarot. While there had been a basic understanding within the tarot world that Wands equaled fire and fire equaled passion, the art in Thoth Tarot took these elemental links and pushed them to their extremes. What we find is a deck based on the elements layered in complementary philosophical and astrological associations.

When we look at the Ace of Wands, we see the foundation of the suit that represents fire and passion, so the card is filled with vivid reds, yellows, and oranges. The Ace of Cups, which represents water and the depths of emotions one can experience, is all blues, greens, creams, and reds. The Ace of Swords stands for the element of air, and reveals the way our mind impacts us in yellows, greens, Ceylon blues, and whites. Disks depicts the natural earth and material world in perfectly chosen shades of browns, greens, and yellows.

ABOVE, LEFT TO RIGHT: Adjustment (Justice), Two of Disks, The Devil, Ace of Swords

UNDER LADY FRIEDA'S BRUSH, the Thoth court cards received the same astrological and elemental makeover treatment as the Major Arcana cards, as well as the occasional name change.

In Tarot de Marseille and Rider-Waite-Smith decks, court cards were labeled Page, Knight, Queen, and King. Crowley's naming conventions were perhaps more confusing, but they were based on beliefs and teachings from the Golden Dawn: Princess, Prince, Queen, and Knight (replacing King).

In each case, Crowley and Lady Frieda turned up the astrological and elemental associations a few notches, resulting in their figures becoming more alive in the artwork. For example, the Knights in Thoth are all associated with Fire. If you look at a specific Knight, the suit reveals how their unique personality fits into that element.

The Knight of Wands, therefore, would be a Fire (Knight) of Fire (Wands), and in the artwork of the Thoth tarot, Frieda captures this energy with a figure on a horse with a robe made of fire. His scepter is alight with bright red flames. In contrast, the Knight of Disks, or the Fire (Knight) of Earth (Disks), carries red and yellow tones that are much deeper and earthier, visually depicting that the fire is smoldered by the earthly element. The elemental association of the court card can amplify or dampen a card's meaning, making the nuances even more significant.

Lady Frieda's difficult task was to weave together this chaotic assembly of elemental, numerological, and astrological motifs. Not only did she incorporate all of Crowley's strict details—which at times meant she practically had to read his mind—but she also melded those ideas with the traditionally accepted meanings of the cards.

As far as we know, Lady Frieda didn't have much personal experience with the tarot, but she successfully put together all the moving parts to express things deeper than her own understanding. She often spoke of the artwork as if it were a living and existing thing and about her frustration with figures not obeying her vision. It was almost as if she had

expressed a magical quality to make them come alive. In an undated letter to Crowley, she said:

"I will struggle with the Fool. He does writhe about. I can't see him. Has he got any children with him and is not his bag a jester's balloon? That innocent gaiety asks for the brush of a saint and my lines come out like treacle. I wish I could paint in crystals."

BELOW: The Knight of Wands

OPPOSITE PAGE: Diagram of Synthetic Projective Geometry (top), and The Hermit and Adjustment, which demonstrate Synthetic Projective Geometry principles

Cavaliere di Bastoni

SYNTHETIC PROJECTIVE GEOMETRY

WHILE LADY FRIEDA WAS TIED to Crowley's directions for each card, she also brought something he did not: thought-provoking images.

Lady Frieda's style of art viewed more than eighty years later still has a certain timeless modernity, and this is accomplished in part by her use of projective synthetic geometry in her creative process and artistic execution.

Synthetic projective geometry, an axiomatic approach to projective geometry, doesn't require projective space to be defined over an algebraically closed ground field, or even a field at all.

Wait, what?

For those of us who did not understand that description *at all,* synthetic geometry is a way to project how shapes intersect and coexist with each other, especially three-dimensional shapes drawn in a two-dimensional model. In art, it's a way to play with perspective and draw attention to certain things that may otherwise be lost in the background. (Mathematicians, we truly do not want to hear from you about how we're explaining this.)

Frieda had experimented with these concepts since at least 1937, when she took classes at the Anthroposophical Society in London from Olive Whicher and George Adams, who had written a book called *Space and the Light of the Creation—Synthetic Geometry in the light of Spiritual Science.* Anthroposophy is the philosophy that there is an objective spiritual world accessible by humans, so it was clearly popular among the spiritual and occultist set. Even at the age of sixty, Frieda was an enthusiastic student and would often excitedly talk to Whicher about incorporating projective synthetic geometry into the Thoth Tarot deck.

The result, in layperson's terms? Building on mathematical principles, Lady Frieda brought us visual depth that Crowley's words alone never could have.

I have made an effort in this present pack to embody this current mode of the century. There-fore I have tried to introduce among the cards the element of Time . . . I hope to convey the idea of movement. "Death" in Trumps has to suggest the idea of reincarnation, as opposed to putrefaction, he is weaving with his scythe a geometrical web of new forms.

—Lady Frieda Harris, "Lecture to the Sesame Club," 1942

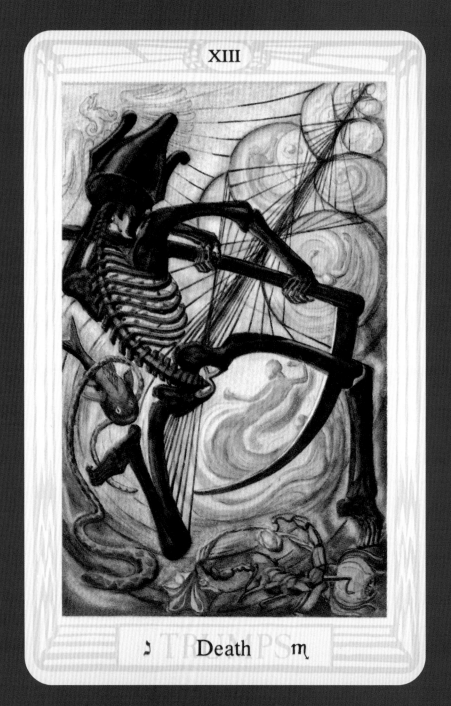

LEFT: Thoth Tarot's Death

OPPOSITE, LEFT TO RIGHT: Thoth's The Hanged Man, Aleister Crowley, the first commercial release of the Thoth Tarot deck

THE COMPLETION OF THOTH TAROT

IN MAY 1941, as she finally neared the completion of the Thoth Tarot, Lady Frieda prepared to exhibit the art she had created and looked for ways to publish the deck in a small batch. Staging a proper exhibition during a war proved to be difficult, but even harder was obtaining money to fund the printing of Thoth Tarot.

It wasn't just the war against her. Frieda's task of creating positive buzz and public interest about her project was twice as hard because her coauthor had recently been coined "The Great Beast" and "The Wickedest Man in the World" by the newspapers and tabloids.

Lady Frieda began to strongly hint, then almost downright beg Crowley to keep his mouth shut about the project. At one point, she wrote to him that she was preparing an exhibition of the deck in Oxford, but if her patrons were to find out that the "Arch Magician of Black Magic" were behind it, they would withdraw their funding.

Lady Frieda's exhibitions and lectures about the artwork of the Thoth Tarot resulted in the private publishing of 200 decks that she sold directly at her events, but being shut out hurt Crowley's ego. He wrote angry letters in the spring of 1942 to both real and fabricated individuals about being cheated out of money from the Thoth deck, and in the vein of misogynists everywhere, he heavily implied that Lady Frieda was an unstable individual who had no right to question him about the wider commercial production of the deck.

This, as well as other misunderstandings, led to a falling-out that seems particularly one-sided. In letters, Lady Frieda's frustrations were largely about how much money he demanded from her rather than how abominably he spoke about her to others. She would stay devoted to Crowley for the rest of his life, writing and visiting him even while he went through periods of being hot or cold toward her. For his part, there must have been some lingering fondness for her, because he named her an executor to his will.

Crowley died in 1947. Lady Frieda Harris lived until 1962, but she would never see a wide commercial publishing of their tarot deck.

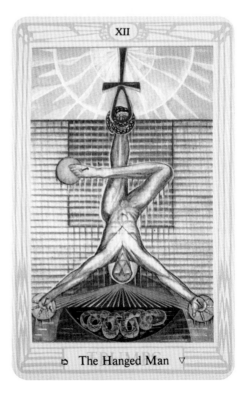

IN ADDITION TO FRIEDA'S soft publishing in 1944, there were a few other releases during her lifetime, but those were done by a smaller publishing house without color. Today, copies from that earlier run are known as the Sangreal One Color Tarot edition.

The Thoth Tarot was not fully published or made available to the public until 1969, when the so-called Age of Aquarius was in full swing and there was a resurgence of interest in occult tools like tarot. We'll talk more about this culture shift in the next chapter.

In the years between their creation and the wider publication, the eighty-two original paintings Lady Frieda completed for the Thoth Tarot deck were damaged, deteriorating because of time, improper storage, and improper care of the fragile wartime materials. In 2011 they were restored by the Warburg Institute at the University College London, but the images in the cards we see in Thoth Tarot decks today are still created only from photos of the paintings, which barely capture the true beauty and glory of her artwork.

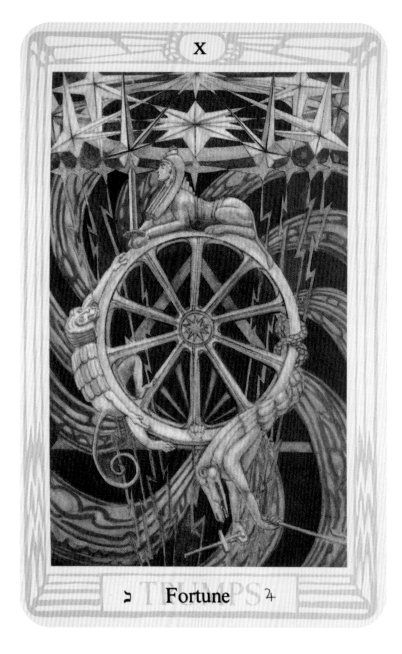

THE LEGACY OF THOTH TAROT

THE LEGACIES OF Lady Frieda Harris and Aleister Crowley could not be more different. Crowley's reputation as "The Wickedest Man in the World" followed him into the twenty-first century, and even as we write this, we have our own strong opinions about the man. His fans hail his writing as brilliant and his personal life as flawed—if you can call casual misogyny and antisemitism a "flaw"—but we all remember him as a man who bucked the system and created his own route to find his true path. "Do what thou wilt shall be the whole of the Law" has truly been his mark on society.

On the other hand, Lady Frieda's reputation has yet to be determined, as her vital role in the creation of Thoth Tarot still lies in obscurity. She has yet to receive her redemptive story arc the way Pamela Colman Smith has. But more and more, Lady Frieda is recognized and named as the soul of and the driving force behind Thoth Tarot.

If there was ever a person to embody the phrase "Nevertheless, she persisted," it would be Lady Frieda Harris.

TODAY, LADY FRIEDA'S tarot images are almost as instantly recognizable as Pamela Colman Smith's, and we find plenty of examples of Thoth in pop culture. It has popped up on the cover of the Blue Öyster Cult album *Agents of Fortune*, in the pages of numerous Marvel Comic Books, and in a variety of episodes of TV shows from *Matlock* to *Are You Afraid of the Dark?* Its most recent popular appearance was in the music video for K-pop group Cosmic Girls for their song "La La Love."

The legacy of Thoth Tarot itself is at a crossroads today, with old guards protecting Crowley's significant influence and newer generations who are leery about the ethically compromised man behind the deck. As we bring Lady Frieda more into the spotlight to take her proper credit, we find new opportunities for a critical piece of tarot history.

LEFT: Blue Oyster Cult album *Agents of Fortune* featuring Thoth Tarot cards
ABOVE: Thoth's The Universe

YOU MIGHT ALSO LIKE: THE URBAN TAROT

URBAN TAROT, created by illustrator Robin Scott, brings Thoth into a twenty-first century landscape full of the everyday life, grime, and magic of urban life. Including recognizable figures of New York life, from The Day Trader to The Environmental Activist, the inclusive Thoth-inspired deck uses modern imagery to propel Crowely's archetypes into the future.

LOVE

COMPLETION

ACE OF RODS

© 1970, 2016 U.S. Games

6

AQUARIAN

WHEN: 1968 ◼ **WHERE:** UNITED STATES ◼ **CREATED BY:** DAVID PALLADINI

IN THE MID-1960S, a hip, counterculture, nineteen-year-old art school student named David Palladini was an intern at a stodgy Chicago advertising firm where he was tasked with creating tarot art for large scale posters to show off a client's paper stock. Palladini had been born in Italy and watched family members play the tarocchi card game using cards in the style of Tarot de Marseille, but this was his first exposure to contemporary tarot or the Rider-Waite-Smith deck. He intuitively selected twelve cards based entirely on his reactions and interest in the names and painted his own versions of them.

WE DON'T KNOW IF the paper company liked his work, but a few months after the posters went up, Palladini was approached by Lloyd Morgan, owner of Morgan Press in the Hudson River Valley. The company had made their name producing beautiful and unique American art, and Morgan wanted to add a tarot deck to their catalog. It's unclear whether this was a personal interest on the publisher's part or a strategic move to capitalize on the spike of popular interest in tarot, as this was about the same time the Thoth Tarot deck was finally widely published. Either way, Morgan Press would go on to publish two of the most iconic tarot decks we have today.

In his memoir *Painting the Soul*, Palladini says that Morgan Press asked him to create the art for an entire deck and offered to pay him $100 per card. "I made the mistake most young artists make," Palladini remembers. "I shook his hand. To me, a man's handshake and his word were his bond. I still had much to learn."

Palladini created the cards, incorporating imagery inspired by the medieval stained glass of the church where he grew up, the art deco and art nouveau styles that were experiencing a revival in the late '60s, and his own interpretations. He sent the images off to Morgan Press and never heard back from them.

Disillusioned, Palladini turned his attention to other projects. He spent 1968 in Mexico City, photographing and creating promo images for the XIX Olympics (which today is best remembered for track stars John Carlos's and Tommie Smith's Black Power salutes on the medal podium). When he returned to New York City, Palladini was shocked to discover that Morgan Press had published his art in a new tarot deck, which they'd curiously named after a current pop culture phenomenon. The deck was surprisingly popular and widely available in bookstores across the country.

In fact, the Aquarian Tarot deck was such a hit that the next year, Stuart Kaplan—the legendary collector of tarot history, writer, and the founder of U.S. Games—bought the rights to the deck. One of the most prolific tarot deck publishers in the world, U.S. Games has printed and sold the Aquarian deck steadily ever since.

The record here is unclear, but Palladini may have never seen a dime from Morgan Press. However, he developed a long-lasting friendship with Kaplan and went on to publish other works with U.S. Games, for which we assume he was better compensated.

Palladini's deck had some astrological symbolism, which we'll look at in the following pages, but it had nothing to do with the Age of Aquarius, the iconic (and entirely inaccurate) phrase forever connected to the hippie movement of the 1960s and '70s. The name comes from a song in the 1967 play *Hair* that promised peace and love when the moon "in the seventh house" and Jupiter aligned with Mars. A 1969 recording of the song by the group 5th Dimension spent six weeks in the number one spot on the Billboard charts, and the phrase started showing up everywhere.

Of course, real astrologers will tell you that everything about the song is astrological nonsense. The moon enters the seventh house basically every other day, and astronomically speaking, Jupiter aligns with Mars for a month every two to three years. That means when Jupiter is in conjunction with Mars, the moon would also be in the seventh house fifteen times. In other words, it's nothing all that special, and there's no correlation between the '60s and '70s and the Earth beginning a transit into a new astrological age.

So now that we know what it's not, what's the actual story of the Age of Aquarius? It's not well-defined, and astrologers have suggested a variety of opinions about when the age will "dawn," from the 1400s to the 3500s.

Nevertheless, by 1969, the term "New Age" was commonly used to describe the spiritual and cultural shifts that happened during this time period, and tarot fit right into the vibe. Aquarians promoted themselves as a revolutionarily just and loving bunch, an idea bolstered by the cultural changes happening all around. The spring and summer of 1969 saw social justice efforts on a

ABOVE: LP album cover front of the original Broadway cast recording of the rock musical *Hair*

OPPOSITE PAGE: a poster designed for the Mexico Olympics by David Palladini.

national scale, not to mention the "Aquarian Exposition" we now call the Woodstock festival. Throw in the first moon landing, and it seemed like the young, countercultural, middle-class, white Americans had a reason to believe that the world would be better, wiser, and more in balance with time.

Palladini unintentionally captured all this in his tarot deck.

WHILE PALLADINI WAS NOT WELL-VERSED win the esoteric interpretations of tarot, he was a product of his generation and intrigued by images that came with spiritual connotations. After the tarot deck, he went on to paint an equally esoteric series of astrological sign posters that shared the same style of strikingly bold lines, deep colors, and a stained glass look.

Palladini's Libra poster is taken straight from the artwork he created for the Temperance card. A woman draped in peacock feathers is inserted into a frame that balances scales, a reference to the symbol Libra expresses.

While the posters are less widely known today than the Aquarian Tarot deck, they remain beautiful and fresh examples of the ways that Palladini crossed art deco, art nouveau, and the psychedelic posters so emblematic of his era.

ART DECO INFLUENCES

ART DECO DESIGN HAD EMERGED in France before World War I, and its influence expanded to include design elements found not only in fine art, but also furniture, architecture, posters, monuments, planes, trains, automobiles, and even normal everyday things like vacuum cleaners. It's probably the look you imagine when anyone mentions the roaring twenties or *The Great Gatsby*.

While we see art deco in everything from paintings to fashion, perhaps the easiest place to see the style is in the architecture of the early twentieth century, with design elements based on straight lines, perfectly formed patterns, and geometric shapes. Some of the most iconic buildings in New York City—including the Empire State Building, Radio City Music Hall, and Rockefeller Center—were created with art deco design elements.

Palladini's peers were drawn to art deco, taking the bold elements of what could have been a 1930s Parisian poster for absinthe and replacing it with a woman drinking coffee.

ABOVE: An example of an art deco-style advertisement poster

PAGE OF PENTACLES

THE PAGE OF PENTACLES is generally considered calm and serious in tarot, and the Aquarian deck stays true to that tradition. The feathers and the swooping, unbroken lines within the Page's cloak are very art deco, while the watercolor sky brings the ethereal nature of tarot back into the earthier page.

THE ACE OF CUPS ALSO feels particularly art deco. Typically, the Ace of Cups in tarot design shows a cup overflowing with water, displaying that joy and love are abundant in the scene.

However, in Aquarian Tarot, the rays of the sun, paired with the angular pattern on the cup, draw attention to the filled-with-emotion nature of the Ace of Cups. The source of these emotions isn't coming necessarily from within the cup, but is available in abundance from the world around it. The source of all these good things comes from the lotus-filled pond and the sun in the sky. This is also a card that's really easy to envision as a glorious stained glass window.

ART NOUVEAU INFLUENCES

WHAT MAKES PALLADINI'S WORK in his tarot deck stand out is the way he seems to effortlessly add art nouveau–inspired flourishes on the border and a contemporary, psychedelic script to center the work in his own era. The art nouveau style Palladini used in the Aquarian Tarot deck was nothing new. Since the late nineteenth century, artists had focused on long organic lines and often incorporated florals or botanicals to meld structural motifs like borders and edges with more naturalistic, asymmetrical, and eye-catching movement.

Art nouveau made a comeback in the 1960s, and by 1969, was popular with the creators of psychedelic art styles, who were drawn to the nouveau idea of art and beauty for the sake of art and beauty alone. Palladini's generation embraced freedom of movement and included playfulness and whimsy in their work, often as a direct contrast to their parents' more stoic aesthetic. Psychedelic concert posters done in art nouveau styles were all the rage.

With his background in commercial art and poster design, Palladini was able to capture the excitement and style that spoke to this energy. If you were a teenager in the 1960s, chances were you had a few favorite posters hanging on your walls. Bonnie MacLean and Wes Wilson were two of the most well-known psychedelic artists of the 1960s. Both artists were connected to the Fillmore, a historic venue in San Francisco that was the center of much of the 1960s counterculture. Wes Wilson was the primary promotional artist for the venue for most of the '60s, but when he had a falling out with the manager, Bill Graham, Graham's wife Bonnie MacLean took over the role.

Bonnie coincidentally worked at Pratt Institute in New York just a few years before David Palladini enrolled. That was where he had been a student crafting the Aquarian Tarot, seemingly without realizing that fellow tarot artist Pamela Colman Smith had also attended in her youth.

OPPOSITE PAGE: Fillmore Auditorium poster for Otis Rush, the Grateful Dead, and Canned Heat, by Wes Wilson, 1967

ABOVE: a Fillmore poster promoting appearances by the Yardbirds, The Doors, James Colton Blues Band, and Richie Havens, designed by Bonnie MacLean

THE ART OF THE CARDS

THE AQUARIAN TAROT DECK spoke to the twentieth century in a unique way that is easiest to see in the details of specific cards, which capture the shifting culture and emotions.

The Lovers card blends art nouveau and art deco in the swooping plumes of a peacock on the man's helmet, as well as the spiky feathers on the woman's headdress. Palladini plays with the extravagance of the duo, setting them against straight lines and geometric shapes. The strong lines of the man's cloak reflect the gentler, curved lines of the woman's hair, bringing the two figures into harmony with each other.

Palladini later acknowledged that he drew himself as the male figure in the image alongside an imagined woman who he portrayed as a confident and equal partner. They are close to one another, and for the first time in a tarot deck, they both have equal weight in the image.

WE SEE THE STAINED GLASS that inspired Palladini's vision for the deck most clearly in the Sun card. Each distinct line of its rays could be a pane of glass, and the overall richness of the colors creates warmth and vibrancy. Many times, tarot artwork for The Sun focuses on a baby riding a horse or include other human figures in the card that draw the eye. However, in Palladini's work, there is nothing to distract us from this invitation to bask in the joy and happiness of the scene.

While most images in Aquarian tarot align fairly closely with the Rider-Waite-Smith deck, Palladini broke tradition with the Star card. In modern tarot, The Star typically comes after The Tower, which represents the fiery destruction of long-standing belief systems and the desolation of everything normal in life. (Oh hello, sudden flashback to 2020!) Coming after this frightening archetype, The Star traditionally signifies hope, renewal, and a cleansing away of traumatic things experienced in the past. In Palladini's depiction, we find a gorgeous peacock with flowing plumage below an eight-pointed northern star, bringing a sense of peace, hope, majesty, and underlying mystery to the source of comfort.

Is there some deeper symbolism there? Probably not. We know Palladini painted these cards to be works of art, not to necessarily convey any esoteric meanings. From his later writings and interviews, we also know Palladini also never associated any deeper meaning to peacocks or feathers in his work, and so we can fairly confidently say that when we read these cards, we should look at what we normally associate with peacocks: pride, majesty, and being obnoxiously loud. Or we could decide that Palladini really enjoyed drawing peacock feathers.

TRADITIONALLY IN TAROT ARTWORK, the figure of Temperance is a grand angel passing water between two cups. In Palladini's artwork, Temperance is still a bold angelic figure, but there's no sign of an alchemical mixing process. Instead, Temperance stands still and confidently looks into the distance. The reds, browns, and intricate feather detailing of the Temperance card shows the strength and control the traditional meaning of the card has.

This card is a good example of the psychedelic poster tendency of dainty facial depictions paired with striking, colorful surroundings.

XVIII

THE MOON IS ONE of the most vibrantly colored cards in the Aquarian deck. Palladini again spins his own artistic vision on tarot, moving away from the images that often show up on these cards. There are no wolves, wayward lobsters climbing from a lake, or two towers surrounding the moon, with the esoteric meanings of uncertainty, insecurity, and a time of wandering in the dark.

Palladini chose instead to focus this card entirely on the negative space created by the crescent moon. Much like Aquarian Tarot's The Sun, the glow is the focus of the card. To Palladini, the Moon is a close friend, confidant, and guide, and it's certainly being anthropomorphized as stable, wise, and thoughtful.

SEVEN of CUPS

© 1970, 2016 U.S. Games

THIS SEVEN OF CUPS in Aquarian Tarot is a card about choice, now brought to the space age. Each of the four elements is found here, but we also see unexpected additions of technology in the space helmet, as well as humankind in the face within the cup.

THE LEGACY OF AQUARIAN TAROT

DAVID PALLADINI WAS YOUNG and unknown when the Aquarian Tarot came out. Over the next fifty years, he established himself as a celebrated illustrator with dozens of credits to his name, including the movie poster for the 1979 Werner Herzog movie *Nosferatu the Vampyre*. We can see here the ways his art matured over time.

More than twenty-five years after the Aquarian Tarot, Palladini created another tarot deck called The New Palladini, also published by U.S. Games. We can only assume there was a much more normal contract in place for this deck than Palladini had experienced with the first printing of his first deck. Here again we see the maturation of the artist with images incorporating influences from all over the world.

YOU MIGHT ALSO LIKE: MUCHA TAROT

MUCHA TAROT, LIKE AQUARIAN, relies heavily on art nouveau styles. Mucha Tarot's art is legendary, drawn completely in the style of Alfonse Mucha, but it also feels like a fresh take on the Rider-Waite-Smith standard.

THE HISTORY OF TAROT ART

ETHEREAL VISIONS is a completely unique art nouveau take on the Aquarian and Rider-Waite-Smith formats, created by artist Matt Hughes. This deck pairs soft colors with illuminated gold highlighting to stunning effect.

MORGAN-GREER

WHEN: 1979 **WHERE:** UNITED STATES

CREATED BY: LLOYD MORGAN AND BILL GREER

HE FIRST COPY OF MORGAN-GREER TAROT that I (Esther) ever laid eyes on was battered, torn, and well-loved by a tarot reader in Union Square, New York City. The bold white stars on the cornflower blue backs of the cards immediately transported me to a time when things were groovy, far out, and mellow. The art on each card felt simultaneously vintage and modern, transcending my ability to visually date the deck, which added to its charm.

While Morgan-Greer Tarot wasn't published until 1979, the style harks back to the late 1960s and early 1970s, a time of anti-war hippies and countercultural movements. It's full of emerging spiritual themes and even vaguely famous people from pop culture and was one of the first decks to combine Rider-Waite-Smith imagery with contemporary entertainment figures and symbols. While this could be considered a "clone" of the Rider-Waite-Smith in that many of the cards follow the older deck's meanings exactly, the art style stands on its own as a cultural cornerstone for the way it influenced future tarot decks.

THE ORIGINS OF MORGAN-GREER TAROT

MORGAN PRESS, the same publishing company that commissioned and produced Aquarian Tarot the decade prior before selling the rights to another company, wanted a new tarot deck in their lineup. Artistically, they wanted a "refreshed" Rider-Waite-Smith deck, as Bill Greer described it, since one had not been attempted in many years. But a new deck also needed something fresh, different from the Aquarian Tarot.

The publishers decided their project would be based on the classic writings of Arthur Waite, but also on the lesser-known tarot approach of esoteric writer Paul Foster Case, one of the leading American occultists in the early twentieth century. Case argued that the colors, symbols, and numbers in the Rider-Waite-Smith deck weren't as accurate to their esoteric associations as they could have been. We're talking about some very nuanced differences here. Since Case used colors to represent tonal sounds associated with Hebrew letters, some of the issues he took with color associations of the Golden Dawn (and therefore Rider-Waite-Smith) were things like using pale blue versus deep blue, or a blue-green versus green-blue.

The cohead of the publishing company, Lloyd Morgan himself, took on the role of project manager for this deck, even writing the little white book that was by then becoming the common name for the small informational books enclosed with tarot decks. Morgan didn't include all of Case's opinions, but he did want the art of the new deck to be squarely in line with Case's thoughts about color tones and associations.

Morgan approached illustrator Bill Greer, and the two agreed to create a new deck that would carry both of their names.

Greer didn't have much experience with tarot, although he'd illustrated tarot images for the super groovy pop culture magazine *EYE* in 1968. While not many records of

their conversations or negotiations survive, we did find correspondence from Bill Greer to various fans stored in the recesses of the Wayback Machine archives, in which he says he was already friends with Lloyd and Doug Morgan, the two brothers at the helm of Morgan Press, and that he created the artwork for the Morgan-Greer Tarot as a favor for their fledgling publishing house.

It is nearly impossible to find information about the process by which the deck was created, but we do know Bill Greer went to an unspecified remote countryside (presumably in New York near where Morgan Press was located) with just colored pencils and Case's book to complete the project without any distractions. He recalled:

"In this deck, the Case book was used as a primer. There are certain colors used as dictated by Case for symbolic reasons. I sought to incorporate these colors and elaborate, so as to create an immediate emotional reaction to each card even before an image could be looked at in depth."

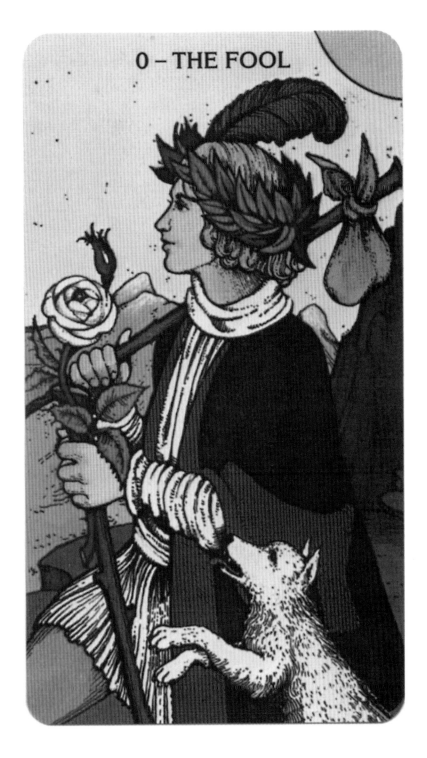

He emerged an unspecified time later with the images that we now see as iconic Morgan-Greer Tarot. (That's it. That's all we know. It's actually wild to consider how little information there is about the creative process of such an important, modern deck to the tarot community.)

The first thing we see in the cards when we pick them up is that they're not just bright, they're saturated and vibrant with color—stark contrasts to the muted tones from the other popular tarot decks at the time. We're transfixed by the blues, yellows, greens, and purples. This was intentional. Greer put everything into getting the colors described by Case just right.

For The Fool, for example, Case mentioned pale yellow, so compared to the other cards that have yellow as a primary color, Greer painted the Fool lighter and gentler, carrying forward the impression that this is the initiation card and everything is new and fresh. In contrast, Case described The World as blue-violet. The blue Greer used on this card is unique from other blues in the deck, signifying the maturation the blue has reached, now ready to progress to the next color, purple.

We see all of this despite the fact that according to Greer, we're only seeing a fraction of his colors. He later said that the colors in his original paintings for each card were even more vibrant and nuanced, but Morgan Press scanned them in a process called four-color separation and not the more detailed, but more expensive, six-color separation that he wanted.

ABOVE: Morgan-Greer's The Fool

OPPOSITE PAGE: *The Tarot, a Key to the Wisdom of the Ages* by Paul Foster Case

ANOTHER WAY LLOYD MORGAN made the art of his second deck cutting edge was his decision to print cards without borders. Up until this point, most popular tarot decks framed their art with borders of varying sizes. Although these borders made the printing process easier by providing a buffer when cards were cut, they also visually created distance between the illustration and the viewer.

By removing the card borders, tarot card users can experience Bill Greer's up close and personal style of painting figures almost as portraits and personally engage with scenes in ways they hadn't before.

Take a look at the cards on this page. The images put you right in the middle of Greer's action. Now contrast this to the other popular tarot decks that we've looked at. Morgan-Greer Tarot is the first to bring you face-to-face with powerful symbols and imagery to the point where you feel included in what's happening in the scene, making the choice between taking action or walking away.

ABOVE: Two of Swords (left) and the Ten of Cups

OPPOSITE PAGE: Morgan-Greer's The Star

THE HISTORY OF TAROT ART

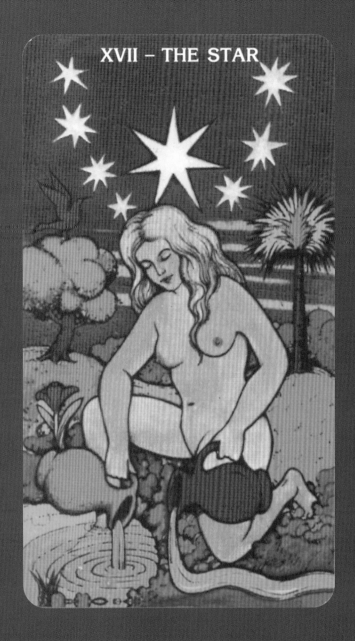

XVII – THE STAR

A THIRD THING YOU MIGHT NOTICE ABOUT THIS DECK is that while it has a modern, pop culture feel, the visual settings Morgan and Greer chose to depict predate their surroundings. This is supposed to be a deck to bring tarot to the 1970s, but there's not one midi skirt or polyester leisure suit in sight (thankfully). Instead, the vibe is very 1960s-Woodstock nostalgia, albeit with a pop culture '70s flair.

To understand why, we need to remember that the 1970s in the United States was a decade filled with political chaos and uncertainty. When Lloyd and Greer set out, people were still trying to regain some sense of normalcy after President Nixon's impeachment and resignation, the end of the Vietnam War, and the cultural conflicts flaring up around civil rights movements. The counterculture movement largely collapsed in the early '70s when their political goals were met and mainstream society capitalized on the movements, making "counterculture" part of mainstream culture.

Knowing all this, we see the art of Morgan-Greer tarot as an escape to an alternate time, when the successful countercultures of the 1960s thrived and people were promised peace, free love, and unity.

AT THE SAME TIME, BILL GREER'S art reflects the success and progress of his generation, going as far as changing some of the white figures in Rider-Waite-Smith art to people of color.

One of the most recognizable images in the Morgan-Greer deck is the Nine of Pentacles, in which a Black woman is surrounded by luscious shades of royal purple with symbols of wealth and abundance all around her. This is one of the first, if not *the* first positive depiction we've been able to identify of a person of color in a tarot card. It apparently took seventy years for a white tarot creator to remember Black people existed.

And this isn't just any person of color thrown onto a card like in some decks (that we're not naming) published later that awkwardly put people of color as the sphinxes pulling the chariot in the Chariot card. Greer painted a Black woman living a life of luxury, satisfaction, contentment, and financial accomplishment. We haven't found any record of what the larger tarot community's reaction was, but considering how ubiquitous the deck became, we'd like to think the increase in diversity was received well from the beginning.

There are other people of color in the Morgan-Greer deck, though their cultural backgrounds are more ambiguous. However, taken together, their presence is obvious as you flip through the deck.

WE CONTINUE TO SEE this distinctive modern feel in the Morgan-Greer Death card. A solitary Grim Reaper cloaked in black stands in front of what looks like a river. That river reflects the color of the rising sun, so vibrant that it also could be a river of blood. The Reaper stands in the middle of the frame, holding a scythe with a large white rose.

Some have commented that the Grim Reaper's cloak looks similar to a priest's collar, although there's no evidence that either Morgan or Greer intentionally meant to depict a priest, and the collar itself is yellow on black, not white on black. On the other hand, the white rose was a deliberate choice based on Case's writings, referring to the white rose in The Fool that symbolizes life and growth. It seems the overall message is that death is not an ending, but a continuance of what has already been started.

OPPOSITE PAGE: The Nine of Pentacles

RIGHT: Morgan-Greer's Death

XIX – THE SUN

ANOTHER CARD that Greer gave a significant face-lift was The Sun. The traditional Sun card in tarot depicts a naked baby victoriously riding a horse in front of a wall, with the face of the Sun at high noon illuminating the entire scene. As we saw in the last chapter, Aquarian Tarot eliminated the figures altogether and focused on the sun.

Greer mixes things up further, noting that in Case's depiction of the cards, The Sun included two individuals. Greer decided that these were young adults, not children, and painted them in close-up profiles, facing each other with giant sunflowers surrounding them. The sun remains the dominant symbol, a giant glowing orb of orange front and center. As a card meaning joy and abundance, the two youthful and attractive figures basking in the sun together is reminiscent of photos taken at Woodstock—where couples stood face-to-face in the New York sun, glowing with peace, love, and music.

LEFT: Morgan-Greer's The Sun

OPPOSITE: 19th-century depiction of a Sabbatical Goat by Èliphas Lèvi, 1856 (left) and Morgan Greer's The Devil

THE HISTORY OF TAROT ART

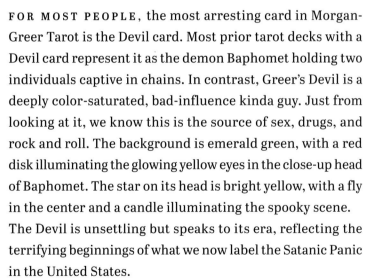

FOR MOST PEOPLE, the most arresting card in Morgan-Greer Tarot is the Devil card. Most prior tarot decks with a Devil card represent it as the demon Baphomet holding two individuals captive in chains. In contrast, Greer's Devil is a deeply color-saturated, bad-influence kinda guy. Just from looking at it, we know this is the source of sex, drugs, and rock and roll. The background is emerald green, with a red disk illuminating the glowing yellow eyes in the close-up head of Baphomet. The star on its head is bright yellow, with a fly in the center and a candle illuminating the spooky scene. The Devil is unsettling but speaks to its era, reflecting the terrifying beginnings of what we now label the Satanic Panic in the United States.

The figure of the Devil showed up all over the media during the late 1960s and through the 1970s, starting with the 1968 movie *Rosemary's Baby.* In the film, Mia Farrow's character, Rosemary, believes the father of her child is the Devil. The movie's commercial success influenced an explosion of other devil-related movies like *The Exorcist* in 1973 and *The Omen* in 1978.

The movies played against a backdrop of real life. In the early 1970s, the Bible verse– and Beatles lyrics–spewing cult leader Charles Mason incited his followers to carry out the brutal Tate–La Bianca murders in California. The real-life tragedy drew public attention through a book, and later a made-for-TV movie called *Helter Skelter.* Neither Manson nor his followers claimed to be satanically influenced, and in fact, they testified that the murders were intended to instigate a race war, but somehow the "Satanist" label attached itself to the story.

Bill Greer's Devil card spoke to that of-the-moment fear, with its pentagram cloaked in bright yellow and carved into the head of Baphomet. The Morgan-Greer tarot was willing to bring the viewer face-to-face with the contemporary belief in a pervasive Satanic influence and a "spiritual war" against an unseen force.

VINTAGE TAROT BATTLE ROYALE

WE KNOW MORGAN PRESS had a lot of success with Aquarian Tarot, so it's not surprising to note that while there are plenty of differences, there are obvious similarities between a few cards in each deck. Both have that more zoomed-in focus on the scenes and faces of characters on the cards, with a similar structure with some of the inanimate objects. The most obvious, and eerily similar, comparisons are between the Nine of Cups and the Page of Cups.

In each Nine of Cups, you see almost the exact same perspective of two men wearing almost identical hats, have the same facial expression, and even look remarkably similar. Both Pages in the Page of Cups glance at a blue fish jumping out of a gold cup, with tulips and plumed hats. There's a general similarity of traits between these images and the Rider-Waite-Smith images, but what's noteworthy is how much Morgan Press's two decks look alike. We're willing to make the short jump to think that Bill Greer had images, or even a full copy, of the Aquarian deck to refer to during his time in the countryside either as reference guides or inspirational examples.

Today, many people who purchase both decks end up on either "Team Palladini" or "Team Greer," ready for long debates about which vintage deck reigns supreme. (Holly is Team Palladini, and Esther is Team Greer.)

 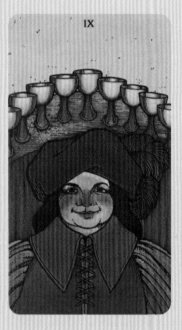

ABOVE, LEFT TO RIGHT: Aquarian's Nine of Cups, Morgan-Greer's Nine of Cups,
Aquarian's Page of Cups, and Morgan-Greer's Page of Cups

POP CULTURE ICONS

AS WE MENTIONED AT THE BEGINNING, the most immediately obvious thing about Morgan-Greer Tarot is that it pictures specific figures we think we recognize from pop culture.

Sure, Pamela Colman Smith used close friends as models for some figures in her Minor Arcana, but none of them were so well-known that people outside her social circle would recognize them . . . and we certainly don't now. Greer, on the other hand, included portraits of people who look strikingly similar to people who were so famous, we still know them today.

Greer never said whether the similarities were intentional or not, but it's fun to imagine that in a closed cabin, away from everyone, all Bill Greer had was art supplies, Case's book, a copy of Aquarian Tarot, and a small television where he would escape nightly to watch *Charlie's Angels*, *The Sonny & Cher Show*, and a rerun of one of Raquel Welch's many movies, all while listening to Fleetwood Mac's newest release "Rumors" and falling in love with Stevie Nicks.

ABOVE: To us, it seems like Farrah Fawcett, Kate Jackson, and Jaclyn Smith of *Charlie's Angels* were inspiration for the Three of Cups

SONNY BONO

THE MUSTACHE! THE NECKLINE! This Magician could be any number of 1970s men, but he screams Sonny Bono to us, and Sonny Bono works great for the meaning of the card. After all, as a songwriter, he created music for himself and for others, including Sam Cooke and obviously Cher. Sonny also created iconic television through the two comedy review shows he starred in with Cher—*The Sonny and Cher Comedy Hour* and *The Sonny and Cher Show*.

Sonny was a man able to use the tools he had to create something with nothing except talent and will, and he became incredibly powerful, which are the same traits The Magician symbolizes.

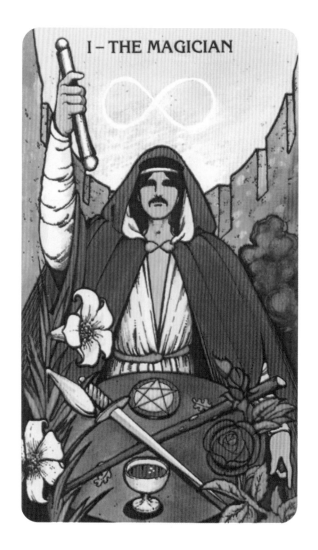

THIS PAGE: Sonny Bono is a dead ringer for The Magician

OPPOSITE PAGE: The steamy depiction of The Lovers in Morgan-Greer reminds us of the beautiful Raquel Welch.

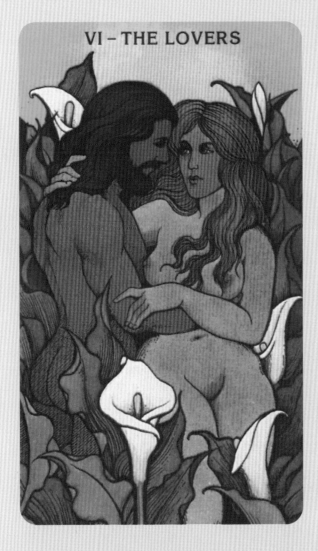

VI – THE LOVERS

THE LOVERS

EVEN IF THIS CARD doesn't specifically reference the famous bombshell, man, is it a wildly sexy Lovers card. When we look at this, the Lovers card's traditional meaning of choice and commitment seems less important than the alternate meaning of just full-blown Lovering.

From a cultural perspective, this card is a testament to how much the country had lightened up about nudity and bodies throughout the '70s. The white lilies, which symbolize purity, aren't fooling anyone. This is a steamy relationship with an alarmingly Jesus-looking dude, but it was the '70s, so maybe that was just the way things were.

STEVIE NICKS

THE EMPRESS IN TAROT symbolizes fertility and creation, and often those meanings are conveyed by a very pregnant female figure. In Morgan-Greer, the idea of creating something to send out into the world and share with others seems to be symbolic more than literal, because this Empress is definitely not pregnant.

We think she looks like Stevie Nicks, who made a name for herself as a songwriter (creator!) and singer with the 1977 release of Fleetwood Mac's *Rumours*.

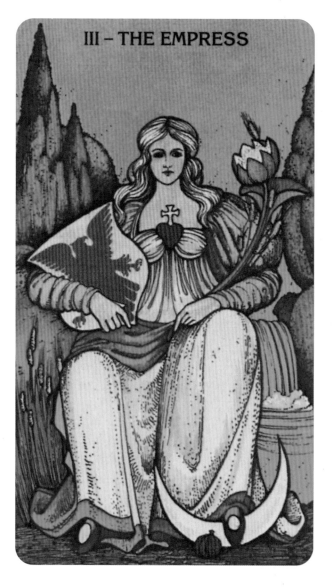

LEFT: Singer-songwriter Stevie Nicks is a possible contender for The Empress

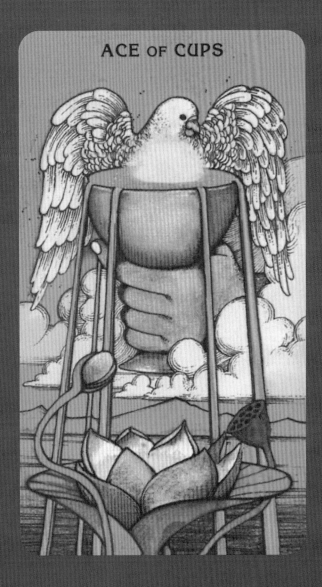

JUST AS THEY DID WITH AQUARIAN TAROT, after Morgan and Greer did the work to create something new, the major game distributor U.S. Games swooped in and purchased the rights to distribute it not long after it was published. The good news for us is that they've kept it continuously in print ever since then.

When we pick up this deck, we can immediately connect with it as being from a very particular time and place, and that's part of what makes it both unique and long-lasting. Plenty of tarot readers yearn for the nostalgia of a more freely esoteric time, so the warmth of a "flower child" perspective paired with its comfortable similarity to the universal favorite Rider-Waite-Smith deck makes it incredibly appealing to new readers.

YOU MIGHT ALSO LIKE: LIGHT SEERS TAROT

LIGHT SEERS TAROT BY CHRIS-ANNE is a bohemian and intuitively inspired deck that takes the archetypes and symbols in tarot and reimagines them in an inclusive and contemporary artistic style. Like Morgan-Greer Tarot, many of the scenes and faces are up close and personal, inviting the viewer into the scene to experience the artwork like never before.

YOU MIGHT ALSO LIKE: HAUNTED HOUSE TAROT

HAUNTED HOUSE TAROT BY SASHA GRAHAM is a spooky, atmospheric deck that narratively follows The Heroine (The Fool) through a haunted house with archetypes from Gothic romance novels and vintage horror movies.

XI

Strength

© 1981, 2016 by Motherpeace

MOTHERPEACE

WHEN: 1981　**WHERE:** UNITED STATES

CREATED BY: KAREN VOGEL AND VICKI NOBLE

FTER A SELF-DESCRIBED "life-changing vision," independent feminist researchers and spiritual seekers Karen Vogel and Vicki Noble set out in 1978 to create what they called "the first feminist tarot deck."

The two women had lived together in Colorado, and eventually their travels led them to Berkeley, California, where they researched goddess religions and oracular activities in prehistoric and early world history. After Noble reported that Vogel received a transmission of ancient wisdom, the two started drawing new interpretations of the seventy-eight cards.

They wanted to create a deck that broke through the masculine, traditional tarot deck archetypes of emperors, kings, and popes and focus instead on the times when women were in charge of community, spiritual healing, and ritual outside their immediate family. To that end, they drew oracles, sages, and wise women from all time periods and geographic areas. The court cards, which normally show the King, Queen, Knight, and Page, were renamed Shaman, Priestess, Daughter, and Son to emphasize the spiritual power of the head of household.

USING THEIR EXPERIENCE in social sciences and biology, their passion for life, and their deep spiritual curiosity, Vogel and Noble were able to synthesize a vast collection of historical information, psychic understandings, and occultist studies. Dividing the deck between them, they drew and finalized all seventy-eight images within a year. Vogel then wrote the guidebook, as she saw herself as a conduit for what the images wanted to say. They released Motherpeace Tarot in 1981.

The Motherpeace artwork is entirely original, not based on the style or images of any other popular tarot deck. Even the round shape of the cards is a departure from the traditional physical structure we've come to associate with cards. It gives the deck and art a certain softness especially unusual for that time, separating it from a sea of tarot decks with the sharp edges of squares or rectangles. These precise edges could imply strong masculine archetypes, while soft, circular cards with no corners imply goddess energy at play with the deck.

The circular shape also offers a unique way to read the cards based on orientation. If the image leans a certain way, it can be seen as passive or slow energy, while tilted another way could be read as a high, accelerated energy or aggressiveness.

This is the first deck we've included in this book that not only has a "divine inspiration" backstory, but also represents another trend that emerged in the early 1980s of tarot art increasingly created by tarot practitioners rather than printing companies or publishers interested in increasing their bottom line by marketing to the esoteric world.

XVII

Star

LOOKING AT THE MOTHERPEACE CARDS through our modern lens that tries to avoid appropriating non-mainstream spiritual practices, we see some obvious issues. Focusing on historic and prehistoric women meant that many of the initiation rites and magical activities drawn by Vogel and Noble depict religious and spiritual practices of Black and Indigenous groups that aren't open for the general population's participation. That's not okay.

However, forty years ago, when this deck was created as an expression of second-wave feminism, focusing attention on any pre-Christian and prepatriarchal religion was new and mostly unexplored. The vibrant community of second-wave feminist authors, artists, and seekers clearly shaped Vogel and Noble.

Motherpeace Tarot emerged about the same time as the non-centralized Goddess Movement that exploded in the 1970s

and introduced a whole new generation to the tradition of worshipping some variation of the Great Mother Goddess. One instrumental leader of the movement was Carol Patrice Christ (the irony of that surname is not lost on us), who wrote a widely distributed article called "Why Women Need the Goddess" and was the keynote speaker of the Great Goddess Re-emerging conference held at University of California Santa Cruz in 1978. We don't know whether Vogel or Noble were influenced by Christ's teachings (Carol Patrice, not Jesus), but it would be hard to have been a feminist in California at the time and not be familiar with her.

One of the ways that feminists in the 1970s and '80s sought to be heard was through "infiltrating" the mainstream art world through pieces like *Some Living American Women Artists*, created in 1972 by Mary Beth Edelson. The poster mashup took Leonardo da Vinci's famous painting *The Last Supper* and replaced the faces of the men with famous female artists, including Alma Thomas, Yoko Ono, and Georgia O'Keefe. Edelson's work included eighty-two women and shed light on the working American women who were generally ignored and left out of the art world discourse.

Second-wave feminism also sought to create women-exclusive spaces for creation and community. An extensive and passionate network of feminist bookstores emerged in the '60s and '70s, distributing feminist journals like *WomenSpirit*, produced by Ruth and Jean Wintergrove, artists and organizers of a feminist farm and retreat in Southern Oregon.

A specific trend in second-wave feminist art that carried over to the Motherpeace deck was the use of natural and earthy materials to emphasize timelessness and connection to the organic world. Works like Zarina's cast paper, called *I Whispered to the Earth,* evokes the memories and secrets shared between the artist and Mother Earth. It seems clear to us today as we study their art that Vogel and Noble must have been deeply influenced by this idea that women share a particularly true and pure affinity with the planet, a through line of this type of art and the Goddess Movement.

ABOVE: The Venus of Willendorf

OPPOSITE PAGE: *The Dinner Party* by Judy Chicago, now permanently housed in the Elizabeth A. Sackler Center for Feminist Art at the Brooklyn Museum.

FEMINIST INSPIRED ART

JUDY CHICAGO WAS PERHAPS one of the most iconic feminist artists of second-wave feminism, and the cofounder of the California Institute of the Arts's Feminist Art Program. Her most famous giant installation, *The Dinner Party,* can be seen as a complementary piece to Motherpeace Tarot, revealing the culturally important themes that Karen Vogel and Vicki Noble brought into their art.

In her book *Motherpeace: A Way to the Goddess Through Myth, Art, and Tarot,* Noble points to *The Dinner Party* as a timeline tracing women, and especially Goddess culture, from its prehistoric roots to the modern era. There are thirty-nine seats at Chicago's triangular table—triangles, along with circles, are often used to represent feminine motifs—and each represents a specific woman. An additional 999 names of other figures are hand-inscribed along the white tiles beneath the table.

The painted ceramics and textiles of the work, both seen as feminine crafts, were immersive. In the first three months it was on display, 100,000 people visited the piece and walked around the table. Some, like Vicki Noble, were perhaps inspired by the combination of real and mythological women depicted, but others saw it as unfocused and even too moralistic. Each place setting included imagery of female sex organs (there are lots of vulvas involved with this piece), and that brought critics claiming it was pornographic content and others decrying the shock value in the name of "education"—all of which is to say, the effort to bring spirituality to the feminist world wasn't universally welcomed.

Noble, though, loved the work, and we see some of its same feminist themes in Motherpeace Tarot's Eight of Disks, which also draws attention to the traditionally female crafts and the value of perfecting them. The women portrayed on the card are performing some of the same ceramics and textile art forms that we see in *The Dinner Party.*

The Eight of Pentacles is also about repetitive perfection of a task like weaving, both utilitarian and also beautiful, to emphasize the importance of "women's work."

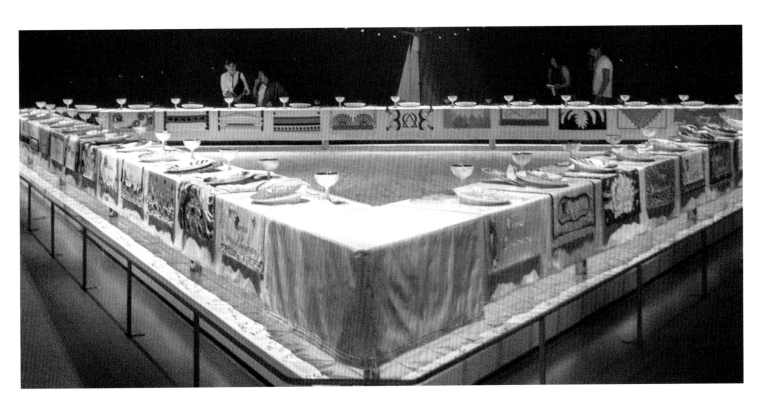

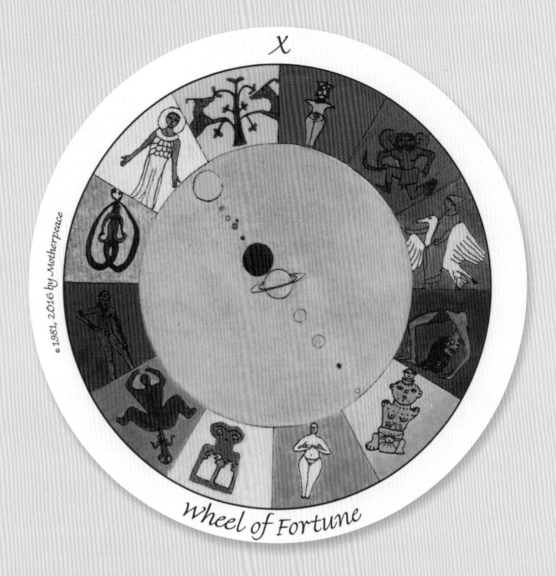

X

©1984, 2016 by Motherpeace

Wheel of Fortune

IN MOTHERPEACE TAROT, the Wheel of Fortune card depicts the solar system, surrounded by twelve images of various iterations of the mother goddess. This is an interesting depiction that caught our attention, because in earlier tarot decks we see a physical wheel turned by or near either fates or actual people. Motherpeace, on the other hand, shifts the card to focus on the impact of the whole universe, and therefore the influence of the goddesses.

The twelve images on this card align with the twelve zodiac signs, starting at the eleven o'clock position with Aries, represented by a copper figure that was an archaeological discovery in India and was dated from 2400–2000 BCE. Each subsequent house is represented by pre-Columbian figures, Stone Age Syrian figures, and figures from all over the ancient world (Egypt, Mesopotamia, Greece), before getting to Pisces, represented by a fish goddess.

XV

Devil

THE DEVIL CARD IN MOTHERPEACE, according to Vogel and Noble, represents repression and lack of control—the Patriarchy writ large in place of a more Christian morality Devil figure. The art depicts levels of conflict in a pyramid shape. At the top is a "Big Man" archetype figure, surrounded by the numbers of a clock to emphasize the timeliness of that power structure. Below the Big Man are chained people, literally buying into or defending the structure. Problematically for us, all of the figures paying into the structure seem to be people of color, including a mother giving her child to the chain of command, while a white woman is shown as having broken her chain to escape, though she is attacked.

The message about the subjugation of women and people of color continues up the tiers of the pyramid, with the second tier representing war and the third representing peace. "Peace" depicted as brown bodies serving white bodies seems gross and inappropriate, but Vogel explains that her intention was to point out that these are the injustices, even during peaceful times, that women and people of color are subjected to.

XX

Judgement

© 1981, 2016 by Motherpeace

THE CORE IDEA BEHIND THE JUDGEMENT card in tarot is a return of healing and regeneration. In traditional Rider-Waite-Smith imagery, this is represented as the Judgement Day described in the Book of Revelation in the Bible.

In Motherpeace, where biblical references are intentionally weeded out, Vogel and Noble depict an Egyptian ankh to represent love and peace. The ankh is a letter in the ancient Egyptian hieroglyph alphabet that, when used in conjunction with other glyphs, has the general meaning of "life." Typically in spiritual circles, the ankh has taken on the meaning of the "key of life." Egyptians believed that life was a force tied to all living things and that we were all interconnected. The ankh in this card is projecting a healing rainbow onto the planet, reconnecting all life back together in harmony.

XXI

world

MOTHERPEACE HERSELF, the Great Mother, takes center stage in the World card. The people around her represent all people in the world—nude, of course, to show the lack of patriarchal class structure.

There is also a floral swag of botanicals used for ritual healing and symbolizing welcome and celebration, including calendula and peyote. The World card traditionally represents unity, celebration, healing, and bliss, and Motherpeace offers a fresh perspective of the time with a goddess bend.

TRADITIONALLY, THE FOUR OF SWORDS represents rest and a respite from the chaos of the world. In the Motherpeace depiction, we see a woman sitting in a pyramid anchored by four swords. She is meditating with the seven chakras aligned with her back.

These chakras appear on several of the Motherpeace cards because Vogel and Noble had a deep interest in New Age ideas of holistic healing, in which chakra work holds a lot of space.

MODERN CULTURAL IMPACT

MANY WOMEN IN 1981 were excited about the publication of the self-identified "first feminist deck." It was an exciting change of pace from the still-patriarchal world that seemed determined to force them into certain societal ideals. It's so easy to forget from our 2020s perspective that women in the 1970s weren't consistently allowed to open credit cards without approval from the men in their lives (huge thanks to Ruth Bader Ginsburg and all her legal work to ensure women had equal rights).

When we dug into discussions and commentaries surrounding this deck, we found lots of testimonies of women entering a (usually said in hushed tones) feminist bookstore and finding Motherpeace tarot as a balm for their souls, connecting with them and revealing things that traditional tarot decks had not been able to do.

At the same time, Motherpeace Tarot is not without its controversies.

During the initial release, and to some extent to this day, there is a counterreaction to this deck, many times from men, that is viscerally resistant to the cards' depictions of male figures. Along with other similar "feminist" decks that followed it, Motherpeace is criticized for not taking men seriously, being created by "man-haters," and disrespecting masculinity—for example, by having the Shaman of Wands wear a skirt (as though kilts and other skirt-like traditional outfits aren't a thing). These types of comments are so cliche that they're almost comical. They seem to come mostly from men whose ideas of manliness are threatened by depictions of anything other than power, strength, and patriarchy.

Noble, who wrote the Motherpeace guidebook, introduces the deck by saying that it is primarily about healing the planet and ourselves. She reasons that the patriarchy did not bring peace, and so to bring peace, there needs to be an embrace of the Great Mother, the source of matriarchal consciousness. That is why Motherpeace tarot focuses primarily on the goddess archetype and her influence on the world.

This effort to emphasize the global, prehistoric Great Mother idea has led to some other controversy today, particularly through the lens of intersectional feminism.

Intersectional feminism, if this is a new term for you, was described by American legal scholar Kimberlé Crenshaw as "a prism for seeing the way in which various forms of inequality often operate together and exacerbate each other." In other words, the concept that feminism does not exist in a bubble and has to include societal layers like race, gender, sexual identity, age, socioeconomic status, religion, ethnicity, and a variety of other identifiers.

Motherpeace was created with a very specific feminist point of view, and while the authors did include people of color in at least half of the cards, critics today will argue that two white feminist creators did not have to right to use depictions of cultural heritage they weren't invited into to further their point of the universal experience of Goddess worship. The artwork and the creators' viewpoints crossed over into appropriation of these cultures without proper understanding and acknowledgment of what these things truly represent to those Indigenous groups.

This modern-day accountability shows that sometimes what we intend as healing is not necessarily the impact for all viewers of our artwork and can be hurtful to others.

9

Swords

IN TAROT, THE NINE OF SWORDS depicts anxiety, sleeplessness, and fear, and we can see the triggers for this restless woman's sleeplessness on Noble and Vogel's card. Yes, there are snakes and monsters and spiders, but there's also a manifestation of a man with a sword and even a figure that appears to be a lady centaur wielding a bow and arrow.

The man with the sword is an obvious stand-in for patriarchal structures, but what about the strong centaur? Perhaps it's meant to symbolize the strength of women, but also how a woman coming into her own personal power can cause anxiety. Noble and Vogel believed that connecting to these prehistoric and prepatriarchy women by communing with the Great Mother would give practitioners the strength to not only fight against the things holding them back, but also to be their truly strong and "scary" selves.

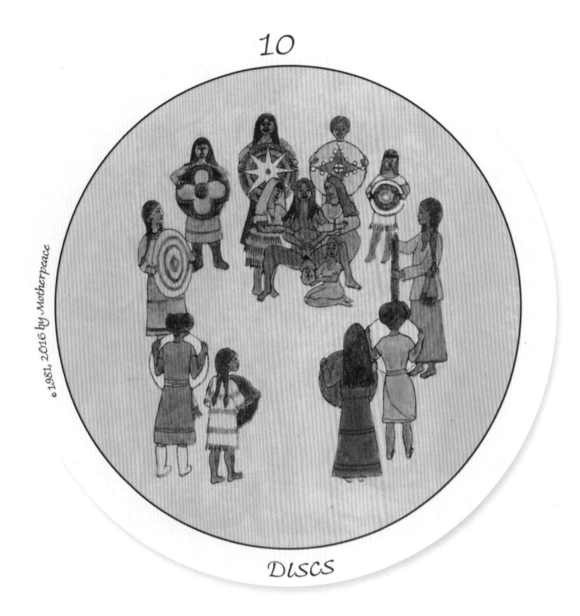

A lot of modern criticism of second-wave feminism points out how "womb-focused" the movement (and particularly its spiritual side) was. The Ten of Disks card is a great example of that, because childbirth is the center of the action.

The Ten of Disks in tarot represents legacy, tradition, and established structures of success being realized. In the context of the Motherpeace deck and second-wave feminism, it would of course depict a birth and a celebration of fertility. We also see that the people surrounding the family giving birth are all presenting the feminine crafts that have been depicted throughout the deck—weavings, ceramics, and other things to honor the sacred moment.

OTHER EARLY FEMINIST DECKS

THE SECOND WAVE OF FEMINISM led to several new tarot decks beyond Motherpeace that also celebrated the feminine. Daughters of the Moon was created simultaneously but independently from Motherpeace by a Welsh spiritual practitioner named Fiona Morgan. There are clear similarities between the decks, most notably their round shape, but Daughters of the Moon takes the feminization of tarot even further by not depicting even a single male body in some iterations.

Morgan also renamed the court cards to be a Maiden, Mother, and Crone, which emphasizes the idea that this deck is for use by neo-pagans and goddess worshippers. She made several changes to the Major Arcana cards to align more closely with her understanding of the spirituality she wanted to convey.

From an artistic perspective, Daughters of the Moon has bolder and more vivid colors, using more imagery of powerful witches than the earthy tribal aesthetic of Motherpeace.

The deck was published initially in 1984 and has released several editions since, including some that abandoned the circular shape of the original cards.

THEA'S TAROT, CREATED BY RUTH WEST between 1980 and 1984, is a harder-to-find early feminist deck. It has largely been out of print since its creation, with only occasional releases happening seemingly at random, making it highly sought after by collectors.

After graduating from college in the late '70s, West found herself surrounded by the feminist arts movement, where women-run artist centers and publishing houses produced and published objects outside of normal heterosexist contexts. This greatly impacted the landscape at the time for the publishing of lesbian and feminist art, poetry—and yes, tarot decks.

The Thea deck was inspired by a 1977 pamphlet called *A New Woman's Tarot* by Billie Potts, which rewrote traditional tarot meanings with matriarchal images and symbols to do away with any patriarchal imagery that would convey war or conquests, and thereby the movement gained momentum in West's own community. She began work on Thea's Tarot around 1980 and named the deck after the Greek word for "goddess," which also happened to be the name of her cat. (To our delight, the cat even appears in several of the images in the deck.)

To create the images for her deck, West pondered the card descriptions, then used a method called paper cutting to create the images. Using a scalpel, she cut images out of a black sheet of paper, then laid the image on a white background. She photographed and photocopied the artwork down to a manageable size to fit on a card. This medium is not used regularly in tarot card creation, but is visually striking, and we think it's very cool.

Similar to Pott's court card descriptions, in Thea's Tarot, the Page became Child, the Knight became the Amazon, the Queen became the Daughter, and the King became the Mother. Fans and supporters often consider it to be the first lesbian tarot deck.

RIGHT: The Two of Pentacles and The Comet (Wheel of Fortune) from Theia's Tarot

OPPOSITE: The Sun and The Witch from Daughters of the Moon

TWO OF PENTACLES

10. THE COMET

THE LEGACY OF MOTHERPEACE TAROT

MOTHERPEACE TAROT BECAME AN ICONIC DECK almost overnight, and it continues to appear in unlikely places today. Perhaps the most surprising appearance was in high fashion.

Maria Grazia Chiuri's Resort 2018 collection for Dior (yes, the same Dior that featured Visconti Tarot way back in Chapter 1) used several images from Motherpeace Tarot, including Death, Judgement, and the Wheel. Chiuri reported that the runway debut came after she'd read Noble's book *Shakti Woman,* which inspired her to contact Noble on the eve of the artist's seventieth birthday. Noble, who had been using Dior's Chimamanda Ngosi Adichie–inspired "We should all be feminists" T-shirts as images on her vision board for the year, felt like it was a magical, synchronistic moment between the two.

Unlike the extravagant Visconti coat Dior showed the previous year, the Motherpeace licensed T-shirts and dresses were available as part of a Ready to Wear collection and therefore available to anyone who had the desire and money to buy them. In 2020, Dior used images from another tarot deck, Our Tarot, for T-shirts and tote bags, also in their Ready to Wear collection.

YOU MIGHT ALSO LIKE: DARK DAYS TAROT

DARK DAYS TAROT is a feminist deck with a unique shape. It almost feels like a combination of Motherpeace and Thea's Tarot because of its nontraditional shape (square, not round) and monochromatic color scheme. To us, it feels modern and inclusive, but doesn't rely as heavily on mythological and historical spirituality as Motherpeace.

Ace of Wands

COSMIC

WHEN: 1988 **WHERE:** GERMANY **CREATED BY:** NORBERT LÖSCHE

 HE COSMIC TAROT DECK, created by German spiritual seeker Norbert Lösche in the late 1980s, is a little bit more obscure than the other decks we've looked at so far, in part because it feels very of-its-specific-time. Traditional tarot art before this point usually depicted medieval (or older) stories, and by doing so felt timeless. Cosmic Tarot, on the other hand, took the occultist and esoteric imagery we've seen in previous twentieth-century decks and paired it with overt references to pop culture figures, dancing couples, and bright, art decoesque depictions of the cosmos straight out of the 1980s and early 1990s.

In Jean Huets's *The Cosmic Tarot Book,* Lösche describes his vision for the deck: *"In creating this tarot, my intention is to make the old knowledge accessible and understandable to everyone by using as few secret symbols as possible. In our times, the search for transcendent meaning and self redemption has replaced the old mystical religions of a distant god. The tarot's age-old knowledge is always quiet and reserved, yet it welcomes the seeker like an old friend. The tarot, with its dynamic concept of constant change, offers a doctrine for the New Age and thus becomes a reliable guide in this chaotic world of shifting social values."*

THE ORIGINS OF COSMIC TAROT

BEFORE HE CREATED Cosmic Tarot, Norbert Lösche spent a stint as a follower of Bhagwan Shree Rajneesh. Yes, the same Bhagwan (later called Osho) from the Netflix documentary *Wild Wild Country,* which drew international attention to the allegations that his community (years after Lösche left) committed bioterrorist attacks against their neighbors. That close encounter with cultlike activity helps us understand Lösche's devotion to making an approachable and intuitive spiritual tool that newcomers could pick up without a guru.

Cosmic Tarot was originally published in 1988 by German publishing house FX Schmid, who Lösche had approached about an oracle deck he had created. At that point, FX Schmid, the largest player card manufacturer in Germany, had only distributed other publisher's tarot decks, and when they saw the oracle deck Lösche had created, they collectively decided having an in-house tarot deck was the best option—and thus, the tarot deck was created! A few years later, when FX Schmid was acquired by a large game publisher, the tarot deck found its new home with U.S. Games, like so many other tarot decks we've looked at. While Cosmic Tarot is now available in several languages, at the time of writing, Lösche's companion book has not yet been translated into English.

ABOVE: Patrick Nagel's cover for Duran Duran's 1982 album

OPPOSITE PAGE: The 1978 cover of the classic novel *The Lion, the Witch, and the Wardrobe*

THE ART DECO REVIVAL that influenced Aquarian Tarot in the '60s never really went away, and two decades later we see its style again in the angular architectural details and stylized clothing and movement of Cosmic Tarot.

In Milan, the Memphis Design Group's vibrant colors and sleek, asymmetrical, industrial shapes were hugely popular in the world of interior design, and in the fine art world, artists like Patrick Nagel were pairing that same colorful playfulness with modern materials and subjects.

Nagel was particularly known for bringing the sophisticated art deco style to pop cultural moments. He is best known for the images of women he drew for Playboy Magazine in the 1980s and the cover of Duran Duran's 1982 album *Rio,* which spent 128 weeks on the Billboard charts. We can assume that the well-traveled Lösche would have been familiar with its eggplant-colored background and sexy, smiling art deco lady when he set out to create a culturally relevant and accessible tarot deck, as we see some similarities in the smiling portraits in some of Lösche's cards.

It wasn't just New Wave–loving teens or adults skimming 1980s Playboys who would have felt a familiarity and fondness for art deco. One of the most popular children's book series of the era, *The Chronicles of Narnia* by C. S. Lewis, had been repackaged and rereleased in 1978 with distinctly art deco covers.

While the twenty-sixth print edition of a children's novel isn't necessarily notable on its own, the rerelease coincided with a prime time, Emmy-winning TV movie based on the first book in the series, *The Lion, the Witch, and the Wardrobe,* and that made them overnight bestsellers. It's hard to find an American who grew up in the '80s who doesn't remember this particular book cover depicting four English children passing through a golden set of doors. A decade after the release, Cosmic Tarot would have felt magical and thrilling.

Did Lösche read the books in Germany? We don't know, but this same feeling of an open portal is reflected in all the aces of the Cosmic Tarot's Major Arcana. Each indicates, in its own way, energized newness, a little bit of apprehension, but also a lot of excitement.

SILVER SCREEN REFERENCES

WHAT STANDS OUT IN COSMIC TAROT more than the general art style are the specific and sometimes surprisingly familiar individuals in the artwork. Flip through the deck and you're sure to recognize a celebrity moment or two. There are a couple of '80s stars, which we'll get to, but many of the people Lösche included were from the silver screen era—beautiful young men and women who had made their names in the 1950s and in the decades since had transitioned into iconic, legendary figures.

The Two of Cups is a great example of this. Many people look at this and see an image of Humphrey Bogart and Ingrid Bergman. We've even found at least two books that credit the star-crossed stars of *Casablanca*. But that didn't ring true to what we knew about Bogart's and Bergman's real-life relationship (Holly's love of Hollywood history may be to blame for her knowing that Bogart famously didn't care for Bergman *at all*), and so we reached out to Lösche himself and confirmed that he actually drew the card to be Humphrey Bogart and his wife, the movie star Lauren Bacall.

This might feel like a surprise to some tarot enthusiasts who have seen the many famous images of Bogart/Bergman, but it makes a lot more sense in the context of what the image is conveying and the energy the Two of Cups is meant to symbolize. The image of Humphrey Bogart and Lauren Bacall smooching is a positive image of two people, deeply in love and in a peacefully supportive relationship filled with camaraderie and respect for one another, despite a twenty-five-year age difference.

RIGHT: Cosmic Tarot's Two of Cups (top) and Bogart and Bacall in the flesh

OPPOSITE PAGE: Cosmic Tarot's Queen of Wands (left) and Elizabeth Taylor

Two of Cups

Queen of Wands

ELIZABETH TAYLOR, a famously glamorous and beautiful star of the silver screen, also makes an appearance in Cosmic Tarot. Taylor was a leading lady with a long list of movie credits, but by the '80s she was most famous for being a luxurious style icon who had passionate love affairs and had been married eight times, including twice to the same man. Taylor's philanthropic work also kept her in the public eye, including her public cofounding of the then-controversial American Foundation for AIDS Research, now called amfAR.

In other words, Taylor makes complete sense on the Queen of Wands card, which typically symbolizes owning and understanding the fire within yourself.

THE DECISION TO DEPICT RITA HAYWORTH as the Nine of Pentacles is an interesting one.

The Nine of Pentacles generally represents abundance and luxury, but one of the many things we know about Hayworth is that she struggled her whole life with financial consistency. The pinup model and glamorous movie star had public disputes with her studio at the height of her acting career in the '40s, and continued to live a tumultuous, unpredictable life until her Alzheimer's diagnosis in 1981 and death in 1987. Nevertheless, Lösche chose to remember her through a card that represents the beauty and glamour of her many accomplishments.

Nine of Pentacles

WE'VE HEARD SOME TAROT USERS describe the Prince of Wands as looking just like Tom Cruise. To our eyes though, this prince could more easily pass for a 1980s Johnny Depp. Either interpretation works for Lösche's purposes. Both stars were young, brash, and famous in the '80s, and tarot users who pull the Prince of Wands can connect either figure to the principles of action and enthusiasm that the card conveys.

Prince of Wands

OPPOSITE PAGE: Rita Hayworth, and the Cosmic Tarot's Nine of Pentacles

TOP RIGHT: a young and long-haired Tom Cruise

BOTTOM RIGHT: a young Johnny Depp

INTERESTINGLY, THE ONLY KING depicted in the Cosmic Tarot deck that is not clearly documented as being based on a specific person is the King of Swords. Each of the other kings represent the faces of identifiable leading men.

The King of Pentacles looks like Gregory Peck, the King of Wands resembles Sean Connery, and the King of Cups is almost certainly Clark Gable. All three of these men were recognizable enough at the time that if a new tarot reader picked up the deck, they would be able to understand how these kings conveyed the tarot meanings.

Although Gable died thirty years before the deck was released, his lasting reputation as a romantic leading man makes him an excellent and accessible King of Cups, a card known to convey emotional strength and the capability of sharing that strength with others.

Peck's public persona was more in line with the King of Pentacles, a card of stability. Peck played iconic characters like Atticus Finch in *To Kill a Mockingbird* and was known for being kind, secure, and fair, just as the King of Pentacles should be.

Meanwhile, in the 1980s, Sean Connery had just stopped playing the superspy James Bond after a twenty-year run, making him a quintessential man of mystery and action. The King of Wands is a natural-born leader who compels those around him to follow through sheer charisma.

BELOW: Sean Connery and his card doppelganger
OPPOSITE PAGE: Gregory Peck (top) looking kind and fair, and Clark Gable (bottom) looking strong

King of Wands

King of Pentacles

King of Cups

OF COURSE, THE CHALLENGE of putting specific famous and recognizable people on Cosmic Tarot (or any tarot) cards is that the cards become too tightly tied to celebrities. Tarot users start trying to find similarities where there are no intentional comparisons to the meaning behind the card.

Consider the case of Greta Garbo in Cosmic Tarot. The leading lady of Hollywood's Golden Age seems to appear on three separate cards: the Princess of Cups, the Queen of Cups, and The High Priestess. There's no denying they're all beautiful cards and wonderful depictions of the actress, but all three of these cards have different meanings. The High Priestess indicates intuition and hidden knowledge; the Princess is about being thoughtful, romantic, and kind; the Queen of Cups reflects grace, nobility, and dignity.

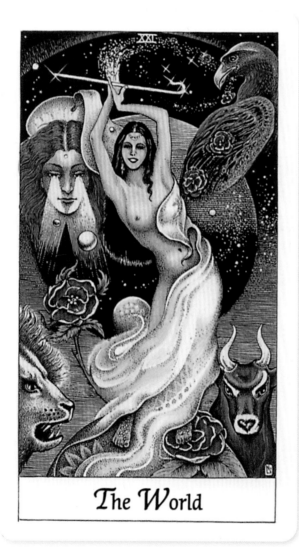

The World

Nine of Wands

Perhaps Lösche just liked Greta Garbo's face and took artistic liberties, but when it comes to the application of tarot cards, using the same, super recognizable face to reflect all of them seems like the wrong choice.

Two more examples of celebrity-sightings-gone-wrong are in the World card, which some people believe looks exactly like 1970s Cher, and in the Nine of Wands, which could bear some resemblance to a young Arnold Schwarzenegger. There is no documented evidence that Lösche intentionally included either person in Cosmic Tarot.

On the other hand, the position of either star at the time wouldn't totally discount their connection to the cards. By the '90s, Cher was recognized for having accomplished basically all of her goals. She could sing, she was hilarious, sexy, and fun, and she could act. The wholeness and fullness of purpose in the World card could very well be linked with Cher's vibe.

The Nine of Wands represents resilience and strength, and attributing a young, bodybuilding Arnold to the image makes sense. But again, these are just suppositions from fans of the deck, not the intention of the artist, and mostly go to show how connected to pop culture this deck is for people who love it.

OPPOSITE PAGE: a very fly-looking Cher
ABOVE: Arnold Schwarzenegger

**CLOCKWISE FROM TOP LEFT: Three of Cups,
Four of Wands, Eight of Swords, Six of Swords**

Seven of Wands

Five of Wands

Two of Pentacles

BEYOND THE INFLUENCES OF CLASSIC HOLLYWOOD and modern pop culture, we find a clear third influence of Cosmic Tarot—dance. And not just one type of dance, either. These cards are full of modern dance, flamenco, ballet, and other sorts of movement. None of the figures are recognizable as any specific dancer, but all of them feel both of this world and yet ethereal due to their grace.

This inclusion of bodies in motion shows Lösche's interest in creating a dynamic and movement-filled deck that veers from stodgy figures seated in front of backdrops and toward humans that feel alive and action-oriented.

ABOVE: Dance and martial arts appear in (left to right) the Seven of Wands, the Five of Wands, and the Two of Pentacles

Wheel of Fortune

WITH ALL THESE CONNECTIONS in the deck's art to pop culture and celebrity sightings, it may seem like we're saying that Cosmic Tarot is more vacuous than others. That's absolutely not the case.

As we study the art, we see that Lösche clearly has a deep understanding and appreciation of tarot symbolism and the associations made by Arthur Waite and Aleister Crowley. Cosmic Tarot offers an entire, multi-layered understanding of the magical mechanisms of the universe behind its bright colors and engaging design.

The Thoth deck in particular seems to have been an inspiration when it comes to the spiritual side of Lösche's Tarot; he uses its Major Arcana numbering system (with the Justice card being VIII and the Strength card being XI) and some of its naming conventions (Princess, Prince, Queen, and King). His Wheel of Fortune card is filled with the astrological symbolism, Hebrew letters, and alchemical symbols that we've come to associate with Lady Frieda's Thoth artwork.

However, Lösche's intent was not to be as obscure as Thoth. He wanted to create an accessible form of art with archetypes that would be easily understood by laypeople the moment they picked up the deck. To do that, he stepped beyond Crowley's intimidating layers of meaning and dense texts to empowered users of his tarot deck to be their own teachers and unlock knowledge from within themselves. In this, Lösche was early to identify a need for self-empowerment in tarot that wouldn't be fully realized for at least another decade.

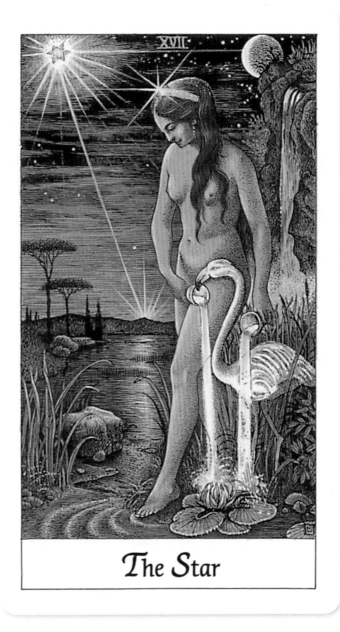

The Star

THE STAR IS ONE OF OUR FAVORITE CARDS in most decks, and this Star is particularly wonderful. It aligns with the Rider-Waite-Smith image in some ways—the serene woman pouring two cups of water into the stream, the starry sky in the background, and even the inclusion of the bird.

What sets the Cosmic Tarot Star apart are the depth of the blue that makes the star's brightness even more striking and obviously the flamingo, which just brings a moment of fun. This card screams iconic Florida patio to us and promises we could find rest poolside with a drink in hand. As a result, the card feels contemplative and semitraditional but simultaneously playful and beautiful.

Death

The Hermit

THE HERMIT CARD DEPICTS what can only be described as a yogi in Ardha Matsyendrasana, the seated twist pose. This card in tarot symbolizes solitude, discipline, and awareness, and a figure like this would be recognizable as having some of those same associations.

There are also symbols in the Hermit's clothes to deepen the meaning. His headband has the Sanskrit Om symbol, used in meditation to express oneness with the universe. His scarf includes the astrological glyphs of the sun, Jupiter, and Virgo. In astrology, Virgo represents detail-oriented thinkers, and Jupiter is understood by astrology fans as representing expansion. All light sources in the card also visibly feel like they represent expansion, which furthers the overall message of thoughtfulness and meditation leading to growth.

We've talked earlier about Death as a card not being about literal death. This Cosmic Tarot Death card strikes us as more bleak than frightening. The skeleton in tattered robes stands on a large field of cement blocks. Everything around him is broken and worn, and we see plenty of symbols of death—the headstone is an obvious one, but there's also a sword, a dried, old branch, and what looks like a skull in some sort of combat helmet. Overall, the card feels like a postapocalyptic scene, reminding us of how fleeting the human experience is.

THE MAGICIAN HAS an ambiguous gender presentation, feeling both masculine and feminine. A light beams from the infinity symbol on their forehead to the outer corners of the card, showing the wisdom of the Magician expanding into the world. The traditional Minor Arcana symbols of the pentacle, sword, cup, and wand are superimposed in the foreground, but the focus is completely on the power and intensity of the individual Magician. The zoomed-in, portrait-style face reminds us of Aquarian and Morgan-Greer and furthers the familiarity of the deck.

The Magician

The High Priestess

ABOVE: There are three cards featuring Greta Garbo look-alikes, but the High Priestess is our favorite

THE HIGH PRIESTESS, one of the many Greta Garbos in the deck, also includes symbols that represent wisdom and understanding. The alpha and the omega in the open book are a common reference to the unknowable (and for Christians, to Jesus himself), and emphasize the peaceful look on the High Priestess's face as she contemplates the beginning (alpha) and the end (omega). She wears a coronet with a yin-yang symbol, representing the duality of life. This is a card that fully represents its message of hidden knowledge.

We're finishing the chapter with this card because not only is it beautiful, it's also a great example of why this deck holds such a soft spot in our hearts. It's solidly recognizable as having spiritual significance, but is also a fun pop culture reference that doesn't veer into feeling overly specific or esoteric.

Tarot decks can be playful and still have great meaning!

YOU MIGHT ALSO LIKE: FOUNTAIN TAROT

THE FOUNTAIN TAROT shares the close-up portraiture style with the Cosmic Tarot, and in a lot of ways feels approachable because it's filled with pop culture references. While there aren't any explicit celebrity sightings in the Fountain Tarot, many of the people depicted seem vaguely familiar. The Fountain Tarot also shares the modern and bright colorways and sometimes stark backgrounds with the Cosmic Tarot, so it seems like a natural successor.

QUEEN OF COINS

SIX OF SWORDS

YOU MIGHT ALSO LIKE: TEXTURED TAROT

TEXTURED TAROT is a deck designed by mixed media artist Lisa McLouglin, who layered the personal story that she received while pondering the cards. Her digital collage-style artwork on the cards feels lush and vibrant, while—like Cosmic Tarot—also being very approachable for new readers.

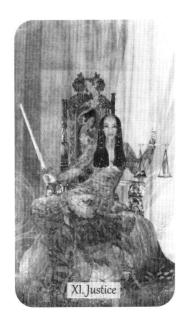

XI. Justice

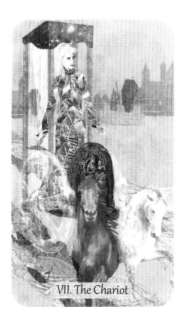

VII. The Chariot

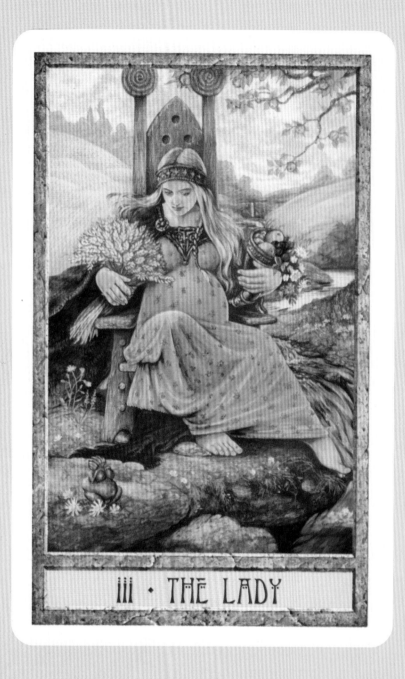

III · THE LADY

DRUIDCRAFT

WHEN: 2005 ■ **WHERE:** UNITED STATES

CREATED BY: PHILIP AND STEPHANIE CARR-GOMM AND WILL WORTHINGTON

RUIDCRAFT TAROT, first published in the United States in 2005, is the second in a three-deck series of Druid-related content conceived and written by Philip and Stephanie Carr-Gomm and illustrated by Will Worthington. It hits a lot of artistic high points for our nature-loving selves.

The three met each other through the Order of Bards, Ovates, & Druids, which Philip cofounded in 1988. The Carr-Gomms had already published multiple key works on Druidry and the natural histories of the British Isles, and Worthington had been researching Wiccan history and practicing Druidry for ten years. He attended a retreat led by the Carr-Gomms on Iona, a Scottish Hebridean Island with significance in modern Druid lore, and then became a member of the Order, as community members called it. Worthington was fascinated by the access it gave him to nineteenth and twentieth century occultist research, which paired his interest in the natural history of Britain with his interest in occultism, spirituality, and art.

ON THE SURFACE, WORTHINGTON hadn't seemed like a natural fit to create the art for an esoteric tarot deck. He was a self-described go-with-the-flow, classically trained artist who worked as an illustrator in advertising. This was the golden age of illustrated advertisements, and Worthington made his living creating commercially accessible art, often emulating popular artists in larger markets.

When the Carr-Gomms tried to sell the idea of the Druid Animal Oracle deck in the early 1990s, publishers balked at using Worthington. According to interviews he gave later, he blames their hesitation on the portfolio he gave them, which was filled with his advertising work and hadn't conveyed a clear artistic vision or consistent style.

However, Philip Carr-Gomm was committed to using Worthington as the illustrator, because Worthington's membership within The Order helped him understand the symbols and meanings more fully. (Remind you of any creator-artist relationships we've already explored?) Instead of looking for someone else, Phillip suggested that Worthington add a Druidic-themed watercolor he had painted for himself to his portfolio and resubmit to a publisher. The artist's appreciation of the subject matter and Pre-Raphaelite style must have appealed to the UK-based publisher Connections, because they agreed to publish the oracle deck. St. Martin's Press would pick up the deck for the US release. It has stayed in print ever since.

Their oracle deck found niche success, and a few years later, a tarot deck seemed like a natural successor. By the turn of the twenty-first century, there were more tarot decks entering the market, some with content similar to what Carr-Gomms-Worthington were doing (specifically Wiccan and Druidic decks like The Greenwood Tarot and the Robin Wood Tarot), but the Carr-Gomms decided that the Druid and Wiccan practices of the Order of Bards, Ovates, & Druids gave them a unique tarot vision worth expressing. They wanted a deck that celebrated ancient stories, the eight seasonal ceremonies (what many people know as sabbats), and imagery featuring the four elements.

Philip was fascinated by the court cards and wanted to begin with those, a decision that was intentionally counter-intuitive. Philip, who also had a degree in psychology and had trained in psychotherapy, had observed that most tarot deck creators started with the major cards, then worked through the minor cards. By the time they got to the court cards, they were often emotionally and spiritually burned out, and the court cards' great explorations into the personality and psyche didn't get as much attention.

When it came to illustrating this new deck, the Carr-Gomms trusted Worthington with their vision. They gave him the basic concepts, and then he sketched in pencil what he thought a card could look like. The Carr-Gomms approved the sketches, and Worthington researched the clothing, architecture, and other design elements he wanted to feature in the card.

Worthington painted the Druidcraft Tarot images using a slightly altered style of pre-Renaissance paint mixing called egg tempera, which uses egg yolk to bind pigment to a surface. To him, this was another way to link Druidcraft Tarot with history, his dedication to collective ancestors, and the importance of the natural world and esoteric content. It's also a nerdy artist move that we completely love, to choose a medium that has to be handmade in small batches.

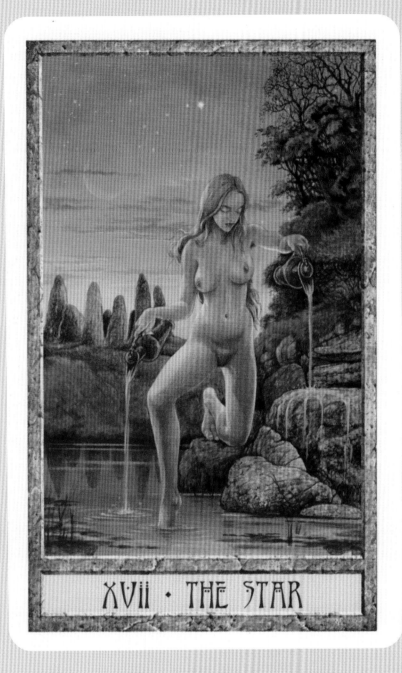

XVII · THE STAR

THE STAR CARD IN DRUIDCRAFT really makes the most of Worthington's egg tempera method. When we look at it, the whole work seems to glow from within, drawing the eye to both the lines of the woman's body and the moon rising behind her. In the background, you can see stones jutting from the ground.

Unlike many of the other Druidcraft cards we'll look at in this chapter, there's no indication or evidence that these stones represent an actual place, but more a feeling of what could have been in the neolithic and Iron Age. It adds whimsy and a more emotional connection to a feeling than a literal place may have.

DRUIDRY AND ENVIRONMENTALISM

THE CARR-GOMMS AND WORTHINGTON were definitely not the first to romanticize our mysterious ancestors of the Iron Age. British and Irish occultists especially have been fascinated by the Druids since at least the mid-1800s.

There's no written record or real historical through line between the Druids and the modern era however, so Druidic beliefs and practices have varied widely over time, and so have the beliefs of the people who study them. At one point, Philip Carr-Gomm created a distinction between "cultural Druids," who participated in reconstructed cultural practices, and "esoteric Druids," who dug into their own psychology and understanding of spirituality to link it to ancient ways.

However, the two things that consistently link the Druid communities together are their commitment to environmentalism and an appreciation of the natural world, and they weren't alone. By the end of the twentieth century, just as the ideas for Druidcraft Tarot were coming together, concerns about the Earth had become so mainstream that a 1990 Gallup poll found that 76% of Americans called themselves environmentalists.

As the commitment to protecting the Earth grew, so did a general interest in religious and spiritual expressions that included the environment. Many groups in the UK and Ireland explored historical landmarks as places for spiritual expression, linking places like Stonehenge, the iconic prehistoric landmark in England where stones stand upright in a ring, and the Hill of Tara, an ancient ceremonial site and inaugural seat for the High Kings of Ireland, to the idea of collective ancestors.

OPPOSITE PAGE: Modern Druids at Stonehenge

ABOVE: Aerial view of the Hill of Tara

RIGHT: Ancient Stone of Destiny located on the Hill of Tara, Ireland

ABOVE: *Storm King Wall* by Andy Goldsworthy

RIGHT: Nancy Hunt's *Over and Under*

THE HISTORY OF TAROT ART

THAT ATTENTION TO THE NATURAL WORLD extended to a deeper environmental awareness in art. This was expressed in a lot of ways, but the one that seems to have the most overlap with Worthington's artwork in Druidcraft is Earthworks, sometimes called land art.

Earthworks used the actual land itself, along with natural materials, to create beautiful and meaningful experiences. Some evoke similar feelings to prehistoric burial grounds, making them seem outside of time. One of the most recognized Earthworks artists is Andy Goldsworthy, a British artist who has been using ordinary materials to create large-scale pieces since the 1970s. His work is mostly found in the United States, but he uses a lot of stonework and masonry reminiscent of the English countryside. His works are pastoral—meant to age, weather, and exist in nature—and it's easy to imagine people hundreds of years from now attributing them to some unknown, mystic, collective ancestor.

Timelessness was also a theme for Nancy Holt, an artist who worked primarily in the American Southwest around the same time as Goldsworthy. She used a combination of cement and natural materials to change the landscape. Her symbols and the naturalistic feelings they reflected were important to the environmental art world as well as neo-Druidic spirituality.

Worthington's art fit right into this trend, using the same swirls, mounds, and stones in the backgrounds of his cards, bringing the rich history of Druidism to tarot and popularizing for one of the first times—if not the first time—the Earth and environment in a tarot deck.

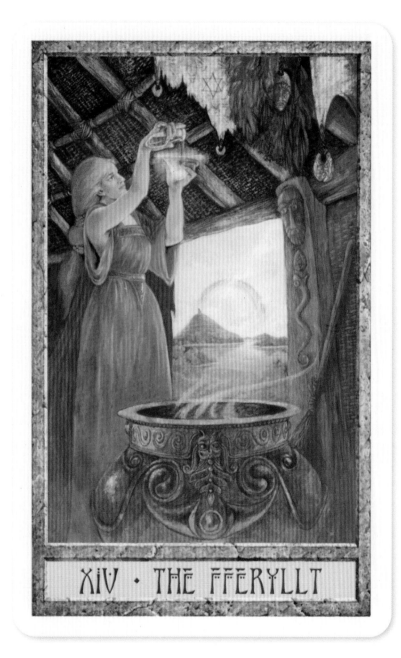

XIV · THE FFERYLLT

NOT SURPRISINGLY FOR A TEAM of creators who had started their own spiritual order, the Carr-Gomms hadn't felt limited by the tradition of tarot and stepped in with some bold revisions.

For example, The Fferyllt (a name for a Druid alchemist) is a card unique to the Druidcraft deck. It replaces the traditional card Temperance, which often represents alchemy, to make the card specifically Druidic.

The Earthworks in the background of Worthington's Fferyllt illustration are Chalice Hill and Glastonbury Tor, two locations closely linked with Arthurian and even early Christian mythology. The water that comes from the well on Chalice Hill is reddish in hue because of its high iron content. It draws those who see both alchemical and magical importance in the mythology surrounding the place.

The figure on the Fferyllt card wears an ancient dress as she participates in some kind of Druidic alchemy ritual. She's surrounded by items and symbols that would be part of a Druid ceremony, showing the earthly as well as divine connection in a specific location.

THE TWO OF WANDS CARD also depicts an actual physical space with meaning to Druids. The Long Man of Wilmington is a hill figure cut into a chalk hillside in Sussex, England. For a long time, the figure appeared as only a shadow or slight discoloration in the grass, mostly visible after a light snow or when the grass changed colors during the spring and summer. Then, people began to cut it to make the shape more obvious, and now because of erosion, the outline is filled with concrete blocks that are regularly colored white (presumably by the Sussex Archeological Society, but occasionally by rogue Long Man lovers). Every year, there's an annual dance for Beltane (also called May Day) at its base.

Some people believe the hill figure is prehistoric, with at least one theory that it was created to track or mark the movement of the constellation Orion. Others believe that it might have been created between the eleventh and fifteenth centuries when a Benedictine monastery, Wilmington Priory, was near the location. As with anything with mysterious origin, there will be mystical associations made, but all we know is that the first documented sighting of the figure carved on the hill is from the late eighteenth century.

The Carr-Gomms built their Two of Wands on this mysterious origin story, as well as the hill figure's continued existence. Worthington painted The Long Man poised on the hillside overlooking the valley below to represent a doorway for exploration. It looks like he's holding open a door for the viewer, inviting them to go deeper into the mysteries that have yet to be solved.

TWO OF WANDS

THE THREE OF PENTACLES, a card that represents working together and finding our place in a team, is represented in Druidcraft Tarot with another piece of history—Iron Age stonework called Pictish stones.

The Picts lived in eastern and northern Scotland as a distinct people group during the late Iron Age and into the Early Medieval Period, until they merged with a Gaelic kingdom known as Dál Riata around the year 900 to form the Kingdom of Alba. They didn't leave behind a written record, and most of what we know about them comes indirectly through the records of people who interacted with them. These stones that stand as a remembrance of their existence.

Scholars estimate the Picts began to erect elaborately carved Pictish stones in the fifth century. Most of the surviving ones today are more likely from the sixth and seventh centuries. Today, the Druid community sees ancient stones like this as a way to access the land and that general idea of ancestors, and Worthington's Three of Pentacles focuses on a craftsman's creation of one of these Picts, indicating a further development of mystical artistic skills. This also seems to indicate that the work being done is connected to a longer lineage than we're aware of or realize on a day-to-day basis. The work depicted on the card was done in the past and impacts the future; the work you choose to do now will also impact your future.

And yes, Worthington also included a Scottish wildcat in the painting, presumably to further emphasize the time frame and location.

THE DRUIDCRAFT SEVEN OF SWORDS doesn't depict a literal or figurative place, but it is unusual and worth examining for a different reason.

Traditionally, this card is depicted as a sneaky or self-serving figure, but Worthington chose a whole different direction. He painted a wise man at a desk, writing.

As tarot readers, this jumped out at us as a unique and unusual expression. The new image changes the narrative into how growth and personal change are the keys to the Seven of Swords and emphasizes the important role of continuing to learn and grow. Yes, there's a certain Machiavellian attitude with the swords showing what could happen if the man's viewpoint turns toxic, but for the most part, this card means gaining knowledge or facts. It focuses on the strategizing and research, rather than scheming or manipulation, involved with personal development.

The change in design probably harks back to Philip Carr-Gromm's belief in the use of psychology in personal development. In his view, strict perceptions of evil and good aren't always drawn in black-and-white; there are lots of gray areas when it comes to a person's internal motivations. Instead of assuming the worst in this somewhat trickster card, Druidcraft Tarot encourages us to consider when constantly thinking could be a positive thing. Maybe they're not always out to steal all of your swords. Perhaps they need those swords, and you should trust that they have the best intentions in using them. (This ends our attempt at giving a redemption story line for the Seven of Swords. But we do love the nuance of the card.)

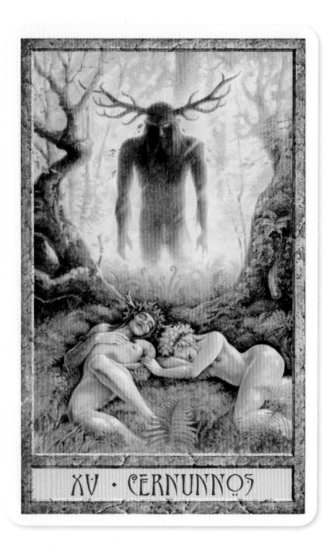

WE CAN'T TALK ABOUT THIS DECK without including the rock star High Priest. He sits on a carved wooden throne, surrounded by tools and references to the old ways. According to Carr-Gomm and Worthington, he holds up the Wiccan Horned god sign of blessing in greeting, but we recognize the "rock on" hand signal when we see it. We can almost hear throngs of people behind chanting and singing a rock anthem that we aren't at liberty to quote, but it will certainly rock you. It's funny to us that some symbols transcend time and others morph into something completely different and unexpected.

All tarot decks have a Devil card of some kind, and as we've seen, those can come with a variety of expressions. In Druidcraft, The Devil is Cernunnos, the "horned god" in the Celtic pantheon.

Modern archaeologists have only found one record of Cernunnos's name—on the Pillar of the Boatmen carved sometime in the first century in Paris. This pillar has carvings of many Roman and Gaelic gods, and Cernunnos's images is one of the few that remain on the top layer of this pillar.

While Cernunnos is the Lord of the Underworld in Celtic culture, he is also known as the Lord of the Wild Hunt, which softens the card's traditional message of helplessness and being controlled by baser instincts.

Worthington's Cernunnos receives a bit of a makeover and is both dreamy and sensual, but depending on your perspective can also be looming and threatening. The meaning of the art points to the enormous power we can have if we maintain control of ourselves.

DRUID PLANT AND ANIMAL ORACLE

DRUIDCRAFT TAROT CAN'T BE EXAMINED ALONE. As we've mentioned, it's part of a series that started a decade before its release with the Druid Animal Oracle.

For those who haven't explored oracle decks, there are a couple of key differences. Tarot decks, as we've seen, always have seventy-eight cards with distinct, similar meanings. Some tarot decks have slight differences, but for the most part you'll always find the same seventy-eight cards split into Major and Minor Arcana, as well as similar archetypes. Oracle decks, on the other hand, are based on whatever the artists and creators want. There can be any number of cards, with any meanings the creator wants to associate, and any pictures (or no pictures at all) on the card face.

Druid Animal Oracle includes thirty-three animals from the British Isles with symbolic meanings. On the Stag card, for example, there's an illustration of a male deer in the forest. The keywords for the card are pride, independence,

and purification. Worthington later joked that they made a mistake by not including a badger card, because badgers are iconically British (think *The Wind in the Willows*), but they did include the sow, the hare, the ram, and even four dragons that correspond with the elements of air, earth, water, and fire.

A few years after the Druidcraft Tarot deck was released, Worthington and the Carr-Gomms created the Druid Plant Oracle to round out their belief system about the Earth and how all things work in harmony together: plants, animals, and humans. The book that accompanies the Druid Plant Oracle includes information about the history and background of each plant, as well as lore and traditional folk medicine remedies.

Worthington has gone on to create other tarot and oracle decks for different authors, but none have been as popular as Druidcraft Tarot. The Carr-Gomms continued to create tarot decks and write books on Druid spirituality and are still involved in the Order of Bards, Ovates, & Druids.

CRANE

POPPY

YOU MIGHT ALSO LIKE: THE ROBIN WOOD TAROT

THE ROBIN WOOD TAROT is another deck that has a Wiccan and early-Celtic focus. It was released in 1991, not long before the Druid Animal Oracle came out. The art style is totally different, tending toward a traditional drawing style, but the focus on the natural world and medieval Arthurian motifs feels familiar. Robin Wood is an American artist and illustrator who also designed the covers of multiple books published by esoteric publisher Llewellyn.

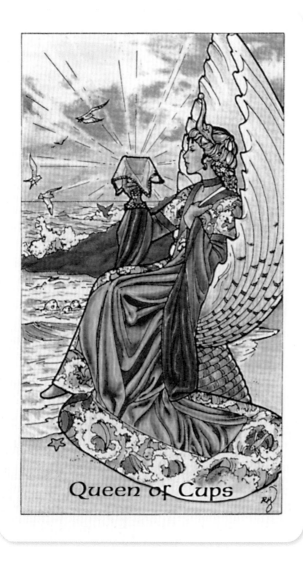

THE WILDWOOD TAROT, published in 2011, was also illustrated by Will Worthington. Its card authors, Mark Ryan and John Matthews, focused much more on pre-Celtic mythology and mysterious magical practices, so there are a lot of forest archetypes in this deck, and it uses a separate meditation structure. It doesn't follow the traditional Rider-Waite-Smith structure as much as Druidcraft Tarot does and therefore seems much more esoteric and much less historical.

1 The Shaman

3 The Green Woman

DEVIANT MOON

WHEN: 2007 ■ **WHERE:** UNITED STATES ■ **CREATED BY:** PATRICK VALENZA

URREAL. FANTASTICAL. NIGHTMARISH. DISTURBING. Since its first publication in late 2007, Deviant Moon Tarot has been one of the most controversial decks in tarot history. Most people either love the dark, monstrous imagery on these cards and the deep emotions they evoke, or they look at the images and, like many of the characters depicted, they cringe. Fear creeps into their throats, and they're compelled to look away.

While plenty of other decks before them diverted from traditional- and Renaissance-inspired art, Patrick Valenza's Deviant Moon Tarot is unusual in how its "in your face," sometimes scary images intentionally try to make readers uncomfortable. This is the deck that knocked down walls and demanded that the tarot community look at the darker side of a person's subconscious. In response, many new tarot viewers became empowered to respond to the darkness within.

Deviant Moon is hard to write about. The chapter that follows isn't all sunshine and roses, or even art techniques and celebrity sightings. However, it's important that we look at this deck because Deviant Moon is groundbreaking as a mainstream expression that allowed a whole new community to experience an authentic experience with the Tarot. Patrick Valenza saw a community of individuals who enjoyed "darker" things, and he believed that the Tarot was for them, too. They saw themselves in the Deviant Moon artwork in ways they never had elsewhere.

Love it or hate it, Deviant Moon demands a response and its rightful place in the history of tarot art.

THE ORIGINS OF DEVIANT MOON TAROT

PATRICK VALENZA HAS SAID that his childhood was filled with dreams, visions, and premonitions of shadowy figures that cried out in terror. He first encountered the Tarot in the mid-1970s when he was around nine, and the rest is history. The images and archetypes of tarot brought a laser focus to his creativity and an outlet for the things he saw in the night.

As a teenager, Valenza taught himself to draw in order to make his own tarot deck, starting as most artists do with The Fool and The Magician. He went on to create the artwork for thirteen of the eventual Deviant Moon tarot cards before he turned eighteen, which laid the foundation for the future deck. However, as he entered adulthood, Valenza put aside his tarot art. Unlike Peter Pan, he grew up and forgot the fantastical world he left behind. For almost twenty years, he focused almost exclusively on illustrating children's books. Still, the creatures called to him at night, begging to be seen.

Finally, at thirty-seven, Patrick found his way back to the project he began as a fifteen-year-old. This time, he took what he called "a vow of completion."

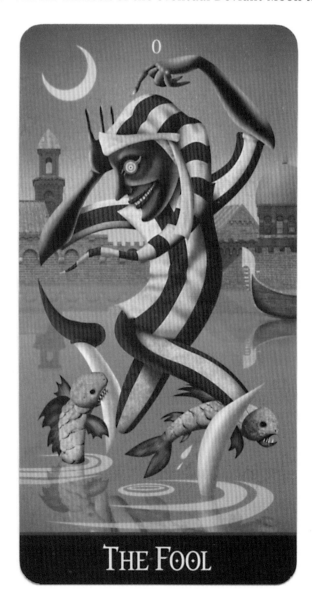

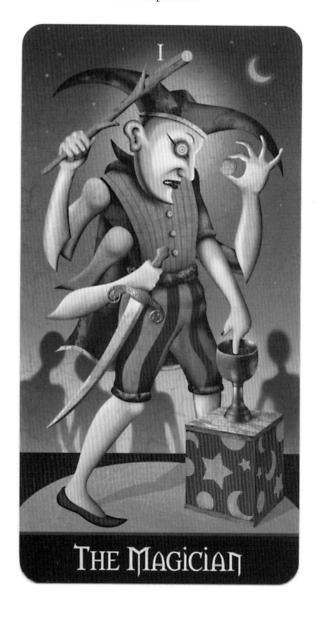

THE BEST WAY WE CAN DESCRIBE the art in the final Deviant Moon Tarot deck is Salvador Dali and Tim Burton meet at an Addams Family Halloween party, have a few drinks, and decide to have a baby together. Valenza's figures show some signs of being inspired by ancient Greek art, but in a wholly original, disjointed, and distorted way.

In an interview with his original publisher, U.S. Games, Valenza cites some of his early influences as the animators Max Fleischer and Winsor McCay. Looking at the clothing his characters wear and some of the illustrations' structural elements, we think he was also influenced by the more classically themed tarot decks he saw as a child, including the Visconti deck and 1JJ Swiss Tarot. The historical settings of these decks didn't matter much to Valenza's vision, but the overexaggeration of the clothes and the fantastical positions of the figures appealed to him. In interviews, Valenza has said that he had listened to harpsichord music to connect with the art better as he created the cards, and we can see that intentional Old World–feel ingrained into the very modern pieces.

ABOVE: Various characters created by Tim Burton (left) and *Lugubrious Game* by Salvador Dali, 1929

OPPOSITE: Deviant Moon's The Fool and The Magician

THE WORLD

VALENZA'S EARLY TAROT card designs were loosely inspired by the Visconti Tarot deck, especially the card dimensions and the metallic overlay, although Valenza applied the overlay to a modern acrylic wash rather than the leafing process of the Renaissance. He later referred to these early illustrations as his "altarpiece" designs, and he kept them for his personal use only; the cards we see today don't have the Gothic-style arched borders or art nouveau flairs.

That was because when he came back to the project as an adult, Valenza decided to modernize his creation process. Instead of drawing the rest of the cards by hand as he did with the original pieces, he scanned the early cards into his computer and continued the project digitally. This allowed him to bring another of his passions—photography—into the tarot project.

LEFT TO RIGHT: The World, Five of Swords

OPPOSITE: Abandoned Pilgrim State Asylum on Long Island, New York. This was partly the inspiration for the art in the Three of Pentacles

VALENZA'S DECISION TO USE his own photography as an element of Deviant Moon introduced unconventional images into the characters and settings on the cards. Flipping through the deck, you might notice photos of tombstones, ancient walls, and Gothic church arches as textures. However, the most unsettling images come from an abandoned sanatorium.

As a child, Patrick lived not far from the dilapidated Pilgrim State Asylum in New York, which his mother told him was called Boogeyman Island. "Those that go there, never return," she warned. Patrick, perhaps unsurprisingly based on what we know about him, couldn't wait to go. He explored the building thoroughly as an adult and brought his camera, captivated by the architecture and the ruins of this eerie presence that had loomed on his horizon.

The crumbling brick walls and hollow structures of Pilgrim State Asylum became the texture for quite a few cards in Deviant Moon Tarot, but we see most of the building in the backdrop of the Five of Swords, framing a phantom soldier who has turned his back on his brothers in arms, seemingly mocking them with his tongue out as he walks away with their weapons.

VALENZA WAS OBVIOUSLY FASCINATED by all kinds of death iconography, weaving threads of memento mori (artistic reminders of the fleeting nature of life) throughout the deck. We see this especially in his vast collection of pictures of headstones, which he took over the years in various cemeteries in Long Island and Brooklyn, New York. You'll find them in Deviant Moon on everything from hot air balloons to gadgets and gears, cloaks, boots, and other clothes. They're Easter eggs for anyone looking closely enough to notice, and they give the digital artwork a gritty, older feeling.

Many religions and cultures use headstones in their funerary art and traditions, but the headstones Patrick Valenza found are distinctly representative of the former Puritan colonies of the American Northeast. Take, for example, the Six of Swords. There are hints of headstones all over the balloon and in the sky, with the most prominent element sitting top and center: an eighteenth-century death head, or Colonial-era skull and wings. The placement of this distinct symbol intentionally grabs the gaze of anyone who passes by to remind them of their own mortality (skull) and the fleeting

nature of this life (wings).

Valenza's funerary images don't stop with headstones. The half-moon faces of the Deviant Moon "citizens," as Valenza calls them, reoccur throughout the deck and feel particularly Daliesque, melting into different shapes and expressions. On the Eight of Pentacles it takes center stage, representing the deities that live within the cogs of factories, blessing the worker below with abundance and prosperity for their faithfulness.

The source of this particular face is unknown, but there's speculation that it's related to the death head image of a moon or sun often carved on headstones. The Puritans rejected attributing human forms to spiritual beings, so in their funeral images, they used images of the sun as a substitute for God or his son (was this an eighteenth century headstone pun?). A headstone with a sun carved on it showed that the person buried was a faithful servant of God to the end of their life. Since Valenza often used the half-moon to represent a deity, the symbology fits.

The artwork for Wheel of Fortune is another example of funerary imagery, displaying several icons such as a palm, a broken heart, a skull, a crescent moon, and a star on a giant carnival spinning wheel.

A palm would have indicated spiritual victory over death. The person with a palm on their headstone was therefore a person who avoided everlasting torment in hell and was now in heaven. In some cases, it may have even indicated they were a martyr for the Christian faith.

A broken heart can be read as a straightforward symbol that the deceased died of a broken heart. However, that doesn't mean the heartbreak was tied to romantic love between a couple, since in those days, marrying for love was more of a fantasy than reality. Take, for example, the headstone found in the Hillcrest Cemetery on Gallow Hills in Lunenburg, Nova Scotia. The whole heartbreaking story can be read on a marker nearby, erected by the Bluenose G.R.S Society. The broken heart headstone and the markers that rest beside it are for a fourteen-year-old girl named Sophia. She was a dressmaker's

OPPOSITE PAGE: Funerary images that appear in the Eight of Swords and Eight of Pentacles, including an 18th-century death head

ABOVE: Funerary images also appear on the Wheel of Fortune

apprentice who died in 1879 of a broken heart after being accused of stealing $10 from her mentor. After everyone in her community (including her own mother) accepted the accusation as truth, Sophia wrote a heartbreaking letter, begging to be believed. Shortly after, her health quickly deteriorated until she died. A coroner's jury unanimously decided that her cause of death was "paralysis of the heart brought on by extreme agitation and peculiar circumstances."

Soon after Sophia's death, the true thief was discovered—the dressmaker's son, if you're wondering.

On the Wheel of Fortune card, the images take a back seat to the action. Once the lever is pulled, we see that the customer is at the mercy of the spinning fates. A trickster god in the form of a monkey stands above the wheel, threatening to tamper with the will of the fates. Spin the wheel, accept your fate, and see where this life leads you next.

NOT SURPRISINGLY, THERE ARE PLENTY OF PEOPLE in the tarot community who stay away from reading the Deviant Moon deck because they find it disturbing. Imagery designed to be "demented" and scary can give cards different meanings and intuitive perception compared to the "traditional" meanings.

Of course, these "traditional" meanings often vary slightly from deck to deck. In Tarot de Marseille, for example, the Lovers card indicates a choice, while in Rider-Waite-Smith, it can mean love or a union—romantic or nonromantic—of two people. In Deviant Moon Tarot however, the Lovers card depicts two people magnetically drawn to each other, harmonious when they're together. So far, so good. But that snake biting the man's leg gives off a very different tone than either classic deck. When we look carefully at Valenza's art, we see that the snake is the source of their infectious passion, and we suspect the Lovers will both soon be filled with its poison if they give in to their desires.

Another example is the Ten of Pentacles, which typically indicates familial abundance, success, and a dynasty built on wealth. Deviant Moon's artwork takes that meaning and gives it a twist. Sitting at a table are two affluent-looking individuals, probably a father and son. They wear fine clothes and play with an elaborate chess set. All their wealth and finery is on display for the viewer, but when we look closer, we find that the table is balanced on the back of another person. That individual is naked and impoverished, a startling contrast to the chess players, but perhaps more surprisingly, they hold an important chess piece that we presume was taken from the table. The figure looks truly miserable and downtrodden. When we see this card, we find commentary about the lineage of our wealth and upon whose backs it was built, and an indication that the person with the lesser position may, in the end, be the winner.

OPPOSITE PAGE: This 18th-century funerary art, including the legendary broken heart, appear on Deviant Moon's Wheel of Fortune

ABOVE: The Ten of Pentacles

The Madwoman

The Plant

Rain

THE LEGACY OF DEVIANT MOON TAROT

THE IMMEDIATE POPULARITY OF DEVIANT MOON TAROT on its release sent ripple effects through the community. Some tarot users complained that the art was unsettling in its dark tone and imagery, but it seemed they were outnumbered by people who found this deck the perfect combination of creepy and interesting. The deck continues to be incredibly popular today.

As for Patrick Valenza, he continues to draw this same style of instantly recognizable art, and his "citizens" of Deviant Moon Tarot make appearances in all the other slightly ominous decks that he creates.

More importantly, the creation of Deviant Tarot opened a door for the acceptance of alternative tarot artwork, which indirectly led to more tarot representation of people with different backgrounds and worldviews.

ABOVE: Selected cards from Patrick Valenza's Abandoned Oracle deck

YOU MIGHT ALSO LIKE: WAYWARD DARK TAROT

WAYWARD DARK TAROT, created by Pixel Occult, is a dark, macabre deck based on the Thoth Tarot system. Its "funhouse of mirrors" archetypal depictions draw from high-contrast images in blue, white, and black, and many of the figures are cloaked in underworld ooze, bones, and darkness.

YOU MIGHT ALSO LIKE:
TAROT OF THE SWEET TWILIGHT

TAROT OF THE SWEET TWILIGHT features the artwork of Christina Benintende, which takes a surrealist look at the tarot archetypes with Tim Burtonesque characters. Pain, beauty, and the bittersweetness of life are displayed in this deck with hidden depths and fantastical meanings.

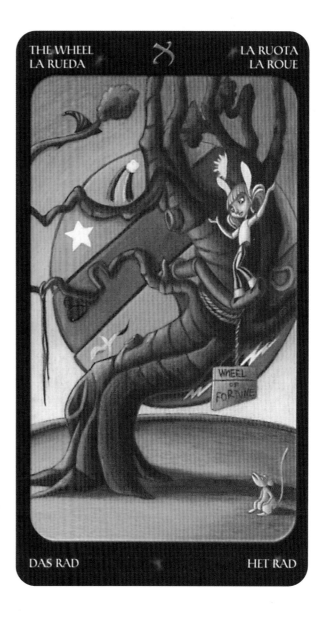

The Wild Unknown's Nine of Wands

THE WILD UNKNOWN

WHEN: 2012 ■ **WHERE:** UNITED STATES ■ **CREATED BY:** KIM KRANS

ITH EACH GENERATION, a tarot deck emerges that defines its time. The Wild Unknown, created and illustrated by Kim Krans, is the deck of the twenty-first century, and from our perspective has become as widely recognized as Rider-Waite-Smith and Thoth Tarot for its artwork and cultural presence. In fact, The Wild Unknown may have even surpassed the classics in popularity.

As The Wild Unknown went from a small, self-published project to one of the best-selling decks in tarot history, this new kid on the block changed everything, including the ways tarot archetypes are perceived—and that is due mostly to Kim Krans's striking artwork.

The best word to describe the art of The Wild Unknown is "engaging"; it doesn't try to act as a gatekeeper or build barriers between the tarot reader and any so-called deep occultist knowledge like so many of its popular predecessors. Instead, the deck is illustrated with animals and recognizable images that are equally approachable to tarot readers of different backgrounds, ethnicities, beliefs, and lifestyles.

That means there are no humans or humanoid figures in The Wild Unknown Tarot deck. Krans intentionally avoided images of people, as well as anything else that could be perceived as judgmental, dated, or reminiscent of Christian themes. In doing so, The Wild Unknown became the standard for tarot artwork intended to be interpreted intuitively, free from hundreds of years of old guard control.

THE ORIGINS OF THE WILD UNKNOWN

IN EARLY 2012, KIM KRANS was already an established artist and musician who had been fascinated by the promise of tarot as a spiritual tool. She was familiar with the imagery, but she had never been able to connect with published tarot decks.

Inspiration struck during a band trip when she noticed a woodcut print of the Magician tarot card hanging above the bed where she was staying. As she drifted off to sleep, the spark of the Magician's magic had already impressed her enough to begin designing a deck for herself. She would later say about the experience that "the Magician crept into my bones."

Soon after this encounter, she sketched cards, filling pages of her notebook with illustrations, phrases, and ideas. Some were already fully realized in the first draft, and others were simple line drawings to develop later, scrawled quickly before the muse left her.

Krans knew from the beginning that she wanted to illustrate her deck with animals and objects. She didn't consult tarot books or research, but instead considered only what the cards meant to her as an individual. After she built the imagery for her deck, she hosted multiple focus groups at her house to see if her adjusted archetypes would resonate with others. If something didn't quite fit, she bounced ideas off friends and colleagues to help her understand and connect to the greater collective.

In May 2012, Krans started selling first editions of her full-sized illustrations in her online store. The drawings quickly sold out, a sign of the massive response this deck would receive.

Because her primary goal had always been to share her personal interpretations, Krans gave those who used her tarot deck permission to apply their own meanings to the tarot archetypes. Everything about The Wild Unknown Tarot was there to help the reader stop thinking about anyone else and let the artwork evoke an instinctual gut reaction.

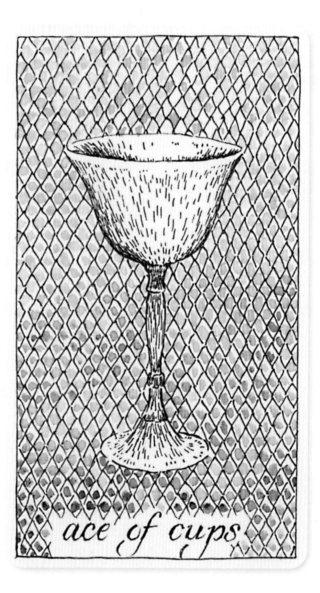

ABOVE: The Ace of Cups

ABOVE: The Father of Cups, The Mother of Cups

THE WILD UNKNOWN is part of a growing trend of decks that come from a single source for both artwork and meanings. For a time, Krans was even the sole distributor.

At the time, if a tarot deck creator wanted their work to reach a wide audience, they had to pitch the idea to publishing houses and hope one was interested enough to understand the artistic vision and offer them a contract. The process of printing and shipping decks, not to mention getting stores to carry them, was almost impossible to do as an individual.

However, by 2012, technologies emerged that changed the game. Not only could a creator find and work with a printer entirely online, but they could also manage sales directly through their own website or a number of online marketplaces like Etsy that catered to creative people.

Krans published the full Wild Unknown Tarot deck and offered it for sale on her website in October 2012, and it quickly became popular within the online tarot community. Her first printing sold out within a few weeks, and demand for The Wild Unknown grew as early fans shared the deck on social media. Krans continued to sell this first edition directly, and wrote and released a full-length guidebook—an artistic project in itself, because when we say she wrote a book, we mean that she personally handwrote and illustrated a guidebook.

Three years later, Krans released a revitalized second edition of The Wild Unknown Tarot deck, which included new card backs and a few card changes. This second edition was also exclusively distributed through Krans's website, available only to people who happened to come across it until 2016, when it was bought by the large US publisher HarperCollins. Krans's vision has now reached general bookstores and growing online marketplaces like Amazon.

The success of The Wild Unknown inspired a new wave of tarot deck creators to publish outside traditional methods. Tarot has seen a boom of indie decks, where a creator raises funds and finds their audience directly through websites like Kickstarter. Often, the quality of these decks is equal to or even better than traditionally published decks, especially when it comes to the art. Indie decks offer personally invested creators more control over the finished product, from ink types to paper stock, than they would have if they had signed a contract with a publisher (who is usually more focused on the bottom line).

This creative explosion isn't just about printers and online shopping. The Wild Unknown also empowered budding tarot readers to set down the little white books written by previous tarot deck creators and use their own senses and intuition to experience what they wanted about tarot archetypes.

By the time Krans created The Wild Unknown, it wasn't revolutionary to change the name of court cards in tarot decks. In fact, it had always been common for creators to put their fingerprint on a deck by playing with the court card archetypes, since those cards were more fluid and open to interpretation than the cards in the Major Arcana, and the original titles of kings and queens could seem distant and out of touch. As we saw, Aleister Crowley called the court cards Princess, Prince, Queen, and Knight in Thoth Tarot; in Motherpeace, the same cards were Priestess, Shaman, Daughter, and Son.

However, Kim Krans went a step further and associated her archetypes of Daughter, Son, Mother, and Father with specific animal species, not humans. What a Rider-Waite-Smith deck would call the Queen of Cups became the Mother of Cups in The Wild Unknown and is depicted as a beautiful trumpeter swan. The Daughter and Son of Cups are the swan's cygnet children. The Father of Cups is a black swan. For the Pentacles suit, Krans saw the Father of Pentacles as a buck, the Mother a doe, and the Son and the Daughter are fawns.

These animals, somewhat paradoxically, created connections for tarot readers that previous human-based

father of pentacles

mother of pentacles

son of pentacles

daughter of pentacles

decks could not. Tarot readers reported that they loved not trying to compare themselves to fantasy-based human archetypes. Images that looked like people, it turns out, were still hard to relate to if they didn't look like real people. Flowing robes and hypersaturated colors lacked authenticity, providing a type of escapism but not a meaningful, real-life connection. On the other hand, The Wild Unknown helped readers let their guard down while they considered the meaning a card's animal might have before looking at themselves.

Consider The Wild Unknown's Death card, depicted as the skeletal remains of a bird against a dark background. It has a completely different feel from the Rider-Waite-Smith,

where the skeleton rides victoriously on a horse. Krans's card focuses on realism so that we, unsettlingly, can almost smell and taste the death we visually see in the artwork. Most of us have seen something similar in our own streets or backyards after all, and so the delicate nature of life is right in front of us. We see that we will one day find the same fate as this lifeless bird.

In The Lovers, the theme is again a bird, but emotionally, we see the opposite. Where Krans's Death feels like darkness invading the space, her drawing for The Lovers feels expansive, warm, and inviting. The energy radiates dazzling colors that dance across the heavens. The geese fly effortlessly in the sky in harmony, soaring on their journey together in unison.

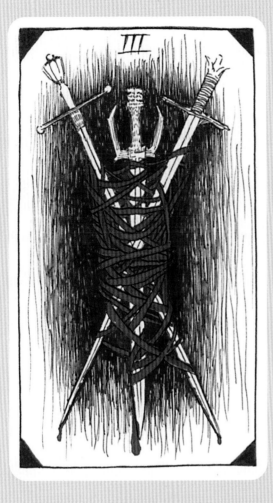

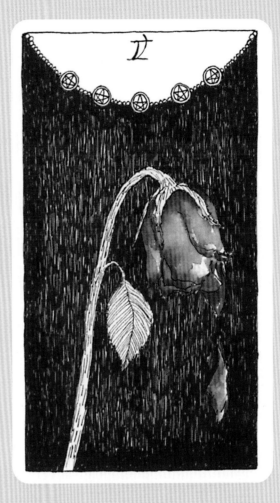

ONE OF THE THINGS THAT PERSONALLY draws us to this deck is that Krans doesn't shy away from negative, artistically brutal, or even "dark" cards. We're not talking about the kind of darkness that we saw in Deviant Moon Tarot, with its tormented expressions or scenes of external violence. In The Wild Unknown, the focus is on what's realistic, not fantastical. The animals on the cards aren't cute and cuddly caricatures; they're real parts of nature, and that includes the brutal parts.

In many traditional decks, the Three of Swords is depicted as a heart pierced by three swords. The violence is in the implications of what happens when a heart is attacked. In The Wild Unknown, Krans extends the image. Two swords cross a central sword, and all three are bound by a tether stained and dripping with blood. As we look closer, we notice the blood is also dripping from the blades, leaping through the artwork and calling to the empathy within us to connect with something shocking and painful.

Krans is an expert at intentionally evoking both positive and negative emotions without slipping into stereotypes, and that rawness helps us connect with things we tend to bury beneath the surface.

Her Five of Pentacles is a wilting rose on a black background with five coins hovering above. The rose takes on an almost human posture, defeated and downtrodden as one petal descends to the ground. The despondency and sadness are breathtaking but understated, giving the viewer the opportunity to find the sadness in themselves. This is the kind of beautiful cruelty that gives us a unique opportunity to explore our own emotions and how we respond to pain as humans.

UNLIKE DEVIANT MOON where the looming threat of terror and darkness seems to consume their entire world, it's not all bleakness and death in The Wild Unknown universe. The ways Krans plays with line work, perception, light, and especially color throughout this deck reminds viewers that we're just as likely to uncover immense joy as we are darkness. With rainbows and bursts of light, she reminds us that while we may be stuck at times in places of gloom and despair, we must not lose hope. The sun sets, but it also rises again.

The Magician, according to Arthur Waite's *Pictorial Key to the Tarot*, signifies the "divine motive in man" and means "skill, diplomacy, address, subtlety, pain, loss, disaster, snares of enemies; self-confidence, [and] will." When we look at The Wild Unknown's version of The Magician on the other hand, we see a leopard with all the tools from the four tarot suits sitting before it, ready to do its bidding. Bright rays of light project from behind it, and the infinity symbol rests

on its chest. In her book, Krans wrote that the meanings of The Magician are "action" and "self-empowerment." It's simplified, yes, but also more direct. For us, the majesty of the leopard, illuminated by rays of orange and yellow, empower the reader to also be striking in the way they move forward.

Similarly, let's look at Temperance. A blue heron stands before an open fire with its wings extended, as if to balance drops of water as they fall onto the flames below. The fire doesn't harm the water, and the water doesn't extinguish the fire. They exist together.

Waite's interpretation of Temperance is "economy, moderation, frugality, management, [and] accommodation," while Krans says that Temperance is "healing" and "renewal." Can you see how people who are new to tarot feel more gently ushered into reading cards for spiritual growth while using The Wild Unknown?

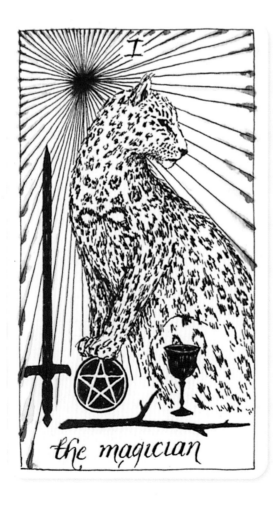

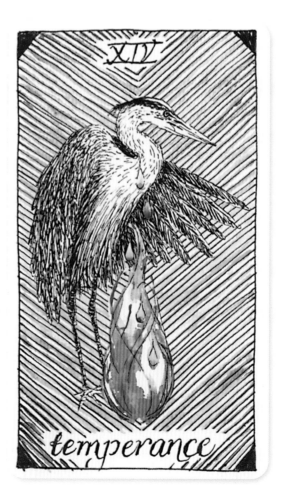

THE WILD UNKNOWN BODY ART

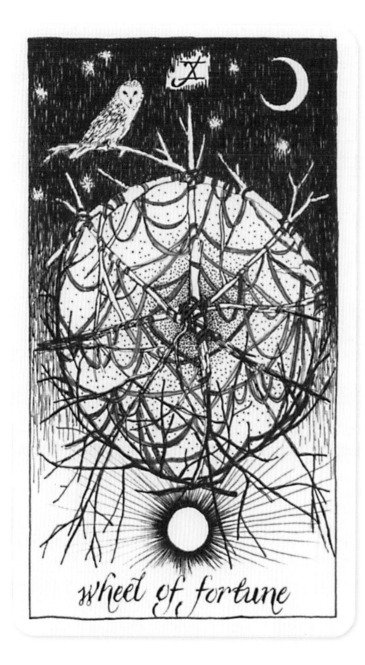

wheel of fortune

AS WE LOOK AT HOW THE WILD UNKNOWN has made its way into the broader culture, one of the most interesting aspects is how it influenced tarot fans (and probably a lot of people who just happened upon the images) to turn Krans's card illustrations into body art that will stay with them for the rest of their lives.

While using tarot images in tattoos wasn't unheard of before this past decade, it has been interesting to see what a strong impact that this deck has made in the lives and bodies of fans of tarot in general, and The Wild Unknown artwork specifically.

PREVIOUS PAGE: Body art inspired by the Daughter of Wands

LEFT: The Wheel of Fortune

THE LEGACY OF THE WILD UNKNOWN

AFTER THE WILD UNKNOWN solidified its place in tarot history, Kim Krans expanded the brand to include Animal Spirit Oracle and an Archetypes Oracle deck. Her Animal Spirit Oracle deck has a similar story of runaway success as an independently published deck, followed by a traditional publisher picking it up for distribution. It's filled with animals, both big and small, and strikes the same balance of lightness and darkness that The Wild Unknown does.

The Archetypes Oracle deck took another leap into the unusual. Not only is it more colorful than its predecessors, but it's round. Each card feels like peeking into a world of spiritual archetypes and recognizable images with the familiar style of Kim Krans.

Since the publishing of The Wild Unknown and her subsequent decks, Krans has also published several picture books, a journal, and even a memoir.

More than that, Krans has influenced a new generation of tarot artists. And it's not just the business side, where indie artists are free to bring tarot to the community directly. We also now have a variety of nonhuman-based decks or decks meant to be read intuitively.

It's a whole new tarot world out there!

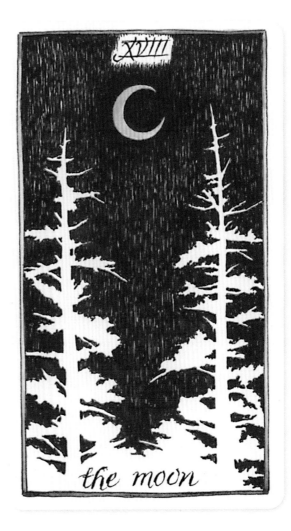

YOU MIGHT ALSO LIKE: THE VINDUR DECK

THE VINDUR DECK, named after the Icelandic word for "wind," features bright colors, earthy tones, and an elegant minimalist and modern art style reminiscent of The Wild Unknown. The creator's intention for this deck was to bring light to things that are deeply felt but remain unseen. The vibrant artwork allows each scene to leap off the page as we gaze upon the figures and landscapes. There are figures depicted as people in this deck, but it transcends time in its designs of humans and the natural world.

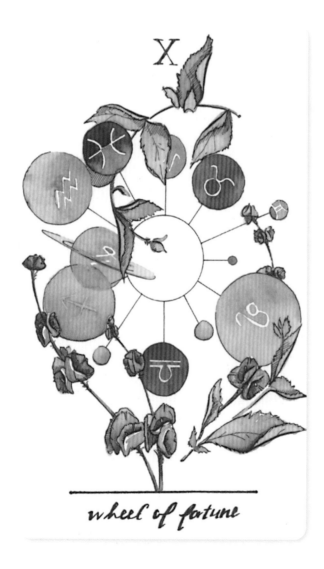

wheel of fortune

VII

YOU MIGHT ALSO LIKE: THE SPACIOUS TAROT

THE SPACIOUS TAROT is an immersive deck that invites you to explore the depths of yourself and the archetypes found in tarot through the lens of the natural world. Personally engage with each scene and allow the artwork to be your guide. The purpose of this deck is to use your intuition as a guide to interpret the artwork in each scene. Don't be scared; dive right in and see where the depths will take you.

GUARDIAN OF SWORDS

The Wheel of Fortune, Antique Anatomy Tarot

13

CONTEMPORARY TAROT

T WASN'T EASY to narrow down 600 years of tarot art into just a handful of influential decks for this book. One of the only reasons it was possible is that, during the explosion of tarot interest in the past century, the number of decks with widespread distribution, sales, and influence had been limited.

As we saw in the last chapter, when the internet made direct sales and crowdsourced funding possible, artists and mystics with a unique vision were suddenly able to get both marketing buzz and enough capital to launch a larger scale production, and the number of new decks every year exploded. To keep up with the market, publishers also started distributing more niche decks. Almost overnight, the tarot marketplace had dozens of new, beautiful, and groundbreaking arrivals each year. (Sometimes, there are a dozen new tarot decks in a month!) Some of these new decks are fun and silly, with cats or rats or unicorns posed to mimic the Rider-Waite-Smith artwork, while others bring mind-blowing new directions to expand and diversify the kinds of stories tarot can tell.

AS MEMBERS OF THE TAROT community, it's so exciting for us to see the creativity and success of our artistic peers, and it's even cooler to see how much more accessible it has made tarot. Whoever you are, whatever your interests, we're convinced you can now find a deck that feels completely right for you.

That's why we won't be looking at a particular deck in this last chapter, but a variety of decks in different art styles and genres emerging simultaneously in contemporary tarot. Each style is represented by several decks that, in their own way, have nudged the history of tarot art in some way. It's impossible to know what each deck's legacy will be, but they're our favorites for multitudes of reasons. These decks are representative examples of what we see impacting the modern tarot community, and we're so excited to share them as an overview of where tarot is today. Many of these decks could obviously fall under multiple subgenres, and this is nowhere near a definitive list.

FINE ART

FINE ART DECKS ARE CREATED either by fine artists or by people emulating the well-known styles of fine artists, with art specifically designed during the creation process with tarot archetypes in mind. They appeal to the fans of a particular artist or style, as well as tarot enthusiasts who want to experience the grandeur and complexity of a totally original set of images and archetypes. While we consider all tarot decks to be little packs of accessible art, the fine arts genre of tarot is particularly focused on emphasizing how beautiful and inspiring the art of a card can be.

The most established and recognized fine artist to create an original tarot deck was Salvador Dali, who released a limited-edition Dali Tarot deck in 1983 (with a 2020 limited edition rerelease), not long before his death. For a more recent project, we love the style of Japaridze Tarot, the original work of Parisian contemporary surrealist artist Nino Japaridze.

XII • THE DROWNED

JAPARIDZE TAROT is the result of a collaboration between Japaridze and Steven Lucas, owner of the Gallery of Surrealism in New York City. In 2011, Lucas approached Japaridze with the idea to create a version of the Major Arcana in her own distinct style and vision. Once the artist completed the first painting for The Star, she was hooked, and she thrust herself fully into the project. She created works for not just the Major Arcana, but continued through the Minor Arcana and court cards as well.

Japaridze used acrylic, gouache, ink, oil, and collage—and sometimes all of them on a single card. The result feels like seventy-eight individual, distinct, and complete works of art that somehow also fit together to create a unified deck filled with abstract beauty and bizarre symbolism. There are a few places we can see the influence of the Rider-Waite-Smith system, but not many.

The Star, the first card she created, is a standout favorite among many fans. The muted colors of the night sky swirl around planets and shooting stars while a woman sits on a bed (or maybe an iceberg?) with her back to the audience. It still takes our breath away every time we look at it.

Japaridze slightly altered a few of the classic archetypes to suit the art, changing names to give them new life and meaning. The four suits are renamed from Wands, Cups, Swords, and Pentacles to Fire, Tides, Winds, and Gardens to give them a more elemental feel. The court cards for The Page and The Knight become The Jester and The Stranger. Even some majors are renamed: The Emperor is now War, The Lovers are simply Love, and The Hanged Man becomes The Drowned.

I · THE MAGICIAN

OPPOSITE PAGE: Cards from The Light Seer's Tarot (top) and Japaridze's The Drowned (Hanged Man)

ABOVE: Japaridze's The Magician

This change from The Hanged Man is particularly interesting from an artistic perspective. Instead of a man hanging from a tree to represent a time of waiting, delay, or change of perspective as traditional Rider-Waite-Smith shows, Japaridze painted an upside-down figure, not bound by anything or held against their will as far as we can see. They have immersed themselves into the depths of the bright, colorful, and calming waters. This card speaks more to our subconscious and the unconscious desires that drive us. It drastically changes the original meaning and gives it a more empowering perspective.

Japaridze's dreamy and peculiar artwork reaches to these things that lie under the surface and brings them up, raising our awareness to thoughts and motivations that have likely never seen the light of day before.

Another type of fine art deck is not one created by a particular artist to showcase their own style, but is instead stylistically inspired by broader art movements. One of our favorites is the Impressionist Tarot created by Arturo Picca and released in 2015.

The nineteenth-century French Impressionist movement included some of the most recognizable art and artists of the post-Renaissance era, and this deck is full of familiar names like Manet, Monet, Degas, and Renoir. Impressionist Tarot doesn't use their actual works, but Picca manages to reflect their unique styles so well that at first glance, you might mistake any of the Major Arcana for parts of famous paintings.

For the Minor Arcana, Picca designed each suit around the unique traits of a specific artist. Claude Monet's style fills the suit of Cups because he is best known for his gardens and water lilies, as well as his overall gently emotive themes. The tortured genius Vincent van Gogh (technically a post-impressionist, but who's counting) reflects Swords, the suit of intellect. Edgar Degas's very physical figures glide and move across the Pentacle suit, and the Wands are dedicated to the style of Edouard Manet, one of the first artists to portray everyday life.

We love how Picca's art picks up the distinct styles and emotions of so many different individual styles while bringing out the deeper meanings and histories of tarot cards in a more subtle way. For example, the card known as The World (here only indicated by its numerals) clearly shows the Eiffel Tower, an icon of the French skyline, with people standing in front of it. To mimic the wreath usually encircling the individual on the World card, there's a cloud formation in white.

LEFT: The World (top) and The Star from Impressionist Tarot

YOU MIGHT ALSO LIKE: GOLDEN TAROT OF KLIMT

IF YOU'RE LOOKING FOR more fine art tarot, you may enjoy the Golden Tarot of Klimt. There's no end to artist Gustav Klimt's works plastered across college dorm rooms and high school lockers, but this is a new experience of the gold leaf and emotive female figures of the prolific twentieth-century artist. The deck, compiled in 2005 by Atanas Antchev Atanassov, uses a combination of Klimt's actual art with some light digital alteration.

MIXED MEDIA

THE EXPLOSION OF CREATIVE ART in tarot has brought us a variety of artistic expressions that step beyond the traditional method of painting. Mixed-media decks are usually created by tarot lovers whose expression of archetypes includes a collage of materials including cloth, wood, paper, found objects, paint, digital textures and photos, and even trash—whatever symbols the creator finds relevant to the meaning. We love these very personal decks that celebrate intuitive creativity, where the creative barrier to entry is lower. Think about how many of the tarot illustrators in previous chapters arrived with formal training from advertising or art school! Creating dynamic mixed-media images is accessible to anyone with magazines and a scanner (or more often these days, software and a laptop).

A stunning example of the depth mixed-media art brings to tarot is found in the Dust II Onyx Tarot. This deck is built from the mixed-media collage paintings of Courtney Alexander.

Alexander grew up in a Christian home and had heard tarot described as evil in fire and brimstone–type sermons on TV. She was leery of tarot at first, but in college she was friends with tarot readers, and the divinatory potential intrigued her. Eventually, Alexander took advantage of a new technology—the phone app—to learn about the cards and archetypes. The digital nature of tarot allowed it to not be so spiritually intimidating, and she wanted to know more.

However, when Alexander went to look for a physical tarot deck, none of them resonated with her as a Black woman. In an interview she did for the art group Creative Pinellas, she said:

There are decks out there that have representations of black people, but all of the tarot decks about black people & black culture were actually not created by black people. I felt an issue with that, because I thought, "How am I supposed to spiritually and emotionally connect with this deck that's made by someone who hasn't also lived my experience?"

Alexander decided if there wasn't a deck that felt right to her, she would have to make her own. Then, she had a set of dreams, including one specifically about imagery that would later be the inspiration for the Death card. Within a few weeks, working day and night on the project, Alexander had twenty paintings to display at a local art event. She received such powerful feedback that she continued the project to its completion.

The Temptation card (traditionally The Devil) is reclaimed from the traditional Western-Christian understanding of the Devil as a dangerous entity out to trick humanity. Dust II Onyx Tarot reframes that message by turning to some traditional African beliefs, where gods and people interact through both positive and negative traits. There's no one entity of evil out to get you and ruin your life, says the card, but all individuals have the choice and opportunity to engage with patience, moderation, and adaptability.

The beauty of mixed media is how different each expression can be. A fitting contrast to the style of Dust II Onyx is Moonchild Tarot, an Ancient Egypt-meets-art deco collage-style deck from Danielle Noel, who also created the popular Starchild Tarot.

XV

TEMPTATION

VII

THE RIDER

Moonchild Tarot explores the power of the moon, its phases, and other astrological associations. The art is grounding, focusing on shadow work and the inner workings of the user's subconscious. The warm, muted colors and Egyptology imagery of deserts, pharaohs, sphinxes, and doorways gives the art an ancient tone, inviting us to look back and explore deeper. An abundance of moons signifies the delicate power it has over the ebbs and flows of our lives.

The power of the Strength card draws from the traditional Rider-Waite-Smith imagery of a woman with a lion. The woman gracefully crouches with her back to the lion, displaying her trust in the relationship they have built together. In this image, Strength shows us that the source of strength isn't brute force or loud demands for obedience, but from confidently following your instincts and having faith in the relationship you've already built.

In addition to the seventy-eight cards that follow the Rider-Waite-Smith system, Noel chose to add three extra cards: Shadow Work, Divine Wisdom, and Moonchild. Each allows the reader to work with additional energies and archetypes not usually available in tarot decks.

THE HIGH PRIESTESS

STRENGTH

YOU MIGHT ALSO LIKE: GUIDED HAND TAROT

IF YOU'RE INTO COLLAGE-STYLE decks, we totally recommend you also check out Guided Hand Tarot by Irene Mudd. Guided Hand Tarot is loosely based on Rider-Waite-Smith archetypes and was designed in mixed-media collages with a "queered" feminist perspective. The people portrayed on Guided Hand cards are intentionally queer or androgynous, blurring the lines between "male" and "female." Mudd's layers of collage, painting, and embroidery gives this deck a unique, textural, and kaleidoscopic depth.

THREE OF CUPS

JUDGEMENT

POP CULTURE AND TV-INSPIRED

WHILE WE'VE SEEN POP CULTURE REFERENCES bin earlier influential decks like Cosmic Tarot or Morgan-Greer Tarot, it's only in recent years that entertainment started driving the creations of entire niche tarot decks. Instead of an artist choosing to bring in a few famous faces to help readers make connections with meanings, whole decks are now created just for existing fan groups. While it might seem a little too commercial for meaningful art or tarot readings, from our perspective, pop culture fan decks can both introduce superfans to tarot and also deepen a tarot lover's understanding of the media portrayed in a fun deck.

A perfect example is the deck that took 2020 by storm, The Golden Girls Tarot.

"A look at your future from the lanai" is the tagline for The Golden Girls Tarot created by illustrator Chantel De Sousa. What a charming invitation from a charming tarot deck! It immortalizes Blanche Devereaux, Rose Nylund, Dorothy Zbornak, and Sophia Petrillo, our favorite gals from the classic 1980s hit TV sitcom, and brings up so much nostalgia for those of us who remember the show, either from its first airing or from bingeing the reruns. While the cards are illustrated, it doesn't come across as a cartoonish or like caricatures of these beloved characters. De Sousa was able to perfectly capture facial expressions, and "the girls" are immediately recognizable to their fans.

De Sousa, the illustrator for several books and a mountain of adorable memorabilia items about *The Golden Girls,* not only has intimate and almost superfanesque knowledge of the intricacies of the show, but also has an unusually clear grasp of tarot archetypes. This is a rare TV spin-off deck that is able to match scenes and characters to tarot.

For example, the Three of Cups is one of the most perfect Three of Cups we've seen in a modern deck. A cherry cheesecake sits on the table in front of Rose, Dorothy, and Blanche, who hold up golden goblets in a toast. It embodies the joy and enthusiasm that this tarot card brings to mind.

De Sousa also reflects something we see in a lot of spin-off decks, the blurred line between moments that actually happened in the show and moments that superfans know aren't in the show but could have happened in an episode. For instance, the Ten of Cups shows sweet, good-hearted Rose with her beloved husband Charlie. As fans, we know this "happily ever after" moment couldn't have happened on the show because Rose was already a widow, but it feels perfect within *The Golden Girls* universe that Rose and Charlie are together. De Sousa also makes sure that even the clothing becomes part of the story. In the Three of Swords, Dorothy is in a stormy scene wearing a sweater with an appliqué heart that has three swords protruding from it. Dorothy is usually known as the most straightforward and even-keeled of the group, but she has also experienced

immense pain in her life. Hinting at that depth gives depth to a character, showing that she's more than a quick and sassy comeback.

Once it was clear that superfans were interested in tarot decks to complement their passions, niche decks for fans started to appear for other areas of interest as well. We both happen to love reading regency romances (set in Britain just before the reign of Queen Victoria) and watching a good costume drama every once in a while, so we were thrilled to discover Le Beau Monde Tarot from creator Jennifer Pool.

One of the established tropes in regency novels and movies is that the main characters, in an effort to be their most authentic selves, must typically buck societal expectations and do what they have to do to make themselves happy. You can maybe see how there's a lot of overlap between fans of these stories and people who are drawn to tarot.

Pool used images from *Ackermann's Repository*, the casual title of the much more formalized periodical *Ackermann's Repository of Arts, Literature, Commerce, Manufactures, Fashions, and Politics*, which was published between 1809 and 1829. *Ackermann's Repository* was filled with fashion plates depicting the new and popular styles of the day, done in line drawings of women engaged with social activities. There were forty published volumes of *Ackermann's Repository*, so Pool had hundreds of images to choose from and alter digitally in order to accomplish specific motifs to fit tarot meanings and archetypes.

Many of the cards are composites of different images. For example, the Magician card collects all the minor card objects and places them on or around a table before a woman who coyly looks at us with the confidence that she knows what she's doing. The images count on tarot users who know the tropes and inside stories. The Death card, one of our favorites, depicts a widow wearing a full mourning costume. It liter-ally references death (of the widow's husband) but we think it's also winking at regency fans who know that upper-class widows of this time period would have way more freedom and room for transformation than their single or married counterparts, which speaks to the transformative meaning of the Death card.

To further emphasize the link between regency fashion, regency romance, and the lady-centric link between romance and tarot, Pool renamed the suits and court cards. Kings, Queens, Knights, and Pages became Dowagers, Duchesses, Bluestockings, and Debutantes—all characters and archetypes familiar to romance readers that also emphasize the growth and transitions of a regency-era aristocratic woman. The suits were renamed Candles (for Wands), Parasols (for Cups), Fans (for Swords), and Reticules (for Pentacles) in order to further the theme. It's just so well-done and super fun, and we think that perfect intersection of fandom, history, and tarot will continue to become even more popular.

Pop culture is such a broad—and popular!—growth area for tarot that we want to share one more example of a different artistic approach. Some twenty-first-century pop culture decks have less of a hyperspecific scope but still have equally effective references to recognizable pop culture figures. We found a great example of this style from Krystal Banner and her delightful Kaleidadope Tarot.

Kaleidadope [kal-eida-dope]
A combination of the meanings: Beautiful, shapes/forms, and cool

Krystal Banner always felt a need to create something. Since childhood, art was her escape and her happy place, but her job as an engineer didn't give her the time or space to sit and traditionally create. Then, she stumbled across

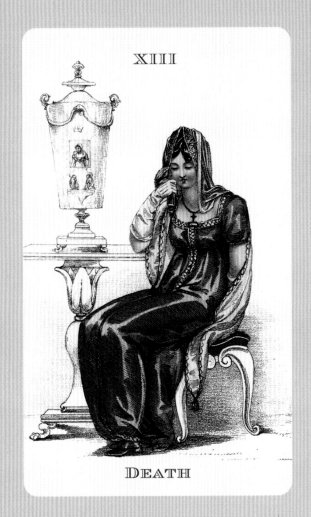

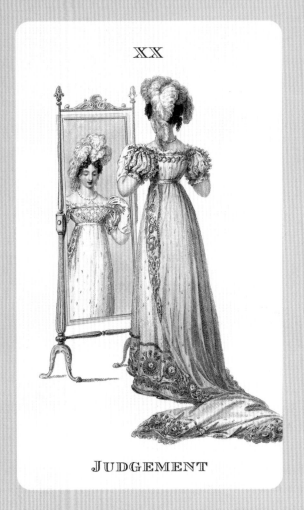

ABOVE: Le Beau Monde's Death and Judgement

FOLLOWING PAGE: The Two of Coins and Nine of Cups from Kaleidadope Tarot

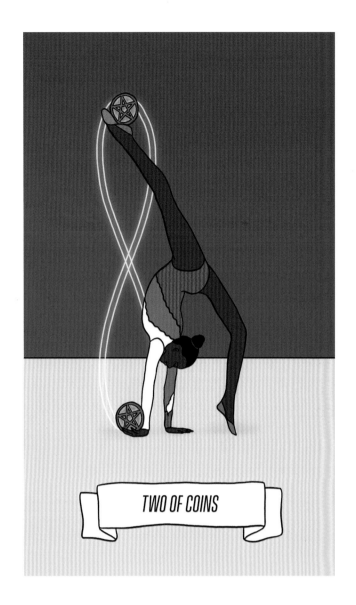

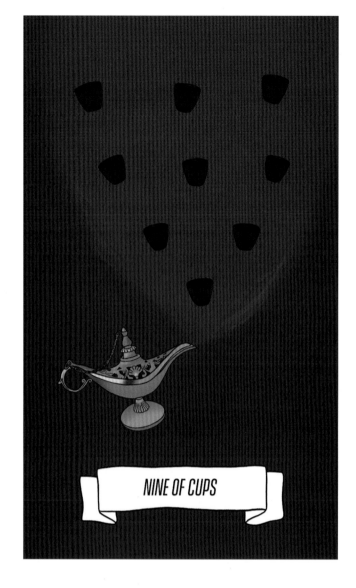

digital art and realized she had the flexibility to create art anywhere, even when she was traveling. At the same time, tarot became a pervasive resource in her life, along with the urge to create her own tarot deck with symbols and images easily understood to the next generation of tarot readers.

Her resulting deck is one of a kind and fresh, with an abundance of pop culture references from Beyoncé to Barbie that makes this deck perfect for new readers or the younger generation who understand these references. Just look at the Nine of Cups and its nod to the early '90s Disney movie *Aladdin,* with nine cups splayed around the

wish fulfillment that comes from the genie's lamp. Another one of our favorite cards, the Two of Coins, depicts a Black girl in the middle of a gymnastics floor exercises routine, balancing one pentacle on top of one foot and holding the other in her hand. In her, we see the legacy of some of the great Black Olympians of the 2010s like Dominique Dawes, Gabrielle Douglas, and Simone Biles, while at the same time helping the reader with the card's meaning of balancing our lives on a day-to-day basis. Even if we fall—and it's okay if we do—we need to just get back up again and practice balancing some more.

If you're a pop culture fanatic like us, you might also enjoy TV Series Tarot by scriptwriter Gero Giglio, who takes characters and scenes from famous TV series and places them into tarot archetypes. The artwork for this deck was created digitally by Davide Corsi, with likenesses of our favorite actors and actresses ranging from the mid-seventies until the deck's publishing in 2018. The cards that we really enjoyed from this deck are *Magnum P.I.*'s Thomas Magnum as the King of Cups, and *Miami Vice*'s Sonny and Rico as The Sun, sitting on their iconic car on a sunny Miami beach. This deck is a fun trip down TV memory lane.

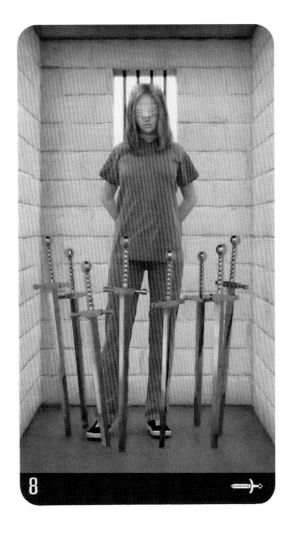 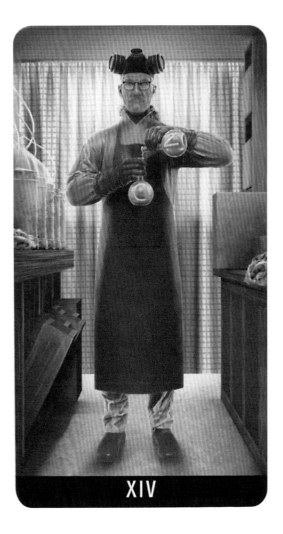

TV Series Tarot also pays homage to *Orange Is the New Black* and *Breaking Bad*

FOLLOWING PAGE: The Lovers (top) and The Empress from Antique Anatomy Tarot

PAGE 239: The Fool (top) and The Sun from Our Tarot

AS WE'VE SEEN since the beginning of the book, every generation and culture has tried to explain the human experience and searched for truth. Historically reverential decks are fully contemporary decks with modern sensibilities that look back to honor specific historical figures or time periods. We've seen the market fill with decks that reference specific forms of "seekers," homages to interesting time periods (historical pop culture, we guess), and those that ruminate about what history really even is. In many cases, the gravitas of the content is paired with interesting and engaging artwork.

Let's start with Antique Anatomy Tarot from Canadian artist and writer Clare Goodchild. This is a great example of a tarot deck inspired by a love of Victorian history, pseudoscientific ephemera, and medical oddities that tapped into spiritual subconscious and reminded tarot readers that our yearning for concrete truth in an uncertain world is not new.

Goodchild initially created a deck by combining digital images of historic artifacts that she found in the Wellcome Library, a British museum dedicated to collecting and freely sharing the works and vision of Victorian-era pharmacist, entrepreneur, and medical historian Henry Wellcome. His namesake museum is filled with skeletal images, historical medical texts, old apothecary remedies, and other symbols of Victorian scientific pursuits that Goodchild could manipulate to convey the deeper meanings of tarot.

Another thing that Victorians (and Goodchild) loved? The spiritualist movement, which attempted to use scientific methodology—along with pseudoreligious practices like spirit boards, crystal balls, and seances—to invoke the dead. This is where the art of Antique Anatomy really stands out to us. Goodchild brought reminders of both the scientific and the spiritual, balanced them with delicate flora and fauna, and succeeded in creating a deck so full of iconography that the Victorians themselves would have understood it.

The first edition of Antique Anatomy filled a niche need that the history and oddities-loving tarot community didn't know it had. It was so popular when it released in 2015 that it led to a second edition of Antique Anatomy—the one available today—that is even more lush, dynamic, and Victorian-referencing, with more medical tools, elixirs, and flowers.

A totally different, and more straightforward, approach to history

comes in Our Tarot by Sarah Shipman. Our Tarot is a carefully constructed multimedia deck, with each card representing a woman from history. Similar to The Wild Unknown, this deck began in 2016 as an indie deck on Kickstarter and went viral beyond the confines of the tarot community after a Huffington Post article was written about it. Soon after, it was picked up by HarperCollins and, with some adjustments, was rereleased in 2020.

The collage mediums are so textural that you can almost feel them, and the women come from time periods ranging from ancient eras to the late twentieth century. It's a beautiful deck filled with creatively layered and striking images. We love The Sun, which depicts Sister Rosetta Tharpe (a singer/songwriter/guitar player from the 1930s and '40s known as the "godmother of Rock 'n' Roll"). Tharpe stands in the foreground with her guitar, embodying the joy and happiness that the Sun card represents, with a painted sun in the background and a pair of sunglasses sitting on the sun itself.

The research for Our Tarot is explained in the super extensive book that comes with this deck. In the section about The Fool, portrayed using Joan of Arc, Shipman doesn't just focus on Joan of Arc's famous visions of battles with the English army, which would be a deviation from the meaning of the card. Shipman also focuses on how many risks she took, including a literal leap out of a prison tower. The deck challenges what we think we know about the Fool card, (which is not just about being a neophyte), as well as our understanding of a historical woman who has been distilled over time to either a literal saint or a lost and possibly mentally ill teen girl.

Shipman is clear that this is not meant to be a sugarcoated version of women's history. There are many figures in the deck that are objectively horrible people. For instance, American socialite and Nazi sympathizer Wallis Simpson represents ruthlessness and self-absorption in the Knight of Swords card. Abigail Williams, the girl who in 1692 accused her neighbors of witchcraft and began what would become the Salem Witch Trials, is on the Devil card to represent malicious intent and deception. Their inclusions in the deck challenge a tarot reader to think about what people become known for and how little control we actually have over how our actions will be seen in the future.

0. THE FOOL

JOAN OF ARC

XIX. THE SUN

SISTER ROSETTA THARPE

YOU MIGHT ALSO LIKE: MADAM CLARA'S 5¢ TAROT

IF YOU'RE EPHEMERA GEEKS LIKE US, check out Madam Clara's 5¢ Tarot, created by Madam Clara, a fortune teller character developed by Rick Pomer. The deck spins off from whimsical, circus-style Victoria posters, using animals instead of humans and including keywords for the meanings of the cards floating around the main figures. Pentacles are Buttons, Swords are Needles, Wands are Matchsticks, and Cups are Teacups; many of the animals and insects depicted are clothed in dapper nineteenth-century-style outfits.

HUMAN EXPERIENCES

LASTLY, AND TO US MOST IMPORTANTLY, contemporary tarot artists have made giant, important, and incredible strides to represent a much wider range of human experiences. In previous chapters, we've talked about decks that broke the molds set by largely white, wealthy, and presumably cisgender people. They often accomplished that in their artwork by illustrating prehistoric scenes like the Motherpeace Tarot, or through nonhuman depictions like The Wild Unknown.

Today's decks go a step further. These decks don't look outside the human experience; they dive deep into what makes us human and celebrates it. They use modern human experiences of race, gender, sexuality, and ability to represent as many people as possible in creative and amazing ways.

Perhaps one of the best known examples of this inclusivity in tarot is Cristy C. Road's Next World Tarot, which brings a postapocalyptic and punk rock aesthetic to the traditional seventy-eight cards.

Next World Tarot's Justice and The Messenger (The Hierophant)

IIII

L'EMPEREUR

KHAN.EATON

Road is a Cuban-American artist and musician who has published several graphic novels focusing on themes of cultural identity, sexual identity, belonging, and trauma and toured with the lesbian, feminist spoken word and performance art group Sister Spit. It was after receiving several moving tarot readings from a founding member of the group, Michelle Tea (who has an amazing tarot book called *Modern Tarot*), that Road started exploring her own experiences.

She used ink, markers, paint, whiteout, and anything she could get her hands on to create a truly unique tarot deck. She changed the names of the more patriarchal cards, turning The Emperor into The Teacher and The Hierophant into The Messenger. Sixty-eight of the Next World cards focus on people of color, and Road says that all the adult humans depicted are queer. Somehow, even though the themes are completely apocalyptic, the deck seems uplifting and focused on positive change.

There are huge challenges in the art of this deck, like the Revolution card (renamed from The Tower) that depicts pipeline protesters and a burning horizon, a far more relatable image than the traditional single, isolated tower struck by lightning. It emphasizes that sometimes to see progress and make actual changes, there needs to be a systematic overhaul and a complete restart to these structures that had been created to oppress others, and it comes through revolution. There are also smaller and individually relatable moments, like the person writing in a messy apartment on the Four of Swords showing a respite. Each card has a multilayered story of

community, responsibility, and respecting each other's humanity while tearing down systems of oppression.

A deck with art that conveys an entirely different take on being revolutionary is Black Power Tarot, a Major Arcana–only deck (i.e., the first twenty-two cards from The Fool to The World) created in the style of the Tarot de Marseille, but replacing the figures with iconic Black activists, comedians, and public figures. The art is even done in a similar woodblock print style.

The project was a joint effort between the musician King Khan and the avant-garde filmmaker Alejandro Jodorowsky, with art done in the traditional Tarot de Marseille style by Michael Eaton. Jodorowsky, a self-proclaimed "purist," believed that Tarot de Marseille was the only deck worth working with, and he even produced a deck in partnership with a French printer that had been producing Tarot de Marseille decks since the eighteenth century for a more accurate tarot experience.

Jodorowsky's influence is felt in the careful associations Khan and Eaton make in the art. It becomes both a pop culture deck and a deck that celebrates Black excellence, with Tina Turner as the powerful, dynamic, strong woman in Force (Strength), among other famous faces. Khan and Eaton have intentionally left some figures less recognizable to allow for personal interpretations and understandings.

OPPOSITE AND RIGHT: Cards from the Black Power Tarot

Finally, one of the more recent decks to grab the attention of the tarot community is the Fifth Spirit Tarot, which describes itself as "Tarot for a World Beyond Binaries." The creator, Charlie Claire Burgess, artistically compiled a cast of people who do not adhere to traditional gender binary. Burgess did not consider themself an artist before creating this deck, but as they started to draw, their artistic style emerged as something homey and meaningful. Burgess had been teaching tarot in Portland, Oregon for years, and their cultural experience lends some serious cozy cottage in the countryside (cottagecore) vibes to the deck, which is filled with coffee cups, plants, and folks living their most authentic lives.

Unlike many of the previous decks we've talked about, Burgess opted not to change any names of the cards in order to further open up a tarot reader's perceptions of who can emulate an archetype. Why shouldn't the Queen of Pentacles be presented as a masculine presenting person who loves growing plants and keeping pets safe and happy? The Fifth Spirit Empress is a person with long flowing hair, no breasts to speak of, and a gentle expression, reminding us that the lushness and creativity of the card doesn't have to be tied to motherhood (that card frequently depicts a pregnant woman).

In the guidebook, Burgess says that they think that every figure is a binary or nonbinary, but we're welcome to make our own assessments and decisions about each person. They go on to clarify that they're not trying to demonize gender; they're just trying to do away with the idea that some cards are inherently feminine or masculine, which further stigmatizes nonbinary people and can make them feel like tarot is not something that is meant for them.

Fifth Spirit Tarot's The Empress and Queen of Pentacles

YOU MIGHT ALSO LIKE: NUMINOUS TAROT

IF YOU'RE LOOKING FOR another deck that goes beyond the binary, check out Numinous Tarot by Cedar McCloud that bridges the gaps between the representation of real-world people and the mysticism of their own personal spiritual journey. McCloud, who is agender and pan/demisexual, started the Numinous Tarot as a personal art project after graduating from college and floundering for inspiration. They opted to create another unique naming system largely removing gendered language. In fact, McCloud says that all figures in the deck should be referred to using they/them pronouns so that anyone using it would be able to see themselves reflected in the artwork.

EPILOGUE

 MORE AND MORE DECKS are being published each month. At the moment of writing, there are two dozen active decks being funded on Kickstarter, and these decks range from deeply esoteric to fully pop culture. This will continue. Tarot decks are affordable, and people who love tarot will expand their collections as they see new styles of art and meanings that appeal to them—we know we sure do. With collectors, we think that rare and historical decks will gain popularity, with Tarot de Marseille recreations and long out-of-print items becoming even more sought after.

When we started writing this book, we knew that digging deep into the history of the art of tarot would be like watching the sausage being made. For two tarot lovers who have experienced immense personal growth and change while using tarot cards as a tool for digging deeper, we worried that knowing the human beings (and their humanness) would make the tools feel less significant. What actually happened was the opposite. Knowing how human, and occasionally problematic, the minds behind the decks we love were has allowed us to create our own personal relationships with the art itself.

It's true that our relationships with these decks have shifted, and decks we once hadn't cared for are now decks we love. And that's what we want all our tarot-reading readers to experience too. We want our friends who have tenuous links to their inner selves to keep reaching out for this tool. We want spiritual seekers to take their exploration into their own hands with their own decks. We want everyone who wants to read tarot to find a tarot deck that feels good to them. We think it's possible, and we're so excited for even more people to have access to personal growth via the Tarot.

WHAT DO THE CARDS MEAN?

(A CHEAT SHEET)

THERE ARE SEVENTY-EIGHT CARDS IN A TAROT DECK, and each one has its own history and meaning. It's a lot to keep track of, we know! Since what the cards represent frequently comes into play with how we understand and describe the art on specific cards, here's a quick reference sheet for some context. There are as many interpretations of tarot cards as there are tarot readers, so we're not claiming that any of this is definitive.

There are three historically significant decks here, with slightly different interpretations of the cards: Tarot de Marseille, Rider-Waite-Smith, and Thoth. Many more modern decks will specify what "style" of deck their cards follow, so you can use those definitions for a general reference (honestly, it's almost always Rider-Waite-Smith)—or you can always choose what feels the most natural for you!

We first compiled the meanings for the Tarot de Marseille and Rider-Waite-Smith cards for our own Wildly Tarot Deck, a flashcard-style tarot deck we created in 2018 to help our podcast listeners increase their confidence with the rote meanings.

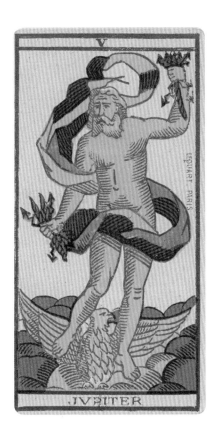

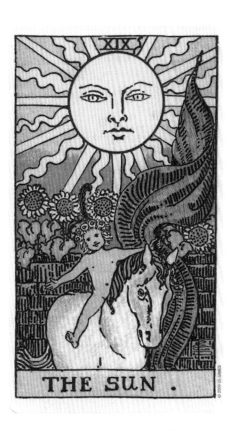

81: Antoine Court de Gébe-
n publishes a reconstructed
rot history leaning heavily on
kelore about ancient Egyp-
an uses of tarot game cards
r divination. This is the first
ocumentation of divinatory
ses of tarot cards, though
ey were likely used this way
efore this point.

1856: Elphas
Levi writes
the immensely
influential
*Dogma and
Ritual of Tran-
scendental
Magic*.

1887: The once-
secret esoteric
society the Hermetic
Order of the Golden
Dawn is established,
based on the writ-
ings of Kenneth
Mackenzie.

1901: Llewelyn is
founded as an astro-
logical publishing
house.

1938–1942: Frieda Ha
creates paintings for
would become the Th
Tarot deck.

1907: The Sola family gives
black-and-white photographs of
the Sola-Busca Tarot deck to the
British Museum for a temporary
exhibit.

1944: Thoth Tarot is
published in a limit-
ed-edition batch of 20
decks.

1856 1880s 1900s 1912 1938-47

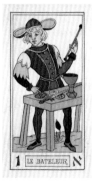

1889: Oswald Wirth
publishes his deck
based on Levi's
teachings. Papus
also publishes
*Tarot of the Bohe-
mians*.

1909: A. E. Waite and
Pamela Colman Smith
publish The Rider-
Waite-Smith tarot deck.
Aleister Crowley also
anonymously publishes
the Liber 777 essays,
exposing the teachings
and rituals of the
Golden Dawn.

1912: Crowley
publishes the
essay "Book T,"
his first teach-
ings about the
Tarot.

1947: Paul Foster
Case publishes
*Tarot: A Key to
the Wisdom of the
Ages*.

MISS PAMELA COLEMAN SMITH

89: First occult
ck based on
rmetic teach-
s is created by
rench occultist
o writes under
pen name
eilla.

1441: To celebrate the strategic marriage between two families of Milanese royalty, the elaborate golden Visconti deck is commissioned. Latest possible introduction of tarot cards to Europe.

1637: Printing date of the oldest surviving pamphlet with rules for the contemporary tarot game.

Late 1300s: Playing cards in the Mamluk style are introduced in Europe. Most documentation comes from local legislation and ordinances about gambling.

1491: Nicola di Maestro Antonio is presumably commissioned to create the art for Sola-Busca Tarot.

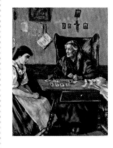

1735: The Parliament of the United Kingdom passes The Witchcraft Act, making it a crime to make claims about foretelling the future, speaking to spirits, or casting spells.

late 1300s 1420s 1441 1490s 1515 1637 1700-1740 1780s

1700–1740: Tarot deck publishers pop up all over France and Italy with increasingly standardized artwork (now generally referred to as Tarot de Marseille–style decks).

1420: Italian nobility starts commissioning luxury decks for game play. An allegorical card game based on virtues and temptations is commissioned by Duke Filippo Maria Visconti of Milan.

1515: Tarot images appear on a German nativity calendar, signaling its pervasiveness in popular culture as a card game.

1490s: France conquers parts of Italy, and most tarot card printing shifts to France.

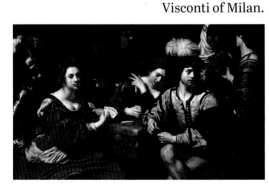

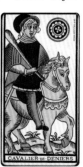

TAROT DE MARSEILLE MEANINGS

Reading Tarot de Marseille cards is super systematic. The Major Arcana each have their own meanings, and the numbered Minor Arcana follow those meanings with a different emphasis for each suit.

The Magician
(first trump card, associated with Aces):
Willpower, Creation, Energy

The High Priestess
(second trump card, associated with Twos):
Development, Gestation

The Empress
(third trump card, associated with Threes):
Raw Energy, Fertility

The Emperor
(fourth trump card, associated with Fours):
Stability, Order

The Hierophant
(fifth trump card, associated with Fives):
Exploration, Growth

The Lovers
(sixth trump card, associated with Sixes):
Joy, Pleasure, Beauty

The Chariot
(seventh trump card, associated with Sevens):
Action, Focused Development

Justice
(eighth trump card, associated with Eights):
Harmony, Balance, Clarity

The Hermit
(ninth trump card, associated with Nines):
Releasing, Letting Go

The Wheel of Fortune
(tenth trump card, associated with Tens):
Completion, Resolution

Strength
Inner Strength, Confidence, Bravery

The Hanged Man
Perspective Shift, Waiting, Reassessment

Death
Cycles Ending, Transformation, Closure

Temperance
Balance, Patience, Self-Care

The Devil
Fixation, Bondage, Release

The Tower
Upheaval, Awakening, Chaos

The Star
Hope, Tranquility, Renewal

The Moon
Hidden Influences, Uncertainty, Illusions

The Sun
Pure Joy, Abundance, Motivation

Judgement
Purpose, Self-Evaluation, Rebirth

The World
End of Journey, Wholeness, Coming Full Circle

The Fool
Exploration, Foolishness, Starting a Quest

	Cups Feelings, Relationships	**Wands** Creativity, Action	**Swords** Intellect, Ideas	**Coins** Finances, Home
Ace	potential for emotional connections	potential for action	potential for inspiration	potential for new opportunities
Two	developing of emotions	planning a course of action	reflection and assessment	taking care of physical needs
Three	expressing emotions without reserve	spontaneous action	expressing a new plan	new investment
Four	controlled emotion	habits and stable routine	systematic analysis	financial stability
Five	exploration of emotions	expanding on projects	open-mindedness	pushing yourself
Six	pleasure in relationships, emotional connections	the joy of a passion project	the beauty of learning new things	comfort, joy of physical space
Seven	giving emotional support	hard work toward project	sharing knowledge	expanding business
Eight	compassion, harmonious emotions	unimpeded actions	clarity of thought, understanding	balance of physical self
Nine	letting go of a relationship	releasing control of a creative project	releasing old thought processes	moving; closing a business endeavor
Ten	emotional closure	completion of a project	compromise is reached	financial goals have been met
Pages: Child	conveyer of a new spark of emotion	conveyer of a new spark of energy	conveyer of a new spark of an idea	conveyer of a new spark of material concerns
Knights: Messenger	bringer of emotions to the world	bringer of action to the world	bringer of ideas to the world	bringer of comfort
Queens: Keeper	master of emotions	master of energy	master of intellect	master of homely concerns
Kings: Leader	leader of emotional concerns	leader of energetic activities	leader of intellectual pursuits	leader of material matters

RIDER-WAITE-SMITH MEANINGS

The Rider-Waite-Smith Tarot deck's Major Arcana are in a slightly different order than in Tarot de Marseille, with the Strength and Justice cards switching spots. The Minor Arcana also have a less systematic method for meanings, which you can see in the table below.

The Fool
Exploration, Naiveté, Starting a Quest

The Magician
Willpower, Creation, Energy

The High Priestess
Development, Gestation

The Empress
Raw Energy, Fertility

The Emperor
Stability, Order

The Hierophant
Exploration, Growth

The Lovers
Joy, Pleasure, Beauty

The Chariot
Action, Focused Development

Strength
Inner Strength, Confidence, Bravery

The Hermit
Releasing, Letting Go

The Wheel of Fortune
Completion, Resolution

Justice
Harmony, Balance, Clarity

The Hanged Man
Perspective Shift, Waiting, Reassessment

Death
Cycles Ending, Transformation, Closure

Temperance
Balance, Patience, Self-Care

The Devil
Fixation, Bondage, Release

The Tower
Upheaval, Awakening, Chaos

The Star
Hope, Tranquility, Renewal

The Moon
Hidden Influences, Uncertainty, Illusions

The Sun
Pure Joy, Abundance, Motivation

Judgement
Purpose, Self-Evaluation, Rebirth

The World
End of Journey, Wholeness, Coming Full Circle

	Cups	**Wands**	**Swords**	**Pentacles**
Ace	New Beginning, Overflowing Love, Emotional Excitement	Willpower, Inspiration, Sparked Potential	New Ideas, Breakthrough, Truth	New Opportunity, Manifestation, Material Increase
Two	Connectedness, Harmony, Unity	Planning, Progress, Internal Discovery	Impasse, Choices, Avoidance	Balance, Flexibility, Control
Three	Friendship, Celebration, Openness	Expansion, External Planning, Foresight	Sadness, Heartbreak, Disappointment	Collaboration, Problem-Solving, Compromise
Four	Contemplation, Apathy, Evaluation	Celebration, Community, Homecoming	Rest, Reflection, Convalescence	Clinginess, Overprotectiveness, Control
Five	Loss, Sorrow, Deep emotions	Chaos, Competition, Struggle	Ambition, Selfishness, Single-Mindedness	Need, Poverty, Accepting Help
Six	Nostalgia, Reconnection, Youth	Victory, Accomplishments, Recognition	Transition, Escape, Inner Journey	Generosity, Kindness, Receive Gracefully
Seven	Choices, Illusions, Daydreams	Opposition, Challenge, Defensiveness	Strategy, Manipulation, Innovation	Investment, Cultivation, Diligence
Eight	Transition, Leaving Things Behind, Changing Direction	Swiftness, Straightforwardness, Taking Initiative	Isolation, Victimization, Negative Thoughts	Hard Work, Mastery, Skill Development
Nine	Satisfaction, Achievement, Gratitude	Emergence from Struggle, Resilience, Persistence	Anxiety, Worry, Nightmares	Reward, Fruits of Labor, Bountiful Harvest
Ten	Fulfillment, Happiness, Serenity	Burdens, Overextending, Commitments	Exhaustion, Responsibility, Rock Bottom	Contentment, Inheritance, Success
Page	Creativity, Intuitive, New Energy	Enthusiastic, Discovery, Adventurous	Intelligent, New Perspective, Curious	Personal Growth, New Skill, Pursuing Goals
Knight	Imaginative, Helpful, Artistic	Inspiration, Passion, Determination	Quick Thinking, Impulsive, Ambitious	Moving Forward, Dependability, Thoughtful
Queen	Empathetic, Nurturing, Open	Courage, Strength, Joy	Sharp-Minded, Ethical, Calm	Warm, Practical, Homey
King	Emotional Control, Compassion, Stability	Natural Leader, Outgoing, Resourceful	Intellectual Power, Decisiveness, Clarity	Hardworking, Reliable, Prosperous

ght
om
k is

ace

BY KAREN VOGEL & VICKI NOBLE
rpeace
D TAROT DECK

2000: Llewelyn enters into a partnership with Lo Scarabeo.

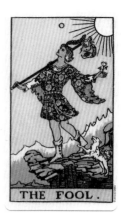

THE FOOL.

2021: Pamela Colman Smith's artwork for the Rider-Waite-Smith Tarot deck enters public domain.

2003: Druidcraft Tarot is published.

2011: Kickstarter ushers in a new wave of tarot decks by independent creators.

1990s	2000s	2010s	2021

2007: Deviant Moon Tarot is published.

2012: The Wild Unknown Tarot is self-published.

ot

1990s: Llewellyn Worldwide begins to publish and sell tarot decks.

2009: Pinacoteca di Brera acquires the last complete and hand-colored copy of a Sola-Busca Tarot deck from the Sola family.

2016: *Our Tarot* is self-published and gains national recognition.

OUR TAROT

1960: Eden Gray publishes *The Tarot Revealed*, the first book to make tarot accessible to a wider audience.

1970: Aquarian Tarot, drawn by David Palladini, is published by Morgan Press. The Fool's Journey is detailed for the first time in Eden Gray's book *Complete Guide to the Tarot*.

1980: *Seventy-E Degrees of Wisd* by Rachel Polla published.

1981: Motherpe Tarot is created

1968: U.S. Games acquires the rights to the Swiss 1JJ deck, solidifying their position in the tarot publishing business.

1951 1960s 1970s 1980s

1951: The Witchcraft Act is repealed in Great Britain, thus allowing for the publishing and selling of tarot decks.

1969: Thoth Tarot is published widely for the first time since its original limited release.

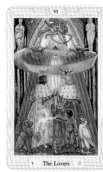

1971: U.S. Games gains the copyright to Rider-Waite-Smith Tarot.

1984: *Tarot for Yourself* by Mary K. Greer is published.

1988: Cosmic Ta is published.

1979: Morgan-Greer Tarot is published.

THOTH MEANINGS

Thoth Tarot is based on a system designed by Aleister Crowley. There are much deeper esoteric symbols in this deck than we can go into here, but this should give you a taste of what Crowley intended for the cards to mean. There are also several name changes (marked with an *) to show intentional differences from the systems that came before it.

The Fool
Initiation of creative energy

The Magus*
Self-determined willpower

The Priestess*
Intuition and subconscious power

The Empress
Creation and source of life

The Emperor
Conquest through self-discipline

The Hierophant
Study and exploration of belief and structures of faith

The Lovers
Unification of opposing forces

The Chariot
Triumph and victory over obstacles

Adjustment*
Finding balance with opposing forces

The Hermit
Obtaining wisdom from within

Fortune*
Ever-changing complexity of fate

Lust*
Passion for life that does not deny its desires nor let them run wild

The Hanged Man
Change of perspective willing to sacrifice for others

Death
Embracing the cycle of death and rebirth

Art*
Combining ordinary elements to create something perfect and precious

The Devil
Freedom through self awareness and autonomy

The Tower
Destruction of old, outdated beliefs and paradigms

The Star
Maintaining hope and optimism

The Moon
Journeying deep into the subconscious, dark night of the soul

The Sun
Generosity with the abundance you have received

The Aeon*
Awakening; awareness of what you need to do

The Universe*
Synthesis between body and spirit, inner independence

Minor cards in Thoth Tarot decks have their primary keyword written on the card. An additional keyword (the second descriptive word for each card below) expands the understanding of the card. The court cards include the natural element corresponding to their title and the element of the suit they reside in.

	Wands (Fire)	Cups (Water)	Swords (Air)	Disks (Earth)
Ace	Untamable Will and Drive	Source of Emotions	Inception of Thought	Source of Creation
Two	Domination, Plan of Action	Love, Mutual Feelings	Peace, Stalemate	Change, Adaptation
Three	Virtue, Collaboration	Abundance, Receiving Love	Sorrow, Devastation	Works, Accomplishment
Four	Completion, Peer Support	Luxury, Stability in Life	Truce, Reflection	Power, Assured Success
Five	Strife, Interpersonal Crisis	Disappointment, Emotional Crisis	Defeat, Intellectual Crisis	Worry, Material Crisis
Six	Victory, Creative Fulfillment	Pleasure, Emotional Fulfillment	Science, Intellectual Fulfillment	Success, Material Fulfillment
Seven	Valour, Overcoming Struggles	Debauch, Illusory Success	Futility, Cutting Away Delusions	Failure, Surrender
Eight	Swiftness, Rapid Progress	Indolence, Moving On	Interference, Restless Thoughts	Prudence, Risk Assessment
Nine	Strength, Enduring Trials	Happiness, Contentment	Cruelty, Despondency	Gain, Satisfaction
Ten	Oppression, Oppressive Power	Satiety, Inner Completion	Ruin, Learning from Pain	Wealth, Material Security
Princess	Earth + Fire, Natural Enthusiasm	Earth + Water, Wildly Imaginative	Earth + Air, Carefully Curious	Earth + Earth, Pure Growth
Prince	Air + Fire, Impulsive	Air + Water, Open-Minded	Air + Air, Idealistic	Air + Earth, Unwavering
Queen	Water + Fire, Emotional Expansiveness	Water + Water, Emotional Depths	Water + Air, Emotionally Perceptive	Water + Earth, Emotional Stability
Knight	Fire + Fire, Individualistic	Fire + Water, Emotional Warmth	Fire + Air, Sharp-Witted	Fire + Earth, Pragmatic

At Fortune Teller's House. Engraving by Walla. *L'Illustration*, 1885. Colored.

APPENDIX:
HOW TO READ TAROT

MAYBE YOU PICKED UP THIS BOOK because you're a longtime tarot fan who has been reading your cards for years, or maybe this whole divination thing is new to you. Either way, welcome! We hope you've fallen in love with the art of tarot. Since reading tarot is so important to us, we couldn't end this book without giving a quick introduction on how to get started with a tarot reading. Remember, always do what feels right to you, and if you're not sure something feels right, keep exploring different ways. Something will click for you.

HOW TO READ TAROT

IF YOU ALREADY KNOW WHAT WORKS FOR YOU, keep doing that! But if you've never tried to read your cards, here's how we would advise you to start:

GRAB A TAROT DECK!

- If you have one, perfect. If you do not have one, most bookstores will carry at least one or two, and there are lots more available online. Look for a seventy-eight(ish) card deck with Major Arcana and Minor Arcana in four suits. You can also download tarot apps if you want instant gratification and something you can carry with you at all times.
- Just to clarify: no, the deck doesn't have to be given to you! (And please do not steal one.) Choose a deck based on how you feel about the art, or go with the one that comes with the biggest book that describes and explains the cards.
- Look through the artwork a few times before you sit down to read. Get familiar with what your cards look like and think about what the images intuitively tell you they mean.

FIND A QUIET AND COMFORTABLE SPOT.

- "Where" is totally subjective. It can be your bed, a park bench, your favorite coffee shop, etc. Wherever it is, you should feel both physically and figuratively as comfortable and safe as possible.

TAKE A DEEP BREATH.

- Find some way to focus on the deck in front of you rather than street noise, your phone, or anything else in the room.

SHUFFLE, SHUFFLE, SHUFFLE!

- How, or how many times, is totally subjective. You can riffle shuffle like you would with playing cards, you can pass them hand over hand, or, if you have lots of space, you can just mush them around on a flat surface with both hands.

- Stop shuffling when it feels right. Esther likes to shuffle overhand seven times, but maybe you prefer to sing Happy Birthday to yourself or just go until you feel like the cards are nice and mixed.

AS YOU'RE SHUFFLING, ASK YOURSELF A QUESTION.

- This should not be a yes or no question. Ask something like "How can I make the most out of my day today?" rather than "Will I have a good day?" An easy way to train your brain to ask questions in an open-ended way is to ask, "What should I know about [situation]?"
- Some people may want to direct this question to their guides, a deity, the universal energy they work with, or the cards themselves. All of these are totally valid.

PULL A CARD OR TWO (or do one of our spreads on the next page).

- One or two cards is the best place to start for clear messages, especially when you're getting started, but you can do your own thing too. Our sample spreads can help you get a more nuanced reading, especially for a complex question.

INTERPRET THE CARD OR CARDS.

- In a journal, write down your first reaction to the cards, or write what you thought after reading the meaning in the book that came with your deck. Make sure you write down your original question too so you can look back at it later.

YOU DID IT! REPEAT AS NECESSARY.

- After you put everything away, go drink a glass of water. Not for any tarot reason, but just because it's almost always a good idea.

HOW TO READ TAROT

HERE'S A SOLID GO-TO SPREAD THAT IS ADAPTABLE FOR ANY TIME FRAME OR EVENT YOU'D LIKE MORE SPECIFIC INSIGHT INTO:

1. What to expect
2. What to be cautious about
3. What to leave behind
4. What to bring with you
5. What to be excited about

A SPREAD FOR DECIDING BETWEEN TWO PATHS:

1. Energy surrounding your decision right now
2. Something to consider about option A
3. Possible outcome for option A
4. Something to consider about option B
5. Possible outcome for option B
6. A pep talk

RESOURCES

FOR FURTHER READING

Ben-Dov, Yoav. *The Marseille Tarot Revealed: A Complete Guide to Symbolism, Meanings & Methods.* Woodbury:Llewellyn Worldwide, 2017.

Carr-Gomm, Philip, Stephanie Carr-Gomm, and Will Worthington. *The Druid Craft Tarot: Use the Magic of Wicca And Druidry to Guide Your Life.* New York: St. Martin's Press, 2004.

"Collections Online: British Museum." Collections Online | British Museum. Accessed December 22, 2020. https://www.britishmuseum.org/collection/term/BIB1187.

"Correspondence between Aleister Crowley and Frieda Harris." The Libri of Aleister Crowley—Hermetic Library. Accessed December 22, 2020. https://hermetic.com/crowley/crowley-harris.

Duquette, Lon Milo. *Understanding Aleister Crowley's Thoth Tarot: New Edition.* Newburyport: Weiser Books, 2017.

Gnaccolini, Paola. *Sola Busca Tarot.* Lo Scarabeo, 2019.

Huets, Jean, and Norbert Losche. *The Cosmic Tarot.* Stamford: U.S. Games Systems, 1996.

Kaplan, Stuart R., Mary K. Greer, Elizabeth Foley O'Connor, Melinda Boyd Parsons, and Pamela Colman Smith. *Pamela Colman Smith: The Untold Story.* Stamford: U.S. Games Systems, Inc., 2018.

"Judy Chicago exhibit to Conclude Brooklyn Museum Feminism Exhibition." *The Untitled Magazine,* June 29, 2017. http://untitled-magazine.com/judy-chicago-exhibit-to-conclude-brooklyn-museum-feminism-exhibition/.

Missing Witches. "Lady Frieda Harris: I Wish I Could Paint in Crystals." *Missing Witches* Podcast. Lecture, n.d.

Noble, Vicki. *Motherpeace: A Way to the Goddess Through Myth, Art, and Tarot.* HarperCollins, 1994.

"Order of Bards Ovates and Druids." *DruidCast—A Druid Podcast.* Episode 02. Other. Accessed December 22, 2020. https://druidcast.libsyn.com/druid_cast_a_druid_podcast_episode_02.

Palladini, David, and Anastasia Haysler. *Painting the Soul: The Art of David Palladini.* San Francisco: Black Swan Press, 2013.

Schatzkin, Paul. "What Ever Happened to The Age of Aquarius? (1)." Medium. Medium, August 15, 2019. https://medium.com/@paulschatzkin/what-ever-happened-to-the-age-of-aquarius-1-9f8b64a635bf.

Smith, Sherryl E. *Tarot Heritage.* Accessed December 22, 2020. https://tarot-heritage.com/.

Tyson, Donald. "THE GAME OF TAROTS by Antoine Court De Gébelin." *The Game of Tarots.* Accessed December 22, 2020. https://web.archive.org/web/20111004232937/http://www.donaldtyson.com/gebelin.html.

Valenza, Patrick. *Deviant Moon Tarot.* Stamford: U.S. Games Systems, Inc., 2016.

Wintle, Simon. "Welcome to the World of Playing Cards." Accessed December 22, 2020. https://www.wopc.co.uk/.

Much love to The Wayback Machine, because without it many of these stories would be lost.

ACKNOWLEDMENTS

A global pandemic sure was a weird time to write a book, but there are so many people who made it an enjoyable process!

Firstly, our Wildlings—this whole thing is for you. Throughout the research and writing process we kept thinking, "WE CAN'T WAIT TO TELL THE WILDLINGS ABOUT THIS." Your support and cheerleading bolstered us.

Nathan and Homin, our heroes, you talked us through countless moments of self-doubt and needless criticism, and we love you so, so much. To our families—especially our parents, Tom and Tina, and Tim and Mila—we appreciate the love of learning and reading you instilled in us. Telling you we were doing this project was nerve-racking and life-changing in so many ways. Tina and Katie, you two particularly have always been in our corner in every single moment, from the dawn of the podcast through all of our different phases . . . you're our favorite Cancerians.

Rachel, Logan, Claire, and Anna, thank you for matching our excitement on every single step of this journey. We want to shout about how cringey Aleister Crowley was or how mysterious Bill Greer is, and you want to shout right back at us about it. Your friendship means so much to us, and we'd never sleep safely again if people saw our group chats.

Jenna, Jamie, Richard, Kimberly, Maura, Sara, Melody, Erin, Natalie, Breanna, Jenny, Jackie, Monica, Benjie, Amanda, and Jo and the many other people who have celebrated with us and pumped us up, we adore you.

Wine & Crime Podcast, you brought us together, and *True Crime Obsessed* and *Heaving Bosoms* podcasts, you've kept us sane and laughing.

And lastly, but most ardently, Beth, you big-sistered us so well and made our words make sense. We'd write a hundred books for the chance for you to pep-talk us and draw out our voices again and again. So many thanks to you, and to Haley, for believing we could do this.

Please excuse our pandemic brains if we failed to include you. Just know that every single message of "hey, how's the book going?" unfailingly helped us and we appreciated them all so much.

IMAGE CREDITS

Every effort has been made to trace copyright holders. If any unintended omissions have been made, becker&mayer! would be pleased to add appropriate acknowledgments in future editions.

INTRODUCTION

Page 4: Shutterstock

Page 6: Charles Walker Collection / Alamy Stock Photo

Page 8: Lucas van Leyden, Public domain, via Wikimedia Commons

VISCONTI

VISCONTI TAROT CARDS: Bonifacio Bembo, Public domain, via Wikimedia Commons

Page 13: Public domain, via Wikimedia Commons

Page 14: (both) Bonifacio Bembo, Public domain, via Wikimedia Commons

Page 15: (top) Leonardo da Vinci, Public domain, via Wikimedia Commons; (bottom) REDA&CO / Contributor / Getty

Page 22: (top and middle) Flanker, CC BY-SA 3.0, via Wikimedia Commons; (bottom) Panther Media GmbH / Alamy Stock Photo

Page 26: Catwalking / Contributor / Getty

Page 27: Illustrations from the 1JJ Swiss Tarot reproduced with permission of U.S. Games Systems, Inc., Stamford, CT 06902 USA. Copyright ©2019 by U.S. Games Systems, Inc. Further reproduction prohibited.

SOLA-BUSCA

Cards from the Sola-Busca tarot deck, Unknown author, Public domain, via Wikimedia Commons

Page 30: Public domain, via Wikimedia Commons

Page 31; Nicola di Maestro Antonio d'Ancona, Public domain, via Wikimedia Commons

Page 32: NMUIM / Alamy Stock Photo

Page 33: Science History Images / Alamy Stock Photo

Page 37: Alex & Griffins: mountainpix / Shutterstock

Page 38: INTERFOTO / Alamy Stock Photo

Page 40: National Gallery of Art, CC0, via Wikimedia Commons

Page 47: (left) Image taken from The English Magic Tarot by Rex Van Ryn, Steve Dooley, and Andy Letcher. Tarot cards and colorization copyright © 2016 by Stephen Dooley, used with permission from Red Wheel/Weiser, Newburyport, MA. www.redwheel-weiser.com; (right) istock

TAROT DE MARSEILLE

TAROT DE MARSEILLE: Chronicle / Alamy Stock Photo and Jean Dodal, Public domain, via Wikimedia Commons; Rodrigotebani, CC BY-SA 3.0, via Wikimedia Commons

Page 50: Photo Josse/Leemage / Contributor / Getty

Page 51: Album / Alamy Stock Photo

Page 53: (top row) Lequart (Paris), Public domain, via Wikimedia Commons ; (bottom row) Jean Dodal, Public domain, via Wikimedia Commons

Page 54: (clockwise from upper left) British Museum, Public domain, via Wikimedia Commons; Lequart (Paris), Public domain, via Wikimedia Commons; Jean Dodal, Public domain, via Wikimedia Commons

Page 56: Lequart (Paris), Public domain, via Wikimedia Commons

Page 57: (both) F.I. Vandenborre, Public domain, via Wikimedia Commons

Page 58-59: Chronicle / Alamy Stock Photo

Page 60: Athanasius Kircher (1602-1680), Public domain, via Wikimedia Commons

Page 61: (top) Rijksmuseum, CC0, via Wikimedia Commons; (bottom) Antoine Court de Gébelin, Public domain, via Wikimedia Commons

Page 62: Public domain, via Wikimedia Commons

Page 63; © The Trustees of the British Museum, released as CC BY-NC-SA 4.0

Page 64: Illustrations from the Marshmallow Marseille reproduced with permission of Jorge Cuaik. Copyright ©2020 by Jorge Cuaik.

RIDER-WAITE-SMITH

Illustrations from the Rider-Waite-Smith Tarot reproduced with permission of U.S. Games Systems, Inc., Stamford, CT 06902 USA. Copyright ©2015 by U.S. Games Systems, Inc. Further reproduction prohibited. The Rider-Waite Tarot Deck® is a registered trademark of U.S. Games Systems, Inc.

Page 68: Gertrude Kasebier, Pamela Colman Smith, Public domain, via Wikimedia Commons

Page 69: Stieglitz/Georgia O'Keeffe Archive at Yale University, USA

Page 70: H. Mairet (photographer), Public domain, via Wikimedia Commons

Page 71: Alvin Langdon Coburn, Public domain, via Wikimedia Commons

Page 72: (left) Oswald Wirth, Public domain, via Wikimedia Commons; (right) British Museum, Public domain, via Wikimedia Commons

Page 80: (left to right) Shutterstock; Illustration from the Tarot of White Cats reproduced with permission of Lo Scarabeo, Torino, Italy. Copyright ©2005 by Lo Scarabeo; Illustrations from the 420 Tarot reproduced with permission of Julianna Rose. Copyright ©2020 by Julianna Rose.

Page 82: Public domain, via Wikimedia Commons

Page 83: Illustrations from Modern Witch Tarot reproduced with permission of Liminal 11. Copyright © 2019 by Lisa Sterle.

THOTH

THOTH: Single card images: theasis / istock

Page 86: (Lady Frieda) Public domain, via Wikimedia Commons; (Crowley) mccool / Alamy Stock Photo

Page 87: User:Fuzzypeg, MahaVajra, Israel Regardie, Frieda Harris, Public domain, via Wikimedia Commons

Page 90: Everett Collection / Shutterstock

Page 91: (top) Astrologer / Shutterstock.com; (bottom) AnonMoos, Public domain, via Wikimedia Commons

Page 94: Dan Shachar / Shutterstock.com

Page 95-96: Astrologer / Shutterstock.com

Page 97: (top) sciencesource.com / SCIENCE PHOTO LIBRARY; (bottom) Dan Shachar / Shutterstock.com

Page 99: (left to right) istock; Getty images / Keystone / Staff; Shutterstock

Page 102: (bottom) Cofiant Images / Alamy Stock Photo

Page 103: Illustrations from the Urban Tarot reproduced with permission of U.S. Games Systems, Inc., Stamford, CT 06902 USA. Copyright ©2019 by U.S. Games Systems, Inc. Further reproduction prohibited.

AQUARIAN

AQUARIAN:Illustrations from the Aquarian Tarot reproduced with permission of U.S. Games Systems, Inc., Stamford, CT 06902 USA. Copyright ©2015 by U.S. Games Systems, Inc. Further reproduction prohibited.

Page 106: Digital Image © The Museum of Modern Art/Licensed by SCALA / Art Resource, NY

Page 107: RidingMetaphor / Alamy Stock Photo

Page 108: Illustration from the astrology series by David Palladini, courtesy of the Palladini family

Page 109: David Nathan-Maister / Contributor / Getty

Page 112: FIG Fotos / Alamy Stock Photo

Page 113: Bridgeman Images

Page 119: (left) Illustrations from the New Palladini Tarot reproduced with permission of U.S. Games Systems, Inc., Stamford, CT 06902 USA. Copyright ©2019 by U.S. Games Systems, Inc. Further reproduction prohibited.; (right) Album / Alamy Stock Photo

Page 120: Illustrations from Mucha Tarot reproduced with permission of Lo Scarabeo. Copyright © Lo Scarabeo.

Page 121: Illustrations from Ethereal Visions Tarot reproduced with permission of U.S. Games Systems, Inc., Stamford, CT 06902 USA. Copyright ©2017 by U.S. Games Systems, Inc. Further reproduction prohibited.

MORGAN-GREER

MORGAN-GREER: Illustrations from the Morgan-Greer Tarot reproduced with permission of U.S. Games Systems, Inc., Stamford, CT 06902 USA. Copyright ©2015 by U.S. Games Systems, Inc. Further reproduction prohibited.

Page 124: © Penguin Random House

Page 131: Eliphas Levi, Public domain, via Wikimedia Commons

Page 133: RGR Collection / Alamy Stock Photo

Page 134: ZUMA Press, Inc. / Alamy Stock Photo

ABOUT THE AUTHORS

ESTHER
JOY ARCHER

HOLLY
ADAMS EASLEY

ESTHER JOY ARCHER has always been a spiritual person and found tarot in her late twenties as a unique tool to empower herself and others on their journeys. Since 2017, she has been an avid tarot reader, deck creator, collector, and educator. After meeting Holly, they began the *Wildly Tarot* podcast, where every week they get the opportunity to be "tarot big sisters" to their listeners. Esther lives with her husband, adorable dogs, and a vast collection of reptiles in South Korea, where she teaches elementary students in a small town.

HOLLY ADAMS EASLEY is a lifelong spiritual searcher with a fondness for surrounding herself with beautiful things. Her first exposure to card reading came at the hands of a friendly nun and a bowl of small angel cards in the early 2000s, but she has been putting her efforts toward studying, collecting, and reading tarot cards since 2016. She cohosts the *Wildly Tarot* podcast, talking about tarot reading, tarot decks, and mystical life with Esther. An academic advisor by day, Holly emphasizes the allure of growth, the importance of knowing yourself, and the joy of learning, both at work and in life.

You can find Holly and Esther on Instagram @hollyenchanted and @celestialesther or on their website, www.wildlytarot.com.